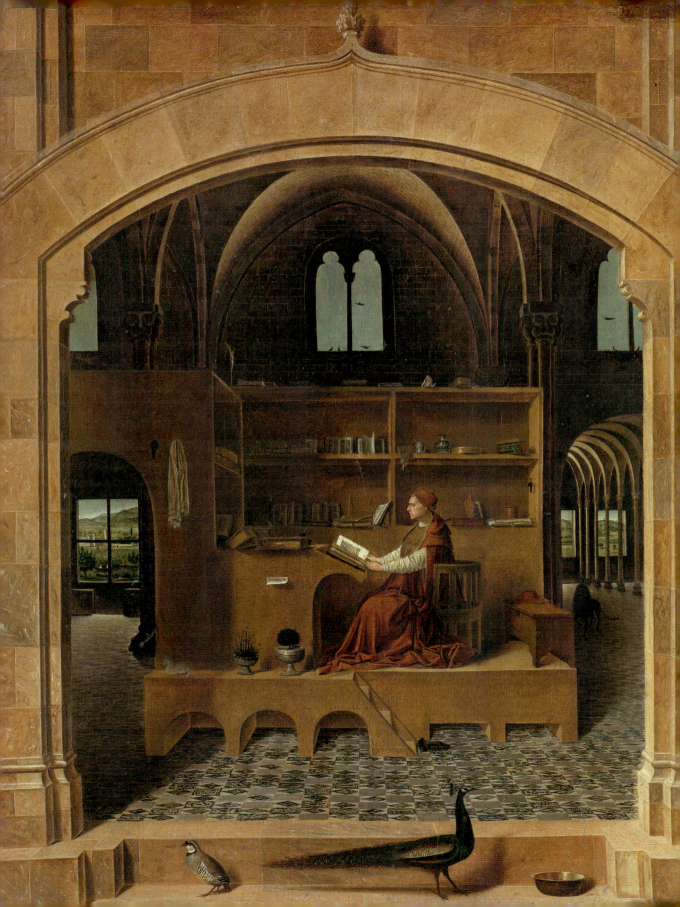

THE HIDDEN LANGUAGE OF SYMBOLS

MATTHEW WILSON

Contents

Introduction 6

THE HIDDEN LANGUAGE OF POWER
12

Wild **Horses** 16

Falcons and the International Language of Authority 21

Scales of Justice 26

Are **Dragons** Good or Evil? 30

Imperial **Eagles** 34

How a **Laurel** Wreath Links Emperors and Poets 40

When a **Column** Isn't a Column 45

Phoenixes and Female Power 50

Next Stop, **Elephant and Castle** 55

Raging **Bulls** 58

The **Pear** That Terrorized a King 63

The Reason **Lions** Rule 68

THE HIDDEN LANGUAGE OF FAITH
74

Why Do Jesus, Buddha, Mithra and Vishnu All Have **Haloes**? 78

Why Your Soul Is a **Butterfly** 84

How the **Palm** Branch Triumphed 88

The **Wheel**'s Revolution 92

The Power of **Doves** 96

Why the **Lily** is the Purest Flower 100

The Hidden Depths of a **Lotus** 105

Of **Eggs** and Origins 110

The Mystical, Multi-dimensional **Rabbit** 114

The Covert Importance of **Goldfinches** 119

Rainbows: Art, Unity and Optimism 123

Holy Grail, Holy **Grapes** 128

FRONTISPIECE Antonello da Messina, *Saint Jerome in his Study*, c. 1475. Oil on lime, 45.7 × 36.2 cm (18 × 14¼ in.)

THE HIDDEN LANGUAGE OF UNCERTAINTY
132

Black **Mirrors** 136

The Rise of the **Skull** 142

Wise **Owl**? 148

Cat Lovers: Don't Read This 152

The Illuminati, the Masons and the **Eye of Providence** 156

Here's Why You Never Trust a **Fox** 161

The **Scythe** of Time and Death 166

Lose Yourself in a History of **Labyrinths** 170

Snakes: The Good, the Bad and the Ugly 174

An Elegy to the **Poppy** 179

The Corruption of a Symbol: The **Swastika** 184

Before the **Bubble** Pops ... 188

THE HIDDEN LANGUAGE OF HOPE
192

The Never-ending Symbol: **Ouroboros** 196

Paradise, Power and Eternal Youth: **Fountains** 200

The Secret Superpowers of a **Peacock** 206

The Greatest Symbol of Hope: A **Fish**? 212

A Wild **Unicorn** Hunt 216

A **Rose** by Any Other Name 222

Why an **Orchid** Represents the Perfect Man 228

Why You Should Always Trust a **Dog** 232

Extraordinary **Parrots** 238

The Friendly Plant: **Sunflowers** 243

The **Carnation**: Flower of Sorrow or Joy? 248

La Peregrina and the History of **Pearls** in Art 252

Notes 258
Sources of Illustrations 265
Acknowledgments 267
Index 268

Introduction

Leaps of the imagination

Despair weighs upon the angel in Albrecht Dürer's famous *Melencolia I* (1514), pinning her in place like a butterfly on a collector's display board. What's the cause of her depression? The answer appears to be encrypted in the diverse apparatus that ensnares her in her workshop. Each object, so carefully selected and placed in the composition, entices us to read them as clues – as symbols with a hidden meaning. But what do these symbols mean, and how can we decode them?

Dürer (1471–1528) was well versed in using symbolic objects in his art, but he never explained the ones in *Melencolia I*. This has helped fuel an astounding corpus of scholarly interpretation about them, the most famous and influential of which was made during the twentieth century by German art historian Erwin Panofsky (1892–1968). He investigated the historical context of the image and observed that the woman was a hybrid of two previously existing allegories. One was the personification of 'Geometry' and creation, marked out by her set of compasses. The other was the figure of 'Melancholy', suggested by her dark complexion and slumped body language. Panofsky proposed that Dürer had amalgamated the two allegories to express the dejection of the frustrated artist.[1]

But Panofsky's detective-work didn't close the case on *Melencolia I*, and scores of later art historians developed alternative theories about its symbols. The melting-pot to the left of the polyhedron has been interpreted as a reference to alchemy,[2] the ladder's seven rungs a reference to Copernicus's seven axioms of astronomy,[3] and the carpentry tools on the floor symbols of Jesus's crucifixion.[4] *Melencolia I* is a seemingly endless trove of puzzlement and inspiration to anyone who is drawn into reading its veiled symbolic language.

The word 'symbol' originates from the Ancient Greek *sumbolon*, meaning 'sign', in the sense of a visual image whose meaning isn't intuitive but

Albrecht Dürer, *Melencolia I*, 1514. Engraving, 23.9 × 18.5 cm (9½ × 7⅜ in.)

For centuries, scholars have debated the true meaning of the symbols in Dürer's Renaissance masterpiece.

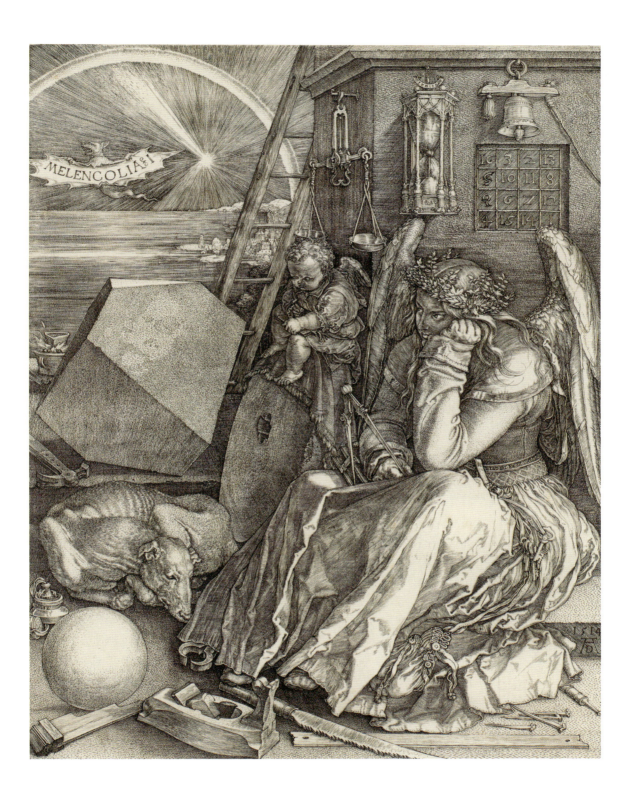

has to be learned, like a 'stop' sign on a road, or the icon for a church on a map. This stemmed from two smaller words: '*sun-*', which means 'together' or 'alike', and '*ballein*', meaning 'to throw'. Symbols, in other words, are two things thrown together: a sign and its apparently disconnected referent. To get from one to the other requires a leap of the imagination. This ability is one of the brain's superpowers, and the essence of all communication. Even the words you are reading now are symbols, each one requiring your brain to make a spectacular jump between the black shapes of letters and the concepts they cause you to think. When you read symbols in art, especially so with an image as complex as *Melencolia I*, your brain is working in an even higher gear, performing sophisticated mental acrobatics as it springs from image to idea, edified by the historical investigations of scholars such as Panofsky.

A history of the world in symbols

Discussing these ideas with my colleagues and students shaped this book. Such conversations led to much more fundamental questioning about the role of symbols. Not wholly content with simple explanations – that a dog normally represents loyalty, or that a rainbow represents hope – my students would usually proceed to ask a very well-justified: 'why?'

I became riveted by the answers I uncovered. What I frequently found was that symbols had unexpectedly deep histories, sometimes leading back to the very earliest civilizations. The story of how they spread, evolved and mutated was not only interesting in its own right, but it also provided a unique perspective from which to see history, linking otherwise very separate cultures in surprising ways. To understand the symbolism of sunflowers (which connote loyalty), for example, the story begins in pre-Columbian America, picks up in Baroque England with the paintings of Sir Anthony van Dyck (1599–1641), and continues through to Vincent van Gogh (1853–1890) in France and the propaganda posters of Chairman Mao (1893–1976) in China. Treating symbols like characters in history and following their journeys through time was an eye-opening experience for me, and I hope you will enjoy the epic routes they take across the globe, often transported by conquering empires, traders and religions.

Popular symbols indicate the things that societies value the highest. Some of the symbols I discuss have even shaped historical events: pearls, for example, were such a prized commodity to Roman emperors and Habsburg monarchs that they inspired perilous exploration and the invasion of foreign

Kara Walker, *Fons Americanus*, Tate Modern, London, 2019. Non-toxic acrylic and cement composite, recyclable cork, wood, and metal, 22.4 × 15.2 × 13.2 m (73 ft 6 in. × 49 ft 10 in. × 43 ft 3 in.)

Here, fountains' typical associations with power and civic pride are inverted to bring home the atrocity of the transatlantic slave trade.

lands. Fountains in art often symbolize purity, but the desire for monumental urban waterworks also drove incredible ingenuity in engineering, and reflected mighty leaders' ability to tame nature. Symbols are slippery, and harder to pin down than you might think: owls are not always wise, poppies were a symbol of death long before the First World War, and despite popular belief the mysterious 'Eye of Providence' is not a secret sign of the Illuminati.

During my research, I began to divide the symbols that interested me into categories. The first section of this book, 'The Hidden Language of Power', is about recurring emblems of authority. While the focus is generally on artworks, you will see how symbols also infiltrate everyday life, featuring

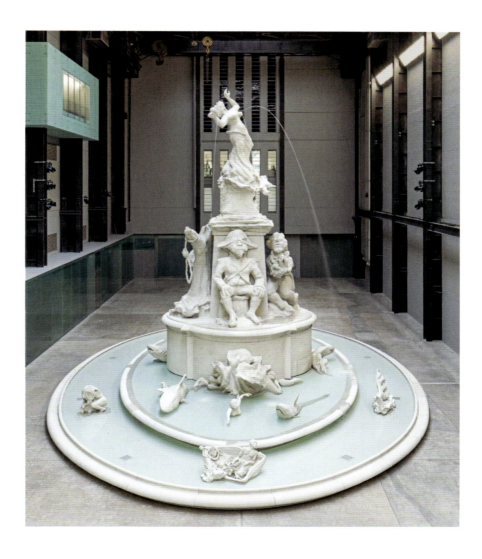

INTRODUCTION

9

in public sculpture, monuments, currency and flags. The next section, 'The Hidden Language of Faith', examines how symbols are used in religions, where they are often an important means of creating shared ideas and identities among illiterate populations. 'The Hidden Language of Uncertainty' presents a collection of symbols of dread and fear, employed by artists envisioning some of our deepest anxieties. 'The Hidden Language of Hope' explores the alternative: these are our symbols of optimism and goodwill.

Of course, not every painting and sculpture in the history of art uses the language of symbols – many are straightforwardly representational, or opt to communicate through abstraction or pattern. But the idea behind this book is to pick a few gems from the history of iconography to show just how powerful the grammar of symbols can be in the right hands.

How to 'read' the hidden language

Three very different methods of interpreting symbols emerged in the nineteenth and twentieth centuries. One of these is the art historical study of iconography. This is the study of the subject matter of art, particularly the reoccurring language of gestures, symbols and motifs. Panofsky's preferred term was 'iconology' to denote the wider, more contextual approach to decoding subjects in art. A more specialized branch of analysing the behaviour of signs and their translation into meaning is called semiotics, also developed in the early twentieth century. This was pioneered by two men: Swiss linguist Ferdinand de Saussure (1857–1913) and American philosopher Charles Sanders Peirce (1839–1914). In semiotics, the visual 'sign' works in three ways: as an icon, where the sign represents the thing being signified – for example, a road sign showing a pedestrian; as an index, where the sign shows the evidence or trace of something – like a footprint to represent a person having once been present; or as a symbol, in which the sign doesn't represent the thing being signified at all, but we decipher it through convention. A third and very different approach was taken by Swiss psychiatrist Carl Jung (1875–1961). Jung believed that symbols were the language of our unconscious minds, which communicated deep truths to our conscious selves via dreams and art. These truths, he said, was personal to the dreamer or artist, but also had a universal significance. He thought that symbols were part of the 'collective unconscious' – a psychic language common to all humankind. This had built up over millions of years of shared experience and created an inherited stock of symbolic associations; to maintain psychic stability, Jung believed, we had to listen to the profound messages contained in dream symbols.[5]

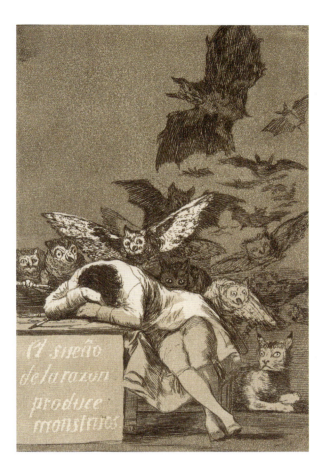

Francisco de Goya, *The Sleep of Reason Produces Monsters*, plate 43 from *Los Caprichos*, 1799. Etching, aquatint, plate 21.2 × 15.1 cm (8⅜ × 6 in.)

The meanings of symbols change between cultures: some considered owls to be a wise animal, but Goya used them to represent squalor and ignorance.

Throughout this book I have focused on the historical trajectory of symbols, tracing their original purposes and their impact on history. In other words, I take my lead mainly from the approach of Panofsky rather than Saussure, Peirce or Jung. But I hope you will see that each of the artists I discuss in this book treats symbols very differently. One of the joys of exploring symbols in art is to continually adapt your preconceptions and methodology – learning the rules of each new puzzle before solving it.

At times during the writing of this book I have felt like the fatigued angel in *Melencolia I*, overawed by the forest of symbols in art history and their complex meanings. But I have always been galvanized by the great field of scholarship on iconography and the ongoing discourse about subjects in art and their meanings. My greatest inspiration comes from the many artists in history who have mastered the multifaceted language of symbols and made it their own.

INTRODUCTION

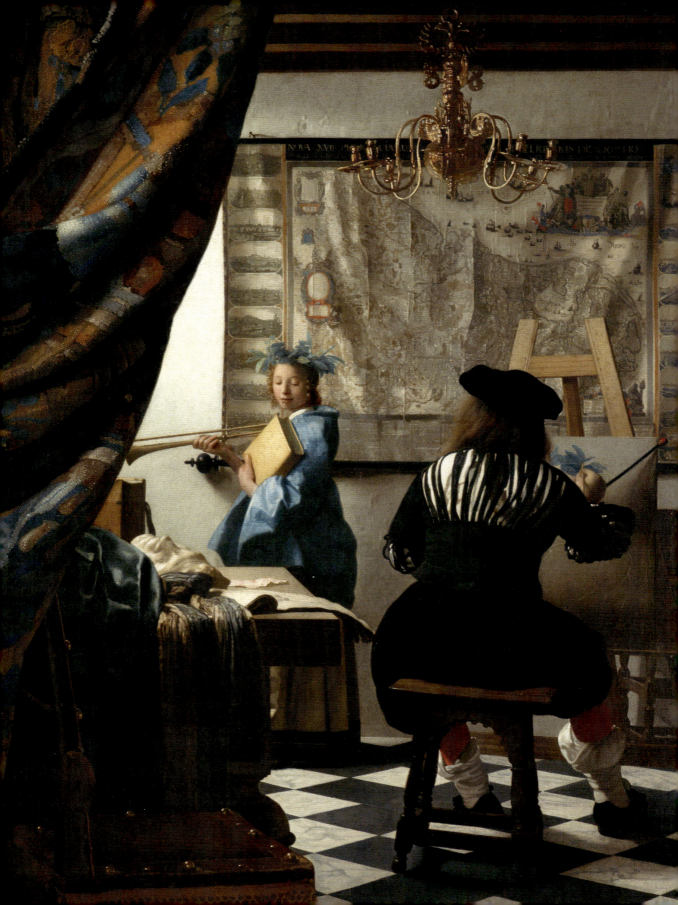

THE HIDDEN LANGUAGE OF POWER

In 1953, the Hungarian art historian Charles de Tolnay (1899–1981) wrote an essay showing how great works of art sometimes hide symbols of political power. He drew attention to the brass double-headed eagle at the top of the chandelier in Johannes Vermeer's *The Art of Painting* (1666–68), which is well disguised enough to pass you by on first viewing. But De Tolnay recognized it as the emblem of the Catholic Habsburg empire that once ruled Vermeer's Protestant Dutch Republic – and thus a covert representation of Vermeer's own Catholic beliefs, and a lament for the fracture of the Netherlands during the bloody religious wars of the previous century.[1] Vermeer's eagle exemplifies the subject of the first section of this book: symbols that surreptitiously embody the authority of mighty leaders, institutions, nations, empires or ruling classes. Emblems that tell a story about those who have possessed power and how they have visualized it.

Each of the following twelve entries investigates a symbol's role as the emblem of power. Historically these motifs – which might be artefacts, animals or plants – unified diverse peoples and cultures under a common banner. Most of the essays deal with symbols of very ancient origins: the story of the symbolic power of horses begins with Palaeolithic art, made tens of thousands of years ago. The symbolic meaning of dragons was established independently in China and Europe, although they evolved with opposing characteristics in the two traditions. The origins of other symbols, such as falcons and weighing scales, occurred in ancient Egypt: falcons progressed as a symbol of aristocratic finesse until the Renaissance period in Europe, while the weighing scales have remained a symbol of justice up to the present day.

Johannes Vermeer, *The Art of Painting*, c. 1666–68. Oil on canvas, 120 × 100 cm (47¼ × 39⅜ in.)

Symbols of power like the double-headed eagle at the top of Vermeer's chandelier can sometimes lie hidden for centuries in artworks.

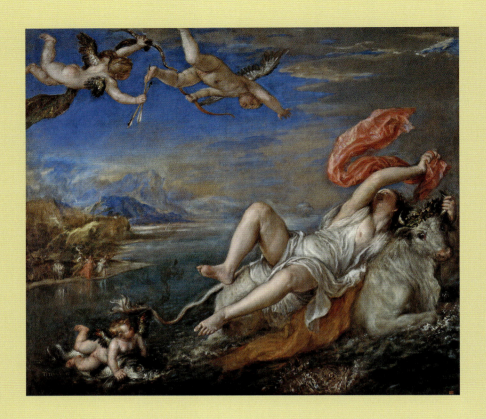

ABOVE Titian, *The Rape of Europa*, 1559–62. Oil on canvas, 178 × 205 cm (70⅛ × 80¾ in.)

OPPOSITE Bernat Martorell, *Saint George and the Dragon*, 1434–35. Tempera on panel, 155.6 × 98.1 cm (61⅜ × 38⅝ in.)

The brutish power of bulls and dragons are a recurrent theme in western visual culture.

 I have chosen to describe the history of the laurel wreath by looking at its revival in the Renaissance, and the phoenix by comparing its use in the imagery of two powerful women from the 1570s: one living in China, the other in England. The unusual 'elephant and castle' motif is one that connects the British exploitation of African natural resources in the seventeenth century with Alexander the Great and an Underground station in modern London. I begin my entry on bull symbolism with a scandal involving human trafficking in Victorian times, to exemplify how this beast has always been an emblem of machismo. My consideration of the symbolism of pears is slightly different, as it tells the story of a specific and short-lived symbol that managed to undermine political power with satire.

 These are all symbols that are visible in art, but they also surround us in our daily lives. You can see the evidence around you in the lions that adorn our public sculptures, the heraldic animals and objects in our national flags or the weighing scales in the emblems of our courts of justice.

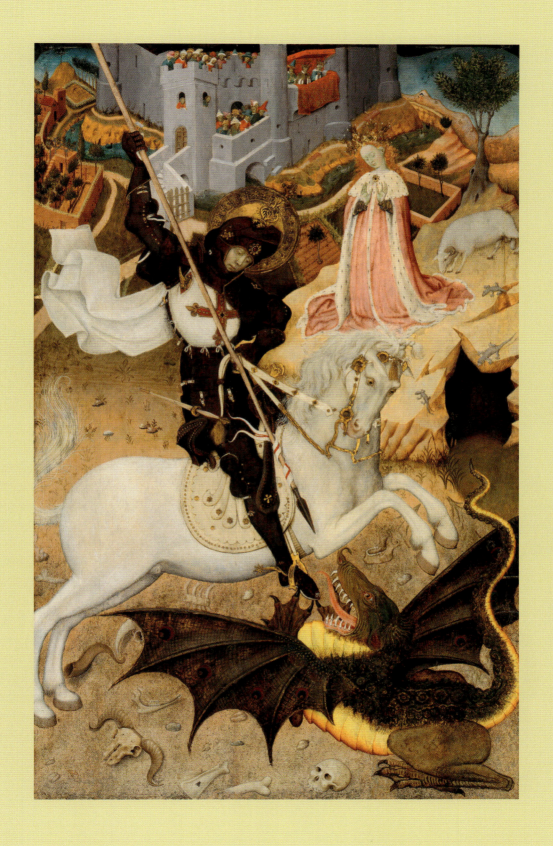

Wild **Horses**

Donatello, *Equestrian Statue of Gattamelata*, Piazza del Santo, Padua, 1447–53. Bronze, 3.4 × 3.9 m (11 ft 1⅞ in. × 12 ft 9½ in.) (excl. base)

A turning point in art: the first equestrian sculpture since Roman times.

When seen from below, the suspended metallic bulk of the horse in Donatello's *Equestrian Statue of Gattamelata* (1447–53) is as awe-inspiring as a falling bomb. For the citizens of Padua, it was a startlingly unfamiliar object when it was unveiled in 1453, and a potent representation of the power of the man astride the horse. His nickname was Gattamelata – the 'honeyed cat' – but his real name was Erasmo da Narni (1370–1443), the brilliant Italian mercenary warrior. To give him the appropriate aura of might, Donatello (1386–1466) chose an equestrian format, but this presented many technical challenges, especially calculating how a horse's four thin legs could be made to support the tremendous weight of the sculpture's upper section. It was the first such example since the time of the Romans, almost a millennium before.

Seated upon a steed, any ruler is given automatic dignity and authority, and many great artists after Donatello used this tactic, including Peter Paul Rubens (1577–1640), Diego Velázquez (1599–1660) and Jacques-Louis David (1748–1825). Above all other mammals, horses are represented as heroes, emblems of nature's boundless zeal and metaphors for humans' suppressed

THE HIDDEN LANGUAGE OF POWER

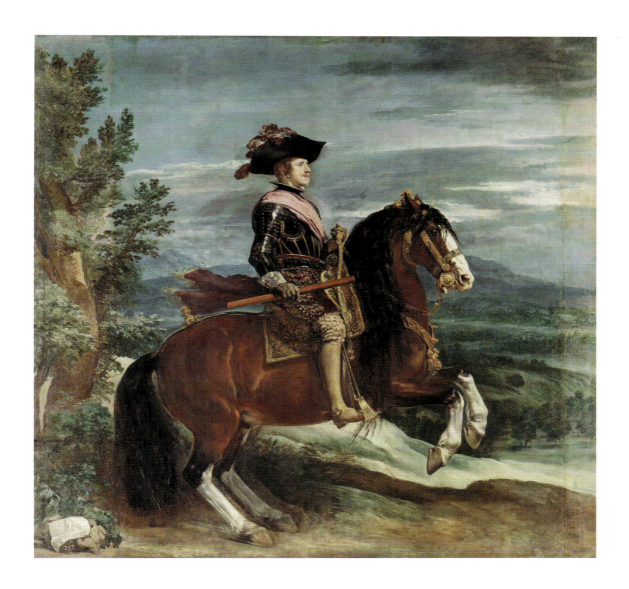

Diego Velázquez, *Philip IV on Horseback*, c. 1635. Oil on canvas, 3.03 × 3.17 m (9 ft 11¼ in. × 10 ft 4¾ in.)

For centuries, talented horsemanship has conveyed sovereignty.

passions and powers of command. The origins of these symbolic ideas were forged when horses were first domesticated on the barren grasslands of Ukraine and Kazakhstan around 6,000 years ago.[2]

Ever since that time, horses have served as beasts of burden for their human masters: they are a mode of transport, a weapon of war and a tool of agriculture. And yet human culture has consistently flipped that reality on its head, elevating horses to an exalted status. For example, horses enjoyed esteemed roles in religions. The *Rigveda*, a Bronze Age collection

Wild Horses

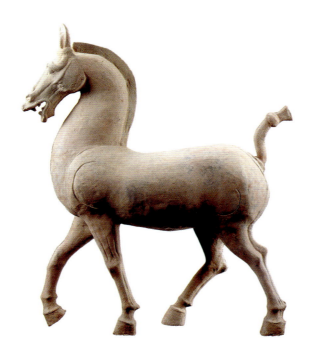

Prancing horse, China, Han dynasty, 1st–3rd century CE. Earthenware with traces of pigment, 106.7 × 92.7 × 29.2 cm (42⅛ × 36½ × 11½ in.)

In China, horses were once believed to be the offspring of dragons, and were rumoured to sweat blood.

of ancient Indian hymns, contains stories of heavenly and magical horses; a similar status is afforded horses in Nordic and Celtic myth. The effect of this is felt across artforms to the present day.[3] We rarely find malevolent or untrustworthy horses represented in literature or art – they are almost always noble and glamorous.

Horses were a recurrent theme in Palaeolithic art, best represented in France's Lascaux and Chauvet caves, which were painted from around 28,000 BCE. Because we know so little about the original function of these images, their symbolism is impossible to interpret, but our ancestors clearly had a fascination with equine speed, agility and strength. Archaeologists who have analysed horses' teeth from around 4000 BCE have noticed that they are worn in such a way as to indicate the use of rudimentary leather bits, giving an approximate date of their first being ridden by humans.[4]

Using horses as a mode of transport was a revolutionary event in history, radically enhancing the ability of humans to hunt, fight and farm. Between the Bronze Age and the nineteenth century CE horses shaped the economies, military policies and international relations of Eurasia. Like all other disruptive events in history, the domestication of horses also influenced the language of visual symbols. From this point onwards, horses no longer served simply as icons of nature's dynamism, but also that of the humans who controlled them best.

In Han-dynasty China (206 BCE–220 CE), such was the status of horses that members of the nobility asked to be buried with their favourite steeds so that they could accompany them to the afterlife. Sometimes sculptures sufficed in their place. These artworks, which represent their subjects with great beauty and care, focused on the horses' grace, speed and *qi*, the Chinese concept of life-force.[5] The best horses, imported from the Central Asian Fergana Valley, were believed to be the offspring of dragons.[6] Among the 'literati' – a class of Chinese scholar-artists – they became associated with the ruling class and good governance. During the Yuan dynasty, when China was ruled by foreign, Mongol emperors, some literati painters depicted malnourished and spooked horses in their art, converting them into coded anti-authority symbols.[7]

Cesare Ripa's 1593 compilation of emblems (the *Iconologia*) gave horses the prestigious role of symbolizing Europe, where they were similarly treated as high-status beasts. In Greco-Roman myth the winged horse Pegasus was the child of Medusa and Poseidon and the mount of the heroic Bellerophon, slayer of the Chimera. Poseidon is also depicted in art with his seahorses. In Christianity, a horse is often depicted as an attribute of military or well-born saints, like St Paul or St Martin of Tours – but they are also vehicles of vengeance, conveying the Four Horsemen of the Apocalypse to fulfil their task of bringing an end to the world through Pestilence, War, Famine and Death.

Horses were unknown in the Americas before 1519, when European explorers and colonizers such as Hernán Cortés (1485–1547) first introduced

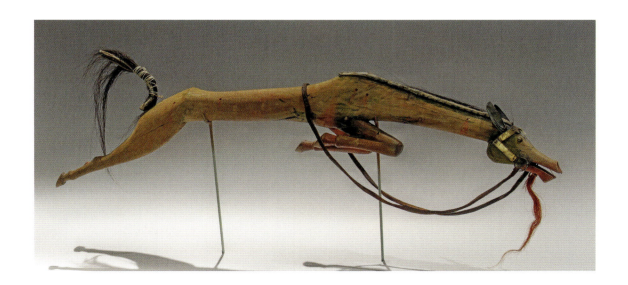

He Nupa Wanica/Joseph No Two Horns, *Horse Effigy*, c. 1880. Wood (possibly cottonwood), pigment, commercial and native-tanned leather, rawhide, horsehair, brass, iron, bird quill, length 97.8 cm (38½ in.)

Although a late arrival in the Americas, horses were quickly represented as prestigious animals in the art of indigenous peoples.

Wild Horses

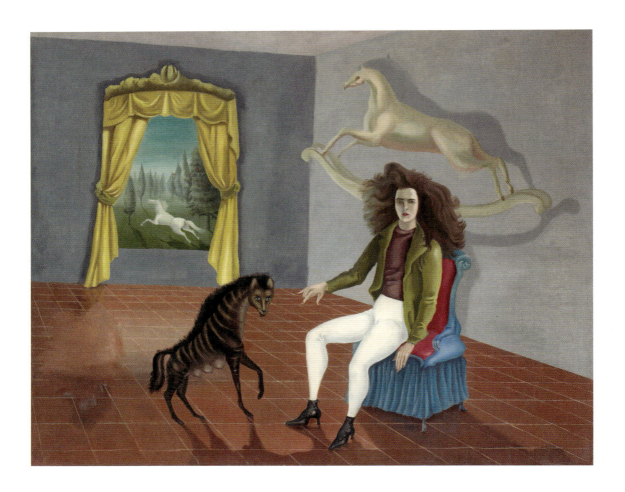

Leonora Carrington, *Self-Portrait*, c. 1937–38. Oil on canvas, 65 × 81.3 cm (25⅝ × 32⅛ in.)

By the 20th century, horses were increasingly represented as mystical beasts in art.

them to the continent, using them to destructive effect to subdue native peoples.[8] The indigenous tribes of North America eagerly embraced the new animals for hunting and fighting, perceiving power in the sounds created by the pound of their hooves, and conceiving them as a symbol of status and dominance.

With the invention of motorized vehicles, horses were displaced as a primary method of transport and communication. The effects of this can be seen in art history: in the twentieth century, horses increasingly became creatures of the imagination and the unbridled passions of the human spirit, especially in Surrealist art.

Falcons and the International Language of Authority

To understand why a falcon is a symbol of love, loyalty, self-control and aristocratic refinement, you have to understand its natural capabilities as a bird of prey.

As a peregrine falcon dives towards its kill, it will sweep its wings back like a jet fighter, and when at maximum attack velocity it can achieve speeds of up to 200 mph (320 kmph).[9] No other animal in the world is faster. Its ability to make last-minute manoeuvres to achieve a surgical strike on its victim has led some to compare the falcon's navigational abilities to the technology used in modern guided missiles.[10]

It was because of these skills of strategy and agility that falcons gained a pivotal role in ancient Egyptian symbolism, becoming synonymous with the god of kingship, Horus, as well as a host of other deities associated with the sky. The bird also represented the living pharaoh, so it is common to see depictions of falcons wearing the symbolic crowns of Upper and Lower Egypt to express political dominance.

Yet as history unfolded, it was the eagle that became the mainstream avian symbol of power in great empires from the Romans to Napoleon, and beyond. The falcon's symbolism in art after the Egyptians is not of solitary magnificence, but close collaboration with humans, as they became linked with the art of hunting.

Which culture first trained a bird of prey to hunt? Some scholars trace the invention of falconry back to 2000 BCE in Mesopotamia or Hittite Anatolia, where we have the first artistic representations of hunting with birds of prey.[11]

Inlay depicting 'Horus of Gold', possibly from Hermopolis, Middle Egypt, 4th century BCE. Faience, 15.6 × 12.9 × 1.2 cm (6¼ × 5⅛ × ½ in.)

In ancient Egypt, falcons were linked with powerful gods like Horus.

Others place its origins in India, Mongolia or China. Certainly, the subject matter of hunters and horsemen were of long-lasting interest to Chinese artists, particularly of falconers from the tribes north of China, such as the Jurchen and the Khitan.

Wherever it was practised, the art of falconry was closely connected to elite culture. It symbolizes the intelligence of both human and bird, and bears testament to a long and patient training regime for both. You cannot breed a trained falcon straight from captivity, and to successfully teach it the owner must possess authority, patience and empathy.

Many symbols in western art history derive from the cultures of ancient Greece and Rome – but not so with falconry. In fact, it arrived in Europe with Hun nomads (hailing from central Asia and eastern Europe) who invaded the Roman empire in the fifth century CE. The presence of tamed birds of prey on the Bayeux Tapestry (1073–83) exemplifies the enduring appeal of falconry in Europe since that time.

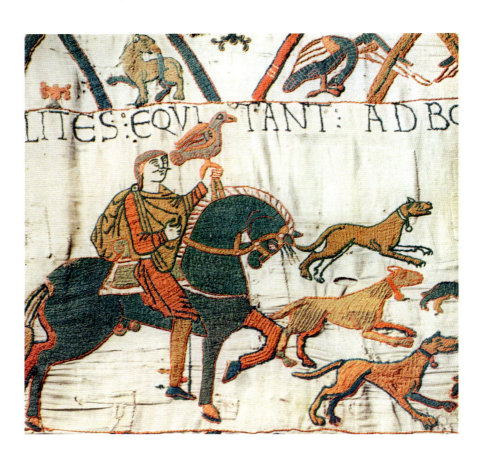

Detail from the Bayeux Tapestry, 11th century. Wool thread on linen, overall length approx. 68.3 m (224 ft)

A record of the noble pursuit of falconry in Europe, introduced by the Huns.

THE HIDDEN LANGUAGE OF POWER

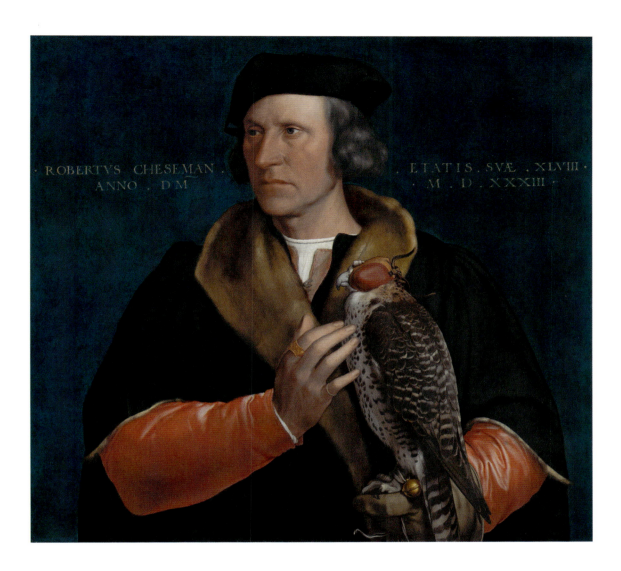

Hans Holbein the Younger, *Portrait of Robert Cheseman*, 1533. Oil on panel, 58.8 × 62.8 cm (23¼ × 24¾ in.)

In this painting of Henry VIII's chief falconer, both sitters radiate nobility and composure.

This was given fresh impetus by an influential text on falconry in Europe: *De Arte Venandi cum Avibus* (On the Art of Hunting with Birds), written by the Holy Roman Emperor Frederick II of Hohenstaufen (1194–1250). Yet even his knowledge was inherited from a non-European source, this time Islamic treatises on falconry, such as *Kitāb al-mutawakkilī* (The Book for al-Mutawakkil), a ninth-century work by the Arabic scholar known in the west as Moamyn. By the dawn of the second millennium CE there was an intercontinental exchange of ideas about the sport across

Falcons and the International Language of Authority 23

the whole of Eurasia. 'Falconry', as one scholar has put it, 'linked the British Isles and Japan into one great information and trade network.'[12]

By the Middle Ages, a falcon was a symbol of nobility in Europe, and wearing one on your wrist could signify high status. The English prioress Juliana Berners even categorized birds of prey into a hierarchy linked to the prevailing social structure, where emperors connoted eagles and kings – one level below – were falcons, in her *Bokys of Haukyng and Huntyng* (1486). In paintings of the late medieval and Renaissance periods a falcon symbolized intensive training for high office combined with natural skill. You can see this in the renowned fresco *The Effects of Good Government* (*c.* 1337–40) by Italian painter Ambrogio Lorenzetti (1290–1348), as well as in many portraits in which a falcon might represent the ambition of the sitter and the suppression of wild forces.[13] In Europe, falcons were given as gifts among the aristocracy, by whom they were highly prized and given names. In European art as well as portraits of the emperors of Mughal India falcons

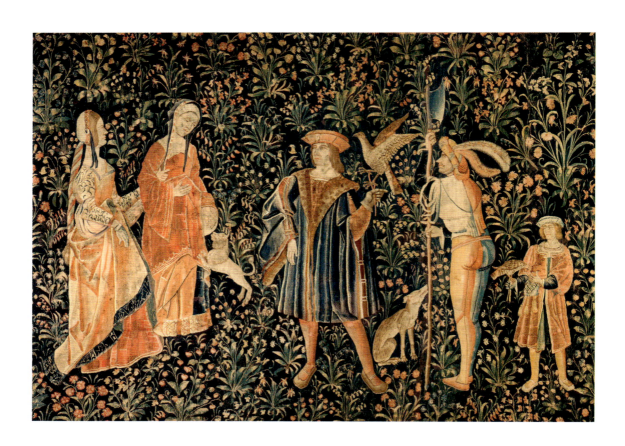

Unknown artist (South Netherlandish), *Falconer with Two Ladies, a Page and a Foot Soldier*, c. 1500–30. Wool warp; wool and silk wefts, 2.5 × 3.51 m (8 ft 2¼ in. × 11 ft 6 in.)

In the medieval period, falconry was a pursuit enjoyed by both men and women.

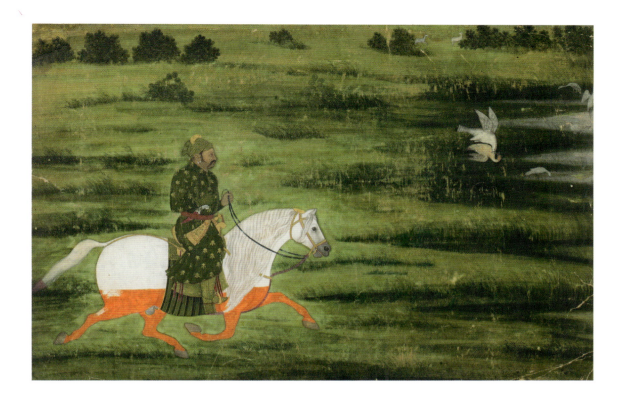

A mounted man hunting birds with a falcon, India, Mughal dynasty, early 18th century CE. Opaque watercolour and gold on paper, 22.3 × 33.7 cm (8⅞ × 13⅜ in.)

Falcons have been a symbol of elite training, speed and skill across the globe, including in Mughal India.

stood for obedience, but not in the sense of servility – rather, the bowing to duty of high calling.

In his book *Gentleman's Recreation* (1677), the English writer Nicholas Cox (active 1673–1721) claimed that the falcon 'flies to such a height, that being lost to the sight of Mortals, she seems to converse with Heaven alone … yet such is her loyalty and Obedience to her Master that a word from his mouth shall make her stoop.'[14] In Dante's *Divine Comedy* (1308–20) the connection between falconer and bird was a symbol of religious loyalty,[15] while in Boccaccio's *The Decameron* (1348–53) this symbiosis was a symbol of earthly love. This was true in the visual arts too, especially because falconry was one of the rare activities that men and women could both partake in on an equal footing.

The popularity of falconry declined rapidly in Europe from the seventeenth century as a result of dwindling falcon populations, changing fashions, the expense of hunting with birds and the altering layout of rural topography.[16] As a result, the falcon, unlike the transcendent eagle, is not a ubiquitous symbol in the modern West, but a relic of the refined sensibilities of history's elite classes.

Falcons and the International Language of Authority

Scales of Justice

Take a look at the emblems of the European Court of Justice, the International Court of Justice and China's Supreme People's Court. All these institutions of law, and many others around the world, use weighing scales as their symbol. But the story behind them begins with judgment of a slightly different nature, in ancient Egypt.

Books of the Dead were travel guides to the underworld, written on papyrus and tucked into coffins. They established the complex procedures and potential pitfalls that would face the deceased in the afterlife. Among the many pieces of advice was 'Spell 125' – a description of the gods' judgment of the dead, represented in imagery by weighing scales. After leaving the body, the soul is led into the Hall of the Two Truths where Anubis weighs the human heart against the weight of a feather. How well behaved have you been during your life? If your heart's good, you enter the afterlife; if it's impure you will be fed to Ammit, a crocodile-headed monster. Spell 125 was invented around 1475 BCE, during the rule of the female Pharaoh Hatshepsut.

Weighing scales have all the hallmarks of a perfect visual symbol. They stand for a clear idea: functionally they offer perfect calibration and are mechanical, placing them above human bias. They have an easily recognized silhouette and through symmetry and asymmetry convey an easily grasped graphic of that most universal of human emotions – a sense of fairness. Whereas other symbols (like **snakes**, pp. 174–78, **owls**, pp. 148–51, and **swastikas**, pp. 184–87) change meanings and may even have opposite meanings in different cultural contexts, a set of weighing scales is steadfast and unambiguous.

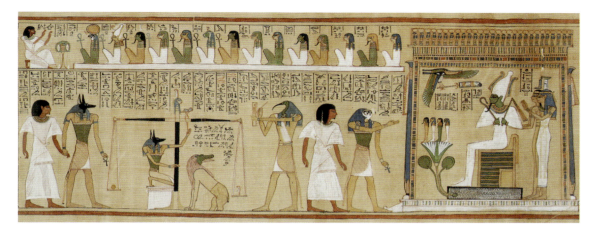

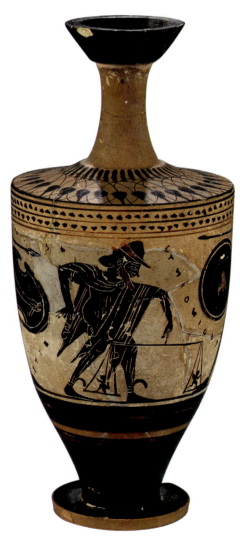

ABOVE Vignette from the Book of the Dead of Hunefer, Egypt, 19th dynasty. Papyrus, 40 × 87.5 cm (15¾ × 34½ in.)

The weighing scale became an important feature of ancient Egyptian funerary art.

RIGHT Black-figured *lekythos* with Hermes Psychopompos weighing the souls, Greek, c. 490–480 BCE. Height 14.6 cm (5¾ in.)

The weighing scale, symbolizing divine judgment, reappeared in Greek art.

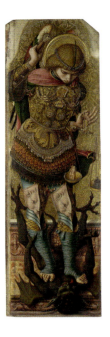 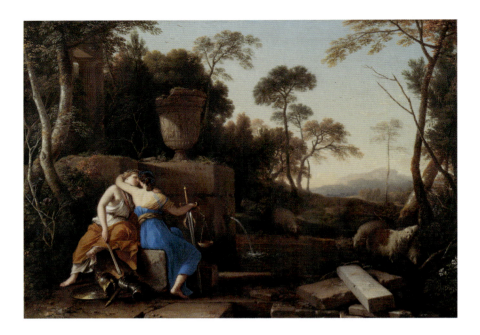

ABOVE LEFT Carlo Crivelli, *Saint Michael*, c. 1476. Tempera on poplar, 90.5 × 26.5 cm (35¾ × 10½ in.)

St Michael weighs Christian souls, echoing the duty of Hermes in ancient Greek art.

ABOVE RIGHT Laurent de La Hyre, *The Kiss of Peace and Justice*, 1654. Oil on canvas, 54.9 × 76.2 cm (21⅝ × 30 in.)

The allegory of Justice is instantly identifiable in this image of harmony, made in the aftermath of civil war in France.

OPPOSITE Petrus Christus, *A Goldsmith in his Shop*, 1449. Oil on oak panel, 98 × 85.2 cm (38⅝ × 33⅝ in.)

The young couple in this painting stare intently at the scales used to weigh rings, suggesting that it is the symbol of a harmonious marriage.

The symbol was adapted from Egyptian culture into the art of the ancient Greeks and Romans.[17] The Greek god Hermes, for example, is sometimes represented with them, symbolizing the balance of fate in warfare, such as in the legendary battle between the Trojans and the Greeks.[18] Coins from the Greek and Roman worlds sometimes show Dikaiosyne, the Greek goddess of order and justice, with a set of weighing scales, and the symbol was attached to the later Roman deities Justitia (Justice) and Aequitas (Fair-Dealing).[19] As Christianity spread and took over the temples of the Greco-Roman religions, the motifs and imagery from the older faiths sometimes got carried over into the new. It has been suggested that the image of Hermes (identified with Mercury in Roman culture), judging the dead with weighing scales, was transposed into Christian culture in the form of St Michael.[20]

Art from medieval Europe also sometimes shows Christ with the attributes of a judge taken from classical visual allegories, such as the weighing scales and a sword of justice. Also to re-emerge at this time was the figure of Justitia. She became the secular version of St Michael, reflecting a general revival of interest in the classical past, including the techniques of Roman art and Roman law. Since that time, weighing scales have enjoyed an unchallenged position in the global system of public visual symbols – it is a rare example of a symbol that completely lacks ambiguity.

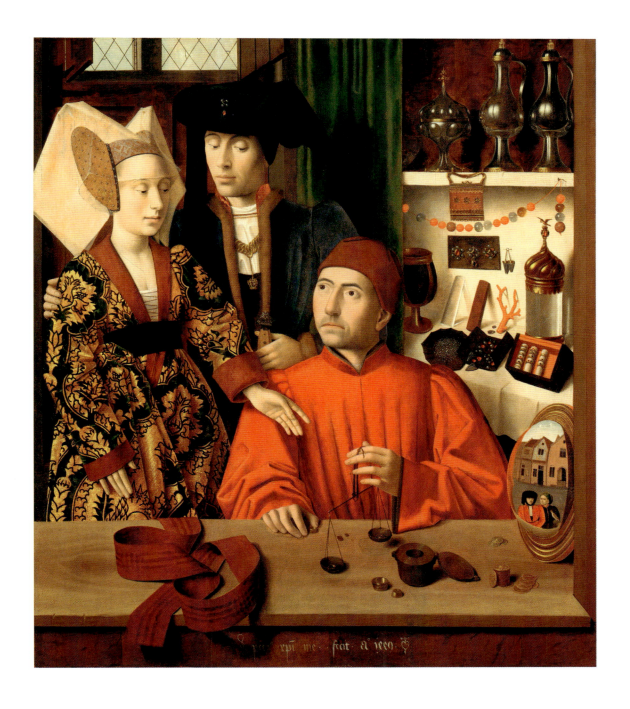

Scales of Justice

Are **Dragons** Good or Evil?

Dragons are the epitome of evil and the epitome of goodness, depending on the perspective you look at them from. The split in opinion originates in the cultures of two great empires that existed at around the same time: the Han dynasty in China and the Roman empire in the west.

One day in 312 CE, the citizens of Rome walked to the Caelian Hill and gathered at the main portico of the imperial palace of the new Emperor Constantine, to see a painting adorning the edifice. Constantine was the first emperor to profess Christianity, and the artwork was a bid to give him a positive public image in the eyes of pagan Rome. It showed beneath the emperor's feet – reeling with a spear in its side and tumbling into the sea – a monstrous dragon.[21]

It was an easily understood allegory for the Roman populace: Constantine was the saintly protector, turbo-charged with his powerful new faith to vanquish a monster, here acting as a symbol for every evil heathen tribe (like the Goths of Germany and the Sasanians of Iran) that sought to defile the empire. Christian scripture connected dragons with evil, but their pairing in an image with a masculine heroic slayer was to become iconic. Over the subsequent centuries of Christianity's burgeoning power and geographical dominance in the west, paintings of St George and the Archangel Michael, Christianity's two most famous dragon slayers, became incredibly popular. This was particularly the case at times when the faith was under real threat. A bristling painting of St George by Peter Paul Rubens (1577–1640), for example, was painted during a time of heightened tensions between Catholics and two mighty enemies, the Ottoman empire and the Protestants of northern

Peter Paul Rubens, *Saint George and the Dragon*, c. 1606–8. Oil on canvas, 309 × 257 cm (121¾ × 101¼ in.)

In western art, dragons were often a coded reference to threatening, non-European outsiders.

THE HIDDEN LANGUAGE OF POWER

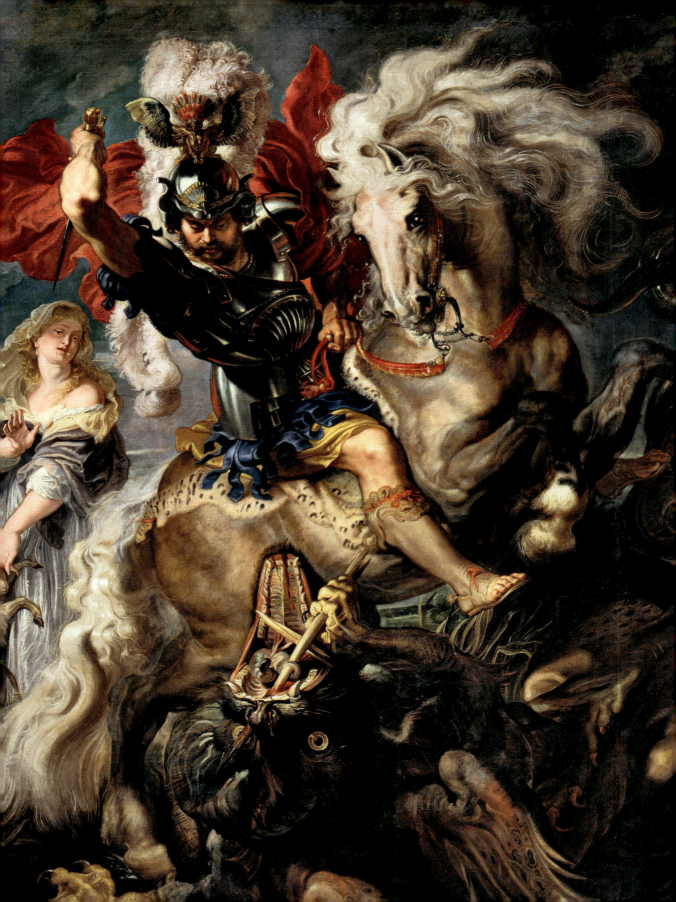

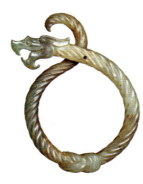

Europe. The dragon in Rubens's painting is gross, lumbering and incapable of flight, a creature of primeval darkness. While it is true that dragons had a positive character in some European heraldry, Christianity had ensured that in religious terms dragons were associated with pagan outsiders, and were therefore unequivocally evil.

Is it possible to dig deeper into history to explain people's fascination with dragons? Humans had been depicting them as motifs and symbols for a very long time before Constantine. One great mystery that still perplexes scholars is the fact that they appear in the art of many disparate ancient cultures and even share many traits (such as being guardians of treasure and water, having scaly skin and being capable of flight), though most of the early societies who created folklore around dragons could never have interacted with one another.[22]

Dragons are not malevolent creatures in Chinese art, where they have been represented from as long ago as the fifth millennium BCE. Dragons were

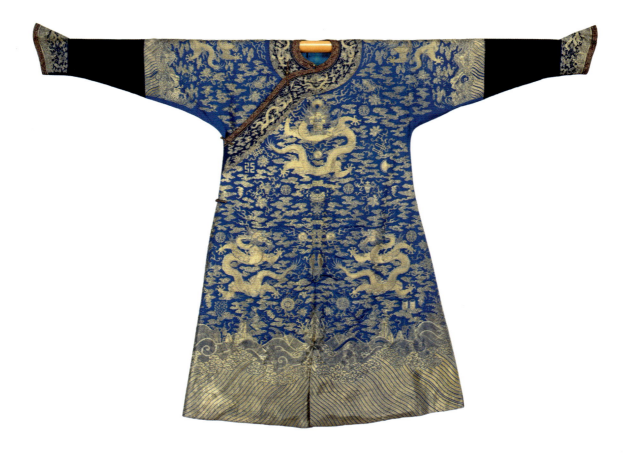

32 THE HIDDEN LANGUAGE OF POWER

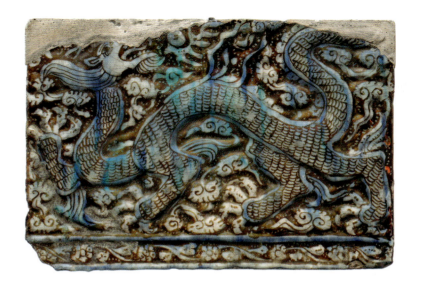

traditionally associated with a set of stellar constellations that appeared in the eastern sky in spring, and were therefore linked with resurgence, power, good fortune and the rising sun – then with power, authority and masculinity.[23] To put it into the language of ancient Chinese philosophy, dragons are a 'yang' creature: extrovert and male in opposition to (but harmonious with) the passive, female 'yin'.

OPPOSITE, ABOVE Knotted dragon pendant, China, Eastern Zhou dynasty, 3rd century BCE. Jade, 7.9 × 5.2 cm (3⅛ × 2⅛ in.)

Dragons are an auspicious creature in China, fit for decorative ornaments.

OPPOSITE, BELOW Emperor's 12-symbol festival robe, China, Qing dynasty, 1736–95. Silk and gold and silver thread embroidery on silk twill, 1.44 × 1.61 m (4 ft 8¾ in. × 5 ft 3⅜ in.)

As a symbol of the emperor, dragons feature prominently in this ceremonial robe.

ABOVE Fritware tile with dragon, Kashan, Iran, 13th century CE. 16 × 35 cm (6⅜ × 13⅞ in.)

With the enormous reach of the Mongol empire, Chinese-style dragons spread across the world, influencing the decor of palaces as far afield as Iran.

Eventually, perhaps inevitably, dragons became the symbol of the emperor himself. The characteristically sinuous and airborne Chinese-style dragon was an invention of the powerful Han dynasty (206 BCE–220 CE). This iconic dragon with its symbolism of life force and Chinese power spread with the political and military influence of the nation itself, appearing, for example, in the art of Korea and Japan. In diametrical opposition to the Christian conception of dragons, the Chinese dragon is light, mobile, celestial and a force for good.

When China became enmeshed with the vast Mongol empire in the thirteenth century CE, trade routes had become so extensive as to connect Beijing with the Mediterranean. Iranian and Central Asian cities under Mongol rule were therefore introduced to Chinese symbols like the dragon, so that tiles made in the Iranian city of Kashan in the thirteenth century proudly proclaimed them as an auspicious decorative emblem. The benevolent Chinese dragon was on its way to becoming a global icon.

The result of this east/west split in dragon symbolism is a modern uncertainty over whether they are good or evil, an ambiguity that has found its way into popular culture. They are symbols of wickedness in J.R.R. Tolkien's Middle Earth, for example, and yet embodiments of goodwill and enchantment in other fantasies, such as George R.R. Martin's series *A Song of Ice and Fire*. The reason for this personality split is to be found in history, for although dragons are mythical creatures, their ambivalent symbolism was forged by real religions, rulers and empires from the past.

Are Dragons Good or Evil?

Imperial **Eagles**

In art, eagles generally represent supreme leadership. They pervaded the symbolism of the Romans, and later empires eagerly appropriated them, including the Holy Roman empire, the Napoleonic empire, the Russian empire, and the Third Reich. Eagles were a recurrent theme in heraldry and can be seen on national and regional flags across the world. There is currently an eagle symbol on the carpet of the Oval Office in the White House, signifying the strength and independence of the United States and the authority of the president.

The history of eagles in art is the subject of one of the most famous essays in the field of iconography, 'Eagle and Serpent: A Study in the Migration of Symbols' (1939) by the German-born art historian Rudolf Wittkower (1901–1971). One aspect discussed by Wittkower was the solar symbolism of eagles. In Babylonian myth, the hero-king Etana was transported into the heavens by an eagle, and Wittkower speculated that this had inspired several Greek myths. One of these was the story of Zeus transporting Ganymede (a boy with whom he had fallen in love) to the heavens in the form of an eagle. Wittkower suggested that the motif influenced a later Roman belief that the eagle was a 'psychopomp' – a creature that takes a dead soul to heaven.[24] This was brought alive during the funerals of Roman emperors, when an eagle was released from the burning pyre to symbolize the ruler's ascension to heaven where, it was believed, he would become a god.

Wittkower's other assertions, such as his belief that eagle symbolism in Mesoamerica and the Pacific islands all directly linked to a common iconographic tradition, may now seem farfetched. But his notion that Christianity adopted the iconographic tradition of eagles from much older Mesopotamian

OPPOSITE Raphael, *Ezekiel's Vision*, c. 1517–18. Oil on panel, 41 × 30 cm (16¼ × 11⅞ in.)

The biblical motif of a god-bearing eagle may have its origins in much earlier cultures.

PAGE 36 Jean-Auguste-Dominique Ingres, *Jupiter and Thetis*, 1811. Oil on canvas, 3.27 × 2.6 m (10 ft 8¾ in. × 8 ft 6⅜ in.)

An eagle was the attribute of Zeus, king of the gods.

THE HIDDEN LANGUAGE OF POWER

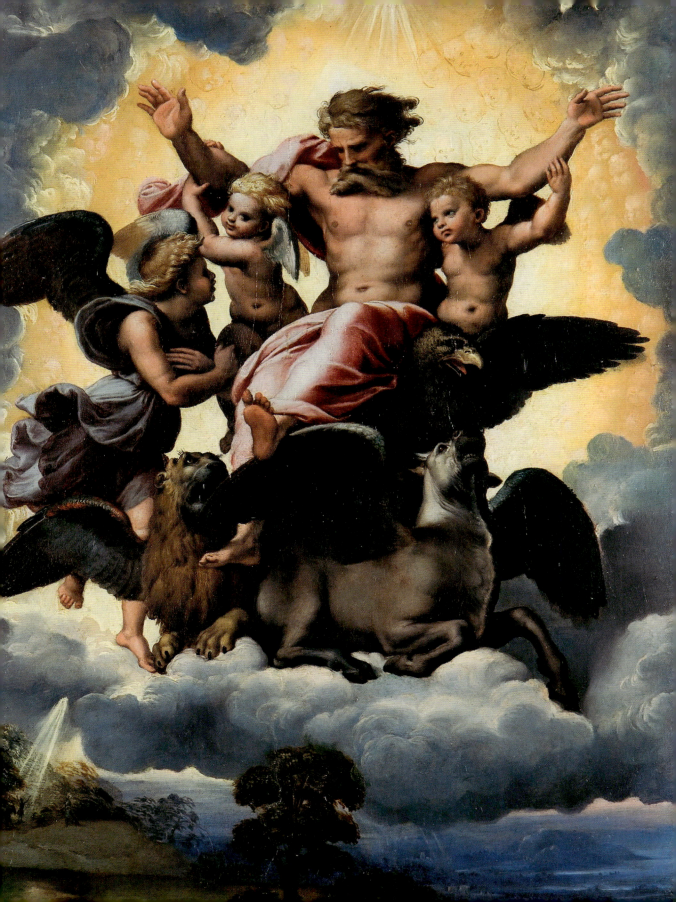

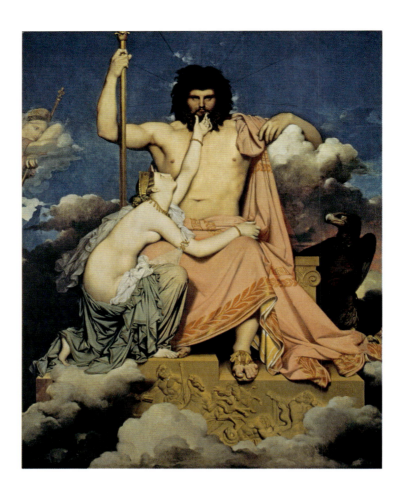

OPPOSITE, ABOVE *Apotheosis of Antoninus Pius and his wife Faustina*, base of the Column of Antoninus Pius, 161 CE. Marble, 2.5 × 3.4 m (8 × 11 ft)

In Roman art, eagles were the vehicle of apotheosis.

OPPOSITE, BELOW Bertel Thorvaldsen, *Ganymede with Jupiter's Eagle*, 1817. Marble, 93.3 × 118.3 cm (36¾ × 46⅝ in.)

Zeus disguised himself as an eagle to seduce the attractive mortal Ganymede.

cultures probably holds true. The Bible contains references to eagles, and in early Christian literature the animal represents resurrection and sometimes vengeance. An eagle is one of the four Apocalyptic Beasts mentioned in the Books of Ezekiel and Revelation. These four animals (Man, Lion, Ox and Eagle) were taken to represent the four evangelists: Matthew, Mark, Luke and John. St John's eagle attribute is believed to allude to his supremacy as a writer and closeness to God.

Our symbolic understanding of eagles has therefore been shaped by ancient religions. The other aspect of their meaning, however, is connected to earthly power. In 107 BCE the Roman general Gaius Marius declared that all army units were to use the same motif for their standards: the Aquila – an eagle with lightning bolts in its talons.[25] It became a symbol of the soul of Rome, and pride in her well-drilled military machine. Great shame befell

36 THE HIDDEN LANGUAGE OF POWER

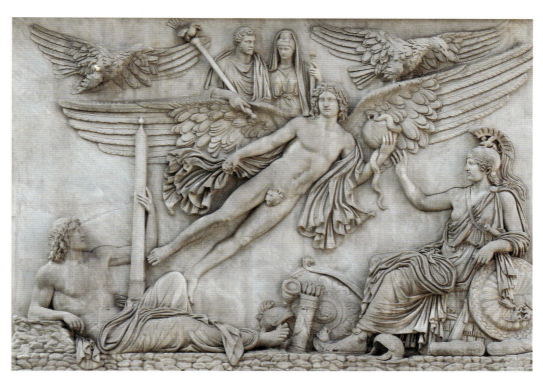
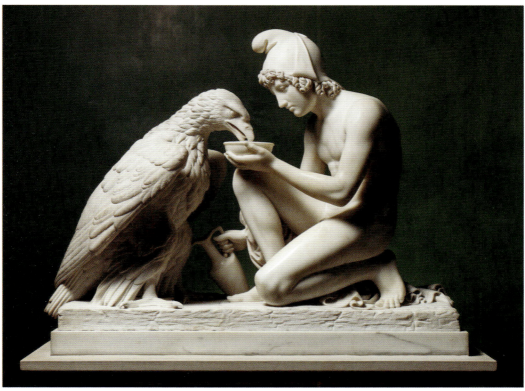

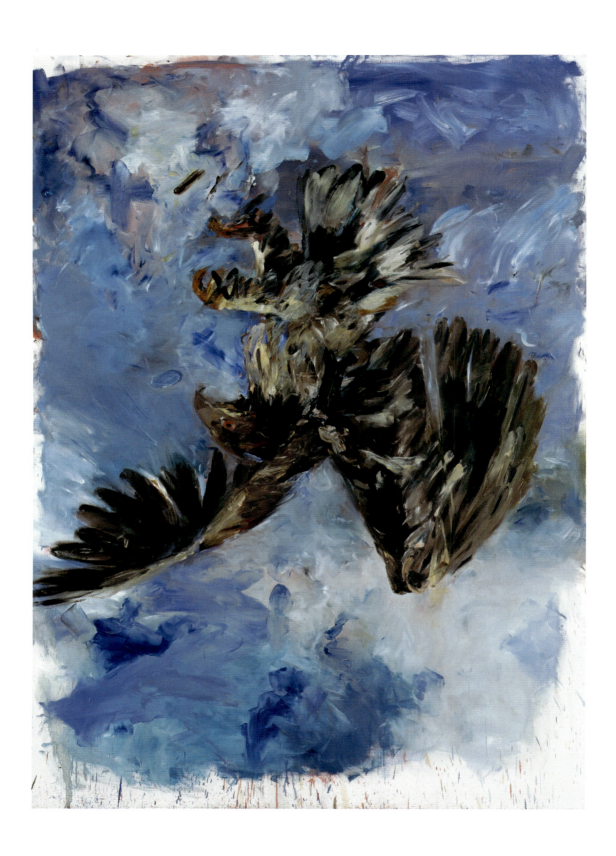

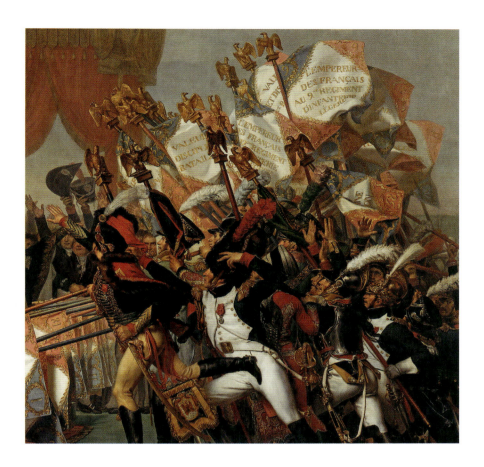

OPPOSITE Georg Baselitz, *Fingermalerei – Adler*, 1972. Oil on canvas, 2.5 × 1.8 m (8 ft 2½ in. × 5 ft 10⅞ in.)

A painting on the same theme as that hung in the German Chancellor's office: the heraldic eagle overturned, tradition subverted.

ABOVE Jacques-Louis David, *The Distribution of the Eagle Standards* (detail), 1810. Oil on canvas, 6.1 × 9.3 m (20 ft ⅛ in. × 30 ft 6⅛ in.)

Eagle standards were revived as a symbol of a mighty empire in Napoleonic France.

any legion that lost their Aquila, and various legions undertook perilous missions to recover ones that had been stolen by enemies on the field of battle.

The Roman empire inspired long-lasting admiration, and the proof is seen in the perpetual re-use of eagles in the iconography of power, especially in national flags and emblems. It has also allowed the symbol to be subverted in the hands of artists.

Gerhard Schröder, Chancellor of Germany between 1998 and 2005, hung a painting by Georg Baselitz (b. 1938) above his desk. It was an image of an eagle, but it did not depict the mighty, authoritative bird of convention. Purposefully undermining the symbolism of the Holy Roman empire and the Nazis, *Adler – Fingermalerei III* (1972) represents an upside-down eagle, plummeting forlornly to earth amid turbulent skies. It symbolizes a modern style of power shaped by recent history – the power to critique tradition and challenge authority.

Imperial Eagles

How a **Laurel** Wreath Links Emperors and Poets

A laurel crown is the marker of political leadership and poetic genius. Its origins as a symbol lie far back in history, but its modern relevance was cemented during a particular event in the city of Rome around seven hundred years ago.

The Renaissance, or 'rebirth', is often seen as a great turning point in history where the achievements of the ancient Greeks and Romans were reappraised, and peoples' skills in science, philosophy and the arts took a dramatic leap forward. When precisely the Renaissance began is a hotly debated issue, but a very specific date has been proposed: 8 April 1341. On that day, the Italian humanist poet and scholar Petrarch (1304–1374) was crowned Poet Laureate in Rome – the second person to be so honoured since classical times. At the ceremony he gave an oration later described as 'the first manifesto of the Renaissance'.[26] It was a radical speech that tackled weighty topics: the deep well of inspiration that the past offered to the present; the necessary raptures and struggles facing the poet; and their glory and immortality. Petrarch argued that the hallmark of the greatest civilizations was achievement in humanist study. Yet his speech ended rather strangely, in a prolonged meditation on a plant species – the bay laurel tree.

Petrarch's 'crown' on becoming Poet Laureate was a wreath of leaves from this tree, a symbolic gesture harking back to ancient Rome. Drawing upon classical sources, Petrarch talked about several of the laurel bush's attributes. These included its fragrance, its evergreen nature, its fabled ability to repel lightning and cause dreams to come true, and the fact that it was sacred to Apollo, Greek god of poetry.

Andrea Sacchi, *Marcantonio Pasqualini Crowned by Apollo*, 1641. Oil on canvas, 2.44 × 1.94 m (8 ft × 6 ft 4⅜ in.)

Musicians ancient and modern have symbolized their skills with the laurel wreath of artistic genius – in this example Marcantonio Pasqualini, the Rome-based composer and soprano singer.

THE HIDDEN LANGUAGE OF POWER

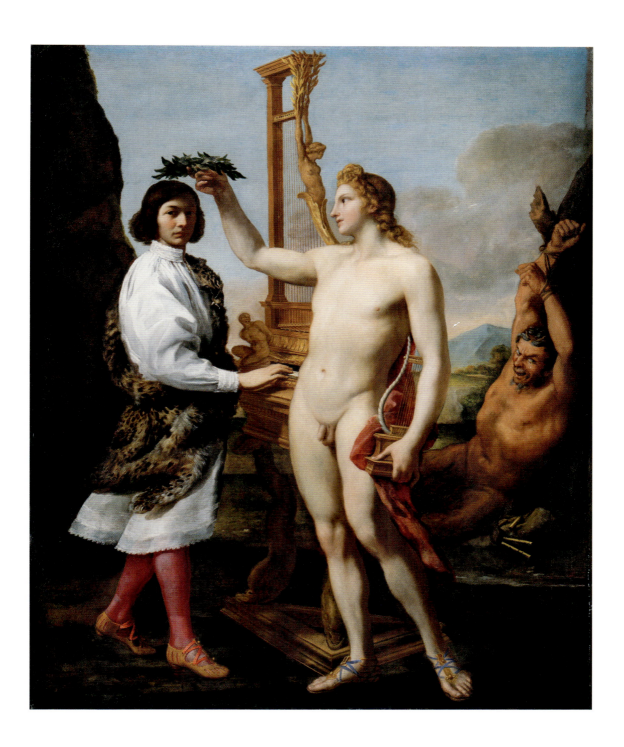

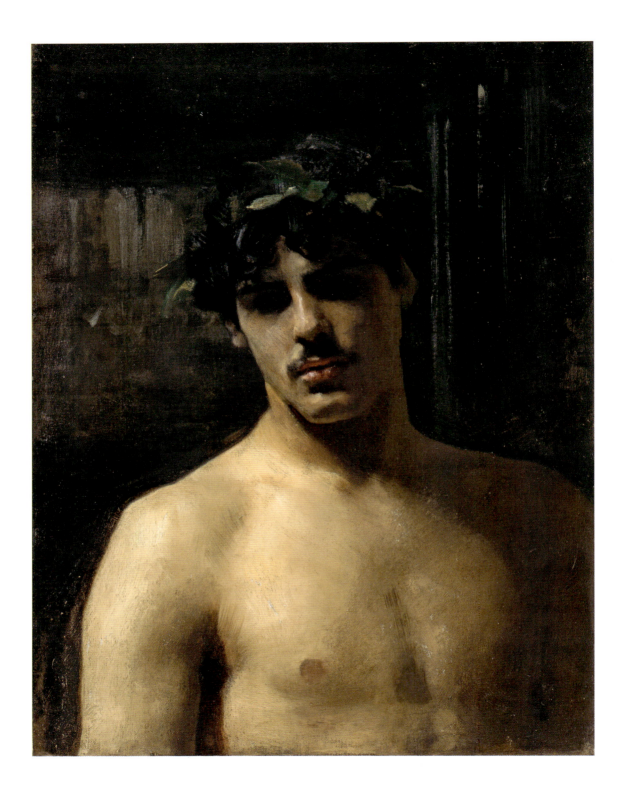

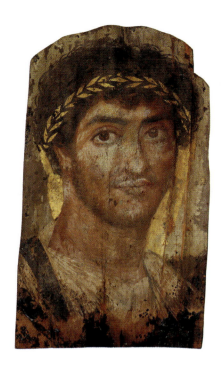

OPPOSITE John Singer Sargent, *Man Wearing Laurels*, 1874–80. Oil on canvas, 44.4 × 33.5 cm (17½ × 13¼ in.)

The anonymous man in this figure study is awarded an aura of timeless dignity with his crown of inspiration.

ABOVE Mummy portrait of a Roman man wearing a laurel wreath, from Fayum, Egypt, 101–150 CE. Lime (linden) wood, beeswax, pigments, gold, textile and natural resin, 41.9 × 24.1 cm (16½ × 9½ in.)

Laurels were a signifier of glory in the Roman empire.

The term 'laureate' still survives into the twenty-first century, with national and regional laureates nominated across the world, and the supreme award being the nomination of the Nobel Laureates in Physics, Chemistry, Medicine, Literature and Peace. The spirit of the Renaissance lives on through the (now sadly figurative) laurel crown.

Laurel wreaths are one of those symbols that crop up again and again in art, public monuments, architectural decoration and on coins. Sometimes they signify immortality and victory, but more often high achievement in the arts. How did the laurel, above all other plants, gain such a prestigious honour from the ancient world onwards?

Mention of the sacred laurel abounded in Roman literature. Julius Caesar's (100–44 BCE) attitude to the plant was formative. Before him laurel crowns were only worn at celebrations of military victories, but Caesar wore them at all official events.[27] Emperor Augustus (63 BCE–14 CE) followed him by using laurels as a personal emblem. In Imperial Roman portrait busts, laurel wreaths would go on to be worn by emperors and members of elite families, but also eventually by children, artists and priests. Its original designation as a symbol of military victory eased into an all-encompassing signifier of auspiciousness, and it became widely used for various Roman ceremonies and rituals.[28] But the laurel was considered especially auspicious by the Romans because it was significant to a culture that came before them: the ancient Greeks, whom the Romans regarded as the epitome of civilization.

At the Greeks' Pythian games, which were held at Delphi, the winners of athletic events and the highest achievers in poetic and musical competitions were crowned with a laurel wreath. Delphi was a sacred site, where the god Apollo had reputedly slain a serpent. It was also the home of a prophetess, Pythia. Pythia was believed to be able to predict future events in trances induced by eating laurel leaves. The link between high achievement and the creative inspiration offered by the laurel was forged here. A later myth (from the third century BCE) justified why the laurel was sacred to Apollo.[29] In this tale, which is most famously recounted in Ovid's *Metamorphoses* (8 CE), Apollo fell in love with a chaste nymph called Daphne. Rather than submit to Apollo, Daphne prayed to be transformed into a laurel tree. The grief-stricken Apollo swore to worship the plant forever.

How a Laurel Wreath Links Emperors and Poets

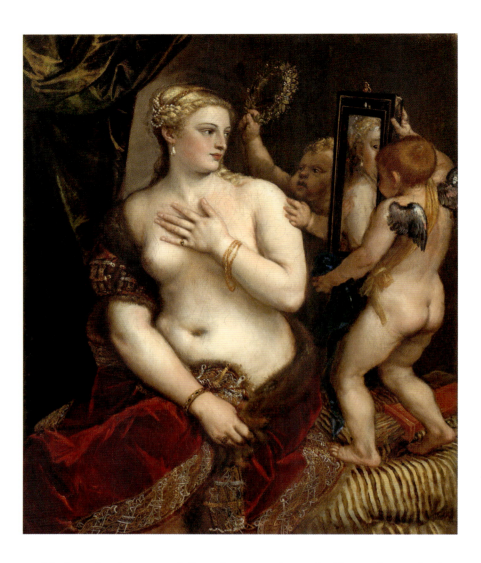

Titan, *Venus with a Mirror*, c. 1555. Oil on canvas, 124.5 × 105.5 cm (49⅛ × 41⅝ in.)

Venus, the most beautiful of goddesses, is immortalized with a laurel crown.

Modern-day laureates follow the example set by Petrarch, continuing to acknowledge the inspiration of ancient Greek culture. In his acceptance speech after being named Nobel Laureate in Literature in 2016, Bob Dylan riffed poetically about the importance of instinct in lyric-writing. He closed his speech with the words of the eighth-century BCE Greek poet Homer: 'Sing in me, oh Muse, and through me tell the story.' Dylan didn't wear an actual wreath when he gave his speech, but he certainly lived up to the spirit of Apollo's honourable, inspiration-laden and immortality-bringing laurel.

When a **Column** Isn't a Column

A pair of columns signify stability and strength, and they also represent a gateway to glory. The story of how the motif earned its associations starts in the sixteenth century, in Spain.

In his lifetime Charles V (1500–1558), Holy Roman Emperor, acquired unimaginable power. He was appointed Duke of the Netherlands at the age of fifteen, and became King of Spain the following year. Soon he took the title of archduke of Austria, then ruler of new territories in Italy. And this was all in addition to his possessing lands in Spanish America, whose hoards of silver and gold, plundered by the Europeans and shipped back to the Old World, made the already fabulously powerful Habsburg empire into the pre-eminent global superpower – and Charles V the richest man in the world.[30]

Early in his life, in October 1516, Charles was appointed master of the Order of the Golden Fleece, an order of chivalry of the Catholic faith. In honour of the event Charles's physician, an Italian named Luigi Marliano, invented a new symbol for the young king: a pair of columns with the inscription 'Plus Ultra' – 'Further Beyond'.[31]

The enthusiasm for creating personal emblems of this kind, known as an *impresa*, was a fad of the Renaissance period. Books of *imprese* were published, featuring sometimes very inventive pairings of mottos and images. In the case of Charles V, the two columns represented the pillars of Hercules, which, according to classical mythology, were set in place by the demigod to mark the boundary of the

Medal in honour of Charles V, 1533. Silver, diameter 5.5 cm (2¼ in.)

The twin columns of Charles V, symbolizing the global reach of the Habsburg empire.

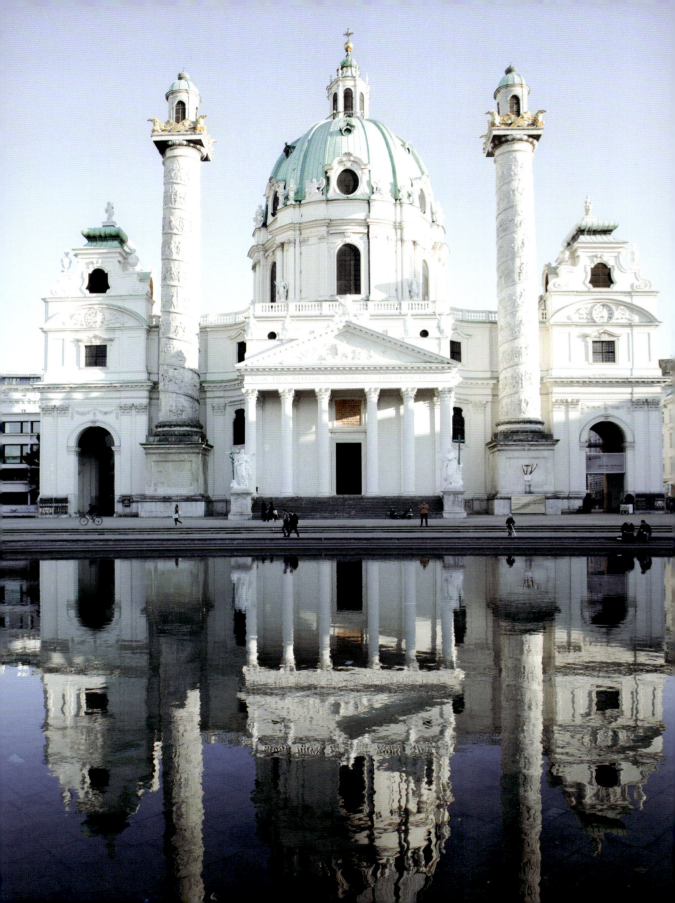

known world. It was commonly believed that the Strait of Gibraltar was the location of the pillars, forming a gateway to the unknown.

The *impresa* succinctly implied that Charles was the new Hercules, intent on expanding his authority across the known world. Its influence is obvious in the design of Vienna's most famous church, the Karlskirche, built by Johann Bernhard Fischer von Erlach in 1737. The church, commissioned by the then Holy Roman Emperor Charles VI, manifested the twin column symbol in three dimensions to express the emperor's ambitions to re-absorb Spain, which had been lost in the War of Spanish Succession (1701–14), back into the empire.[32]

The columns on the Karlskirche also mimic the appearance of Trajan's Column in Rome. Freestanding columns are an ancient symbol of the authority of the heavens, dating back into prehistory. Taken back to its origin, Egyptian and Mesopotamian religions developed and codified freestanding columns as holy monuments. They subsequently re-appear in the Greco-Roman world in honour of the gods as well as human heroes. The colossal Obelisk of Axum in Ethiopia (fourth century CE) and the columns erected by the Mauryan Emperor Ashoka (304–238 BCE – see **lions**, pp. 68–73, and **wheels**, pp. 92–95) in the fourth century BCE are part of this tradition, as are the more modern 'victory columns', raised in honour of contemporary

OPPOSITE Johann Bernhard Fischer von Erlach, Karlskirche, Vienna, 1737

Twin columns reappear in architecture as well as art, symbolic of a great empire.

BELOW: LEFT Obelisk of Axum, Ethiopia, 4th century CE; RIGHT William Railton and Edward Hodges Baily, Nelson's Column, Trafalgar Square, London, 1843

A column reaching to heaven is a global symbol of power from Axum in Ethiopia to London.

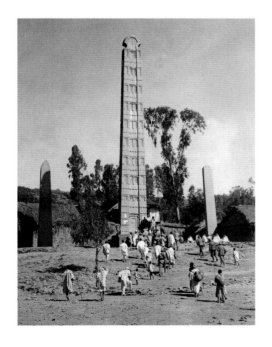
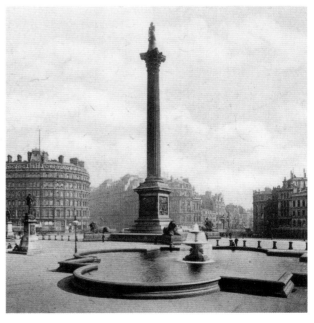

When a Column Isn't a Column

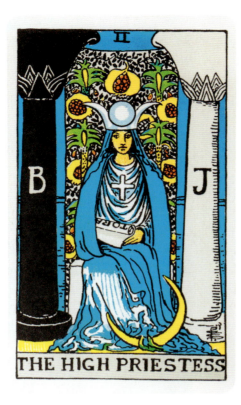 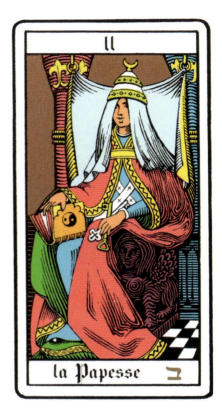

ABOVE: LEFT Pamela Coleman Smith, *The High Priestess*, Rider-Waite-Smith tarot deck, 1909; RIGHT *The High Priestess*, Oswald Wirth tarot deck

Tarot cards feature paired columns, inspired by their appearance in the Bible and Freemasonry.

OPPOSITE Giovanni Battista Moroni, *Portrait of a Gentleman with his Helmet on a Column Shaft*, c. 1555–56. Oil on canvas, 1.86 × 1 m (6 ft 1¼ in. × 3 ft 3⅜ in.)

In this portrait of an unidentified man, the significance of the column is a mystery: they typically symbolize strength and continuity, but broken ones could suggest tragedy.

heroism, produced well into the 1800s, such as Nelson's Column in London and the Colonne Vendôme in Paris.

In ancient Egypt, freestanding columns known as *djed*-pillars were believed to resemble the god Osiris's backbone; as a hieroglyph, the symbol stood for 'stability'. Columns have retained this association throughout western art history. In European paintings, figures beside columns indicate that they are fundamental to the structure of institutions or families, showing stability and permanence. Broken columns symbolize the opposite: death, melancholy or bravery in the face of adversity.

Twin columns may have additional symbolic meanings to Freemasons and the diviners of Tarot cards, as they are linked to the bronze pillars, Boaz and Jachin, that stood outside the temple of the legendary King Solomon. However, there was nothing esoteric or mystical about Charles V's columns: they are directly linked to his real-world political ambitions, and as an iconic design have persisted in global visual culture, in the modern flag of Spain.

48 THE HIDDEN LANGUAGE OF POWER

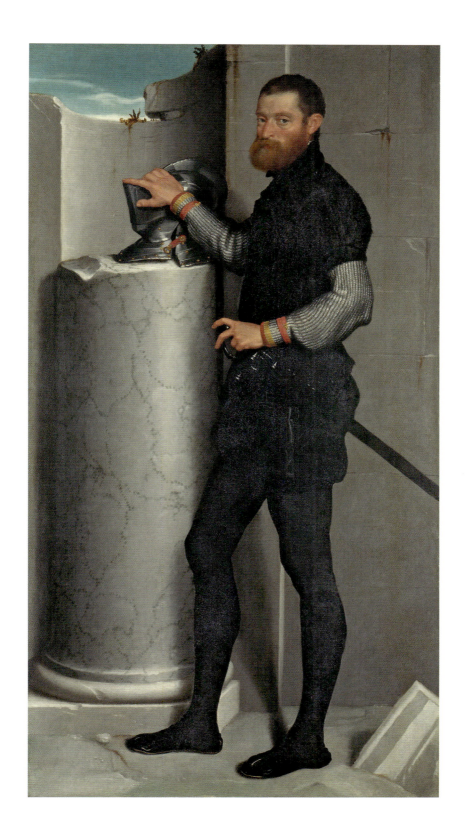

Phoenixes and Female Power

There is a species of bird so rare that there is only one surviving example. It comes from the farthest periphery of the Arabian desert; it is about the size of an eagle, and has plumage of many exotic colours. Its reproductive habits are exceedingly strange: at the end of its lifespan (estimated to be five hundred years) it commits suicide on a fire fed with spices and aromatic wood, and its offspring is asexually procreated out of the cinders.

It wasn't conclusively known whether the phoenix was real or not well into the Renaissance period. An early writer about this fabulous bird was the Greek historian Herodotus, who lived in the fifth century BCE. He wrote that phoenixes originated in Egypt, and later scholars have speculated that the phoenix as we know it may have been adapted in Greece from the mythic Egyptian *bennu*-bird. Phoenixes are not mentioned in the Bible, but early Christian writers such as Pope Clement I (35–99 CE) cite the bird as living proof that resurrection could occur in nature. As such it became an appealing symbol in Christianity. It stood for both Christ and the Virgin Mary because, like them, the phoenix is exotic, rare, self-regenerating and sexless.

Nicholas Hilliard's *Phoenix Portrait* (*c*. 1575) shows how the symbolism of phoenixes could be adapted to new contexts. The phoenix was one of the many emblems and metaphors used in conjunction with the English Queen Elizabeth I (1533–1603). Elizabeth was a queen who never married or had children, and linking her to a phoenix made a virtue out of the situation: she, like the mythic Arabian bird, was above gender distinctions, but possessed the best qualities of both sexes.[33] Hilliard's portrait positions Elizabeth's phoenix brooch close to her womb and beside the **rose** (pp. 222–27) she

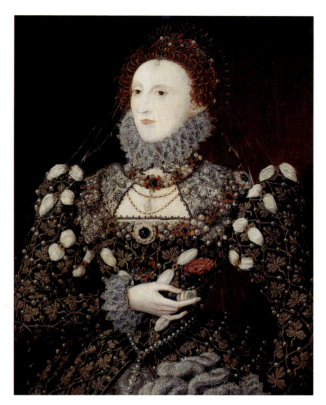 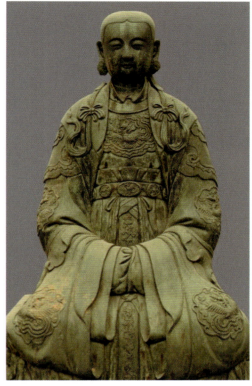

ABOVE LEFT (AND DETAIL OPPOSITE) Associated with Nicholas Hilliard, *Queen Elizabeth I (The Phoenix Portrait)*, c. 1575. Oil on panel, 78.7 × 61 cm (31 × 24⅛ in.)

Queen Elizabeth I of England's phoenix brooch symbolized her singularity and honour.

ABOVE RIGHT The 2nd Bronze Maidservant Idol of Jiangdu Temple, Ming dynasty, China, 1368–1644. Bronze, height 2.31 m (7 ft 7 in.)

A Chinese maidservant goddess bears a phoenix-like *fenghuang* on her chest, similarly a symbol of feminine virtue.

holds in her right hand. The rose was the symbol of the Tudor dynasty, to whom she had not yet offered an heir. The phoenix's perfection made it an apt metaphor for the queen again in William Shakespeare's richly allusive poem about ideal love, 'The Phoenix and the Turtle' (1601).

Possibly at the same moment in history, in China, a sculpture made in Jiangdu District shows a maidservant goddess with a remarkably similar phoenix on her chest. In art history books you will frequently see this type of Chinese bird being referred to as a phoenix. The two share some similarities, being supremely rare, immortal and colourful. However, the western phoenix was not known to Chinese artists. The Chinese version, called a *fenghuang*, was a guardian of the southern quadrat of the compass. Its essential visual features (a hooked beak and splayed tail features) were established during the Han dynasty (206 BCE–220 CE)[34]. It was considered to be a protective animal that appeared at auspicious moments, so artists often depicted them on funerary monuments. However, like most symbols in this book, the distinctive visual form of the bird evolved out of cultural

Phoenixes and Female Power

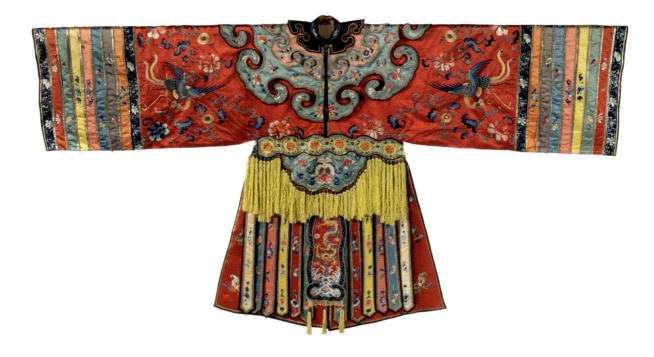

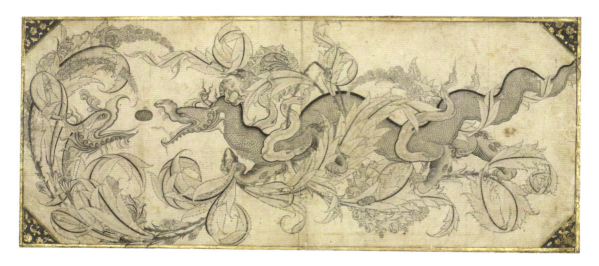

ABOVE Theatrical robe with phoenix and floral patterns, Qing dynasty, China, 19th century. Silk thread embroidery on silk satin, 1.27 × 2.44 m (4 ft 2 in. × 8 ft)

The *fenghuangs* on this Chinese robe suggest that it was designed for an actor playing a female court dignitary.

BELOW Attributed to Sahkulu, *Dragon in foliage with lion and phoenix heads*, Ottoman, Turkey, mid-16th century. Ink, gold, opaque watercolours on paper, 17.3 × 40.2 cm (6⅞ × 15⅞ in.)

This drawing was made in Istanbul, but features a Chinese-style *fenghuang* being attacked by a dragon.

OPPOSITE James Gillray, *Napoleon Bonaparte*, 1808. Etching and aquatint on wove paper, hand-coloured, sheet 40.7 × 30.2 cm (16⅛ × 12 in.)

In this English satirical print, the hubristic Napoleon is shown as a phoenix, resurrected through immolation as a dove of peace.

THE HIDDEN LANGUAGE OF POWER

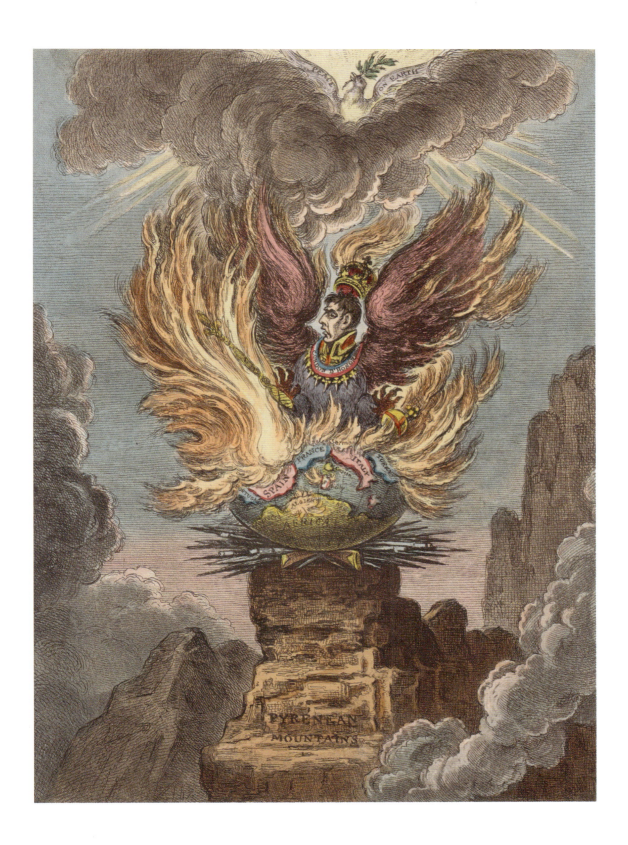

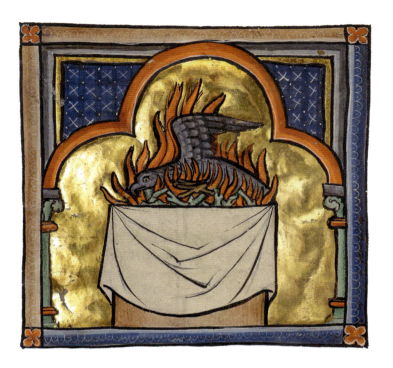

Unknown artist (Franco-Flemish), *Phoenix*, from a medieval bestiary, Ms. Ludwig XV 3, fol. 74v, *c.* 1270. Tempera colours, gold leaf and ink on parchment, leaf 19.1 × 14.3 cm (7⅝ × 5¾ in.)

In medieval times, images and information about animals such as phoenixes were collated in texts known as bestiaries.

cross-pollination. During the Tang dynasty (618–907 CE), trade with western cultures, especially the Sasanians, along the Silk Roads influenced the development of the bird's appearance, making it more decorative and suited to textiles and ornaments rather than monuments.[35]

The *fenghuang* became the supreme mythical bird in Chinese folklore, the ultimate symbol of virtue and beauty. Because of these qualities it was adopted as a regal emblem, often for the clothing of aristocratic women. *Fenghuangs* were sometimes represented in pairs, signifying male and female harmony and thus happiness in marriage, but it also became a specific symbolic of the Chinese empress. In the Chinese conception of the universe, the *fenghuang* represented the feminine 'yin' principle, complementary to the emperor's masculine 'yang' dragon (see p. 33).[36]

Sharing the symbolism of uniqueness, beauty and self-sufficiency, the phoenix and *fenghuang* worked as signifiers of female status in the courts of both Imperial China and Elizabethan England. The birds may have had other religious and philosophical meanings in different contexts, but few other symbols of power are so closely associated with women. And like the **unicorn** (pp. 216–21), the phoenix's power came from the belief that it was real, hidden away and completely alone, somewhere in a Middle Eastern desert.

54 THE HIDDEN LANGUAGE OF POWER

Next Stop, Elephant and Castle

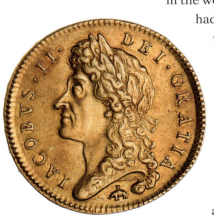

Gold five guinea of James II of England, 1687. Gold, diameter 3.8 cm (1½ in.)

The elephant-and-castle motif appears in miniature below the head of King James II.

In 1686, the citizens of Great Britain found a curious symbol on their newly minted one-guinea coins. Beneath the haughty profile of King James II (1633–1701) was a tiny emblem of an elephant with a castle on its back. You can find this symbol on a variety of apparently disconnected objects in history, including ancient Greek coins, Christian and Jewish architecture and the signage of early modern corporations and taverns. The juxtaposition of elephant and castle seems to be a random, almost surreal combination of things: what is the history and the hidden meaning of this enigmatic symbol?

In the early seventeenth century, Dutch and English trading ships were busy scouting out the coast of West Africa, exploring sea routes and looking to exploit the natural resources of the region, particularly its gold, which was reputed to exist in fabulous quantities. These merchants were following in the well-trodden footsteps of Portuguese traders and slavers, who had been surveying the area and establishing trading stations there for almost two hundred years. In 1660, the British created what was known as the Royal African Company, which was awarded a monopoly to search for and trade in gold. King James II's 'guinea' coin was named in honour of the region recently colonized by the British.

Gold and ivory were among the most lucrative products in global trade at the time, and both were to be found in Africa. The guinea coin was made of gold extracted from West Africa, and ivory was indicated by the elephant and castle symbol. It spoke clearly of imperial power and

55

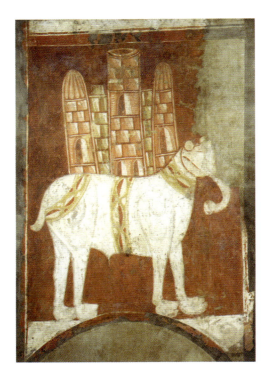 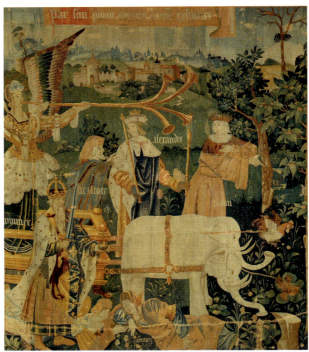

ABOVE LEFT Fresco with elephant, Spain, first half of the 12th century (possibly 1129–34). Fresco transferred to canvas, 2.05 × 1.35 m (6 ft 8¾ in. × 4 ft 5⅛ in.)

A Romanesque elephant and castle from Castile-León, Spain.

ABOVE RIGHT Unknown artist (South Netherlandish), *The Triumph of Fame over Death*, c. 1500–30. Wool warp, wool and silk wefts, 3.66 × 3.25 m (12 ft 1⅛ in. × 10 ft 8 in.)

In this Netherlandish tapestry, the chariot of fame is pulled by two elephants representing wisdom, attracting the attention of Plato, Aristotle, Alexander the Great and Charlemagne.

the exotic. It had held these associations ever since a specific conflict that occurred in Pakistan in 326 BCE.

At the Battle of the Hydaspes, Alexander the Great (356–323 BCE) and his battle-hardened army confronted the formidable armies of the Indian King Porus. Alexander's army was dumbfounded by Porus's secret weapon: elephants with platforms, known as howdahs, strapped to their backs, filled with troops. In the wake of Alexander's victory, coins were struck in remembrance of Alexander's confrontation with such a mighty and outlandish army at the periphery of the known world. They featured a stylized version of the howdah-laden beasts that had harried the Macedonian army. As a result, the 'elephant and castle' motif would go on to symbolize foreign foes and their monumental weapons of war. It also signified the strength of the elephant itself, which was a rarely seen, and thus semi-mythic, animal in Europe, probably as fabulous as a phoenix or unicorn before the modern age.

Elephants on their own were understandably symbols of the exotic in the iconography of European art, but they acquired other associations too. Medieval bestiaries linked them to some hard-to-justify qualities, such as chastity and temperance.[37] But they were also connected to more reasonable

THE HIDDEN LANGUAGE OF POWER

ones (bearing in mind their wrinkly skin), like old age and wisdom. Based on these virtues, Cesare Ripa (1555–1622) made elephants a symbol of the Pope in his book of allegories, the *Iconologia*, first published in 1593. A baroque twist was added in 1667 by Gian Lorenzo Bernini (1598–1680), who made a monument for Pope Alexander VII of an elephant supporting an Egyptian obelisk rather than a castle, which was intended to represent the divine wisdom of the Pontiff.[38]

Elephant and castle emblems entered the visual culture of other religions in Europe, and also became a commercial emblem. For example, they appeared as symbols of religious knowledge in the visual decoration of Jewish books and on the decorations of synagogues in Poland in the eighteenth century – a highly unusual occurrence given that elephants themselves are scarcely mentioned in Hebrew scripture.[39] That it became the logo of London's Worshipful Company of Cutlers in 1622 is more understandable: this was a guild of sword- and cutlery-makers specializing in the crafting of elephant ivory for cutlery handles.

A blacksmith with connections to the company hung an elephant and castle sign outside his forge in south London. When the forge later turned into a coaching inn it kept the elephant and castle motif as a decoration, which subsequently lent its name to an entire district with its own Underground station – Elephant and Castle.

Signifying strength, imperial conquest and trade, the elephant and castle symbol represented a swathe of powerful forces in history. The Royal African Company's use of it declares the early aspirations of the British towards colonialism that would later result in the globe-spanning empire (see p. 68). But its taint in this context is of an even more sinister strain: the Company transported more slaves across the Atlantic during the entire period of the slave trade than any other organization.[40]

Gian Lorenzo Bernini, *Elephant and Obelisk*, Santa Maria sopra Minerva, Rome, 1667. Marble (elephant), granite (obelisk), height 12.7 m (41 ft)

An experimental Baroque variant on the elephant-and-castle theme.

Next Stop, Elephant and Castle

Raging **Bulls**

Bulls are symbols of barbarism. That's what most of the visitors to the Autumn Exhibition at the Walker Gallery in Liverpool in 1885 would have understood when looking at George Frederic Watts's (1817–1904) *The Minotaur*. The artist himself had claimed that his painting was meant to inspire disgust at the most sinister of crimes, 'to hold up to detestation the bestial and brutal.'[41] Although depicting the mythological figure of the half-man, half-bull Minotaur, the painting was covertly about a contemporary scandal that rocked the Victorian world to its core.

Watts reportedly painted the scene in a single morning, in a flurry of creative energy, after having read a particular article in the *Pall Mall Gazette*. The report in question was 'The Maiden Tribute of Modern Babylon' by W.T. Stead, published in July 1885. It exposed the secretive marketing of child prostitutes in London. Stead made repeated references to the Minotaur myth from Greek mythology, to drive home the tragedy of the story.[42] According to the myth, the Minotaur lived in a **labyrinth** (see pp. 170–73) beneath the palace of King Minos of Crete, and fed upon the flesh of children, seven boys and seven girls, who were sent via ship from Athens every nine years. The ship is visible in the distance in Watts's painting. As he stares at it from his high promontory, the Minotaur's eyes and mouth are agog with bestial lust, and he unconsciously crushes a small bird in his left fist.

Even when we see bulls represented emblematically outside of an art context (think, for example, of a tin of Red Bull or the Chicago Bulls logo), they are often symbolic of power, specifically in the following variety: unbridled, primitive, macho. Such associations are perhaps an inevitable result of

George Frederic Watts, *The Minotaur*, 1885. Oil on canvas, 118.1 × 94.5 cm (46½ × 37¼ in.)

Watts's bull symbolized sexual depravity in Victorian Britain.

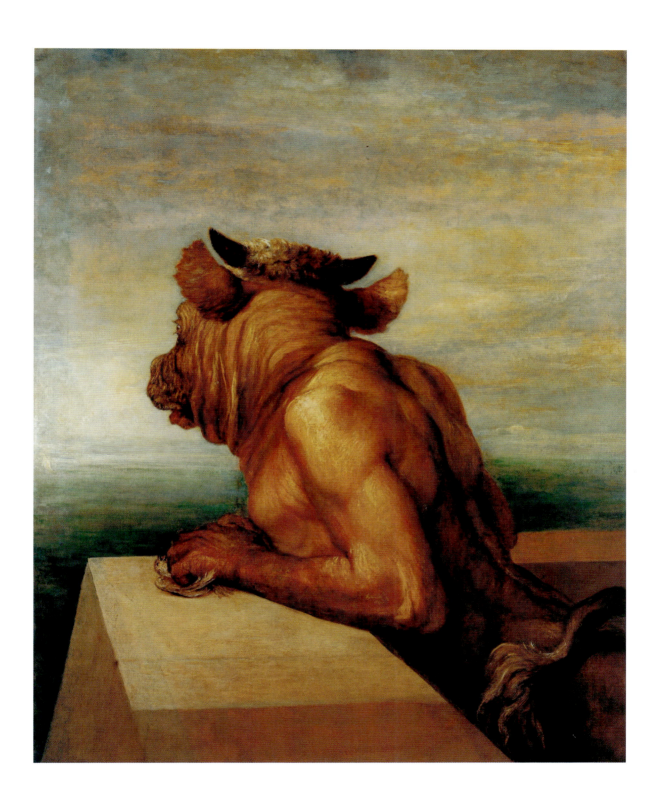

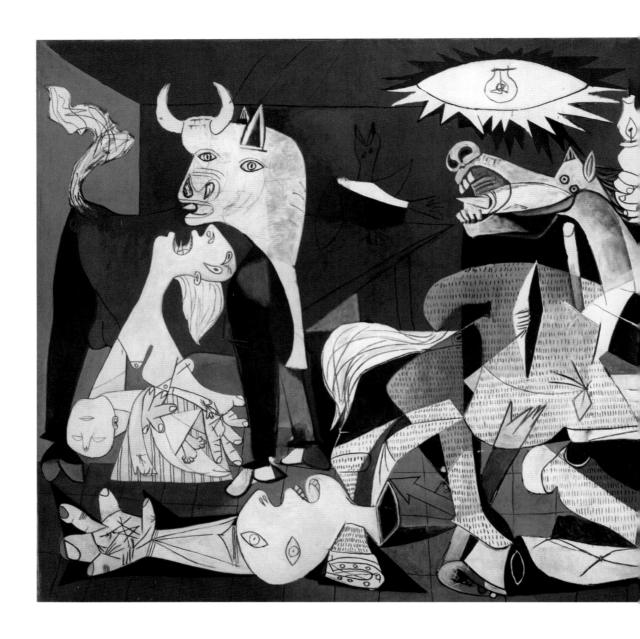

Pablo Picasso, *Guernica*, 1937. Oil on canvas, 3.49 × 7.77 m (11 ft 5⅜ in. × 25 ft 5⅞ in.)

In Picasso's art, bulls could either be symbols of masculine vigour or sacrificial victims.

a bull's physicality, but they are also unquestionably reinforced by generations of human culture. Just as with **eagles** (pp. 34–39), **dragons** (pp. 30–33) and **lions** (pp. 68–73), the symbolic meaning of bulls stems ultimately from the religions of ancient Egypt and Mesopotamia.

In Egypt there were several bull cults that extend back deep into history. The most well-known bull-god is Apis, a deity who emerged in Bronze

Age Memphis and whose powers of virility and energy were linked to the pharaoh. In Mesopotamia during the same period bulls were also regarded as the epitome of strength and fertility, and linked with multiple deities, including Teshub, a Hittite god of storms. Greek mythology was shaped by these earlier beliefs, including such tales as Zeus's abduction of Europa. According to this myth, Zeus turned himself into a white bull so that the

Raging Bulls

 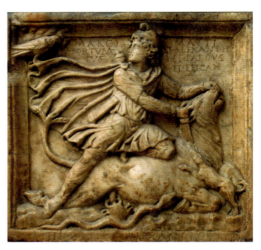

ABOVE LEFT Hathor and Psamtik, from Tomb of Psamtik, Saqqara, Egypt, 26th dynasty, c. 530 BCE. Basalt, 96 × 29 × 104 cm (37⅞ × 11½ × 41 in.)

The significance of bulls as a symbol of potency and strength in art go back to ancient Egypt, and the bull-god Apis.

ABOVE RIGHT Mithras slaughtering a sacred bull, Roman, 2nd century CE. Marble, 37 × 39 cm (14⅝ × 15⅜ in.)

The sacrificial character of bulls was also a key element of the ancient religion of Mithraism.

mortal Europa would pet and play with him. Once she climbed onto his back, he jumped into the sea and swam to Crete, where she became queen – and mother of King Minos. Such tales of bulls' brute masculine strength were counterbalanced by bull sacrifice rituals, which occurred in the Roman world and was a key aspect of the religion of Mithraism, which briefly competed with Christianity as the predominant religion of Rome.

Pablo Picasso (1881–1973) repeatedly represented bulls in his art. The way he conceived of them symbolically varied through his lifetime, although he seemed to draw upon a historic repertoire of Mediterranean associations with the animal. A bull features prominently in what is probably his best-known painting, *Guernica* (1937), which represents a civilian town decimated by indiscriminate modern aerial warfare during the Spanish Civil War. The artist chose to never fully explain the symbolism of the figures in the painting, and the bull may stand for either a sacrificial victim or brute military force.[43]

In his day, Watts enjoyed international distinction as a painter, much like Picasso. But whereas Picasso's painting has become one of the twentieth century's defining masterpieces, Watts's work, like his reputation, has declined in fame. The difference may tell us something about successfully using symbols in art. Watts's symbolic language depends upon the erudition of a middle-class audience, while shielding them from the underlying reality of the subject matter. Such is the metaphorical veiling of *The Minotaur* that it fails to galvanize an ounce of the passion of W.T. Stead's original journalism. *Guernica*, on the contrary, makes its target overt but the symbolism ambiguous. Picasso's symbols don't sanitize, and they inspire continued discussion.

THE HIDDEN LANGUAGE OF POWER

The **Pear** That Terrorized a King

Visual symbols can achieve many things – they can promote the powerful, inspire the artistic, and bind members of the same beliefs. At other times they can be agents of subversion, undermining even the most powerful leaders in the world. There may be no better example of this than the symbol that taunted, humiliated and even had a hand in toppling King Louis Philippe of France (1773–1850) between 1831 and 1835: a pear.

Few dictionaries of symbols devote space to pears – they are among the less exalted fruits in art historical iconography. Where they do appear in art, it is mainly as a symbol of the Virgin's devotion to the infant Christ: pears are sweet, runs the logic, and so is the love of Mary for Jesus. It was a connection devised in hymns and biblical commentaries from the Middle Ages, and was taken up by the Renaissance painters Giovanni Bellini (1430–1516) and Albrecht Dürer (1471–1528), among other artists, as an attribute of the Virgin and Child.

However, even if he was aware of this historical symbolism, none of it really mattered to Charles Philipon (1800–1861), editor of the French satirical journal *La Caricature*.

In November 1831, Philipon stood trial in the Assize Court in Paris, charged with the crime of *lèse-majesté* – offenses against the king. He had recently published a cartoon by an anonymous illustrator that depicted the king himself, violating the censorship laws that protected Louis Philippe against mockery.

At least, it *appeared* to depict the king. And this was the technicality that Philipon would exploit to try to wheedle himself out of trouble. Resemblance, pleaded Philipon, was not a lawful reason to infer reference to the king. If

PAGE 64 Giovanni Bellini, *Madonna and Child (Madonna di Alzano)*, c. 1487. Oil on wood panel, 84.3 × 65.5 cm (33¼ × 25⅞ in.)

In Venetian paintings, pears sometimes accompany the Virgin and infant Christ to signify the sweetness of their love.

PAGE 65 Albrecht Dürer, *Madonna of the Pear*, 1512. Oil on limewood, 49.3 × 37.4 cm (19½ × 14¾ in.)

The German artist Dürer followed in this tradition, but with a twist: a full-bellied Christ has already eaten his pear.

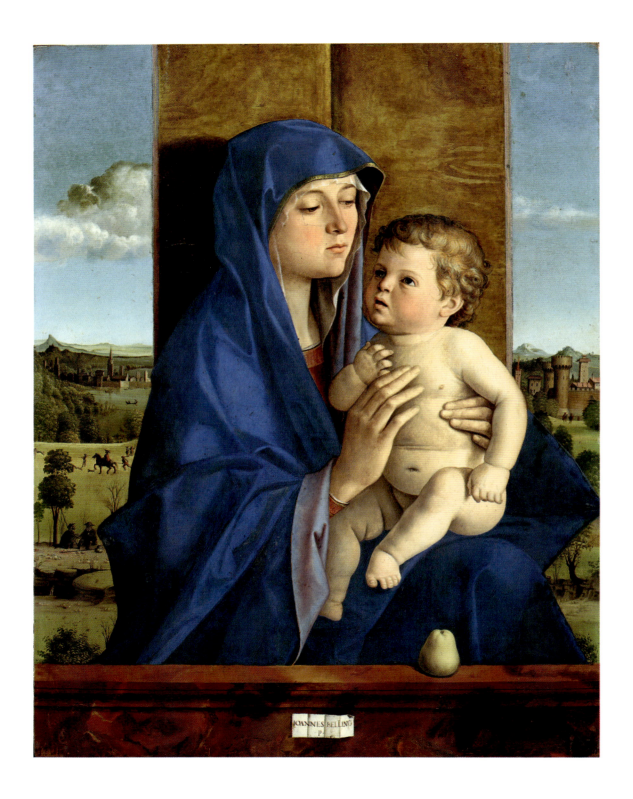

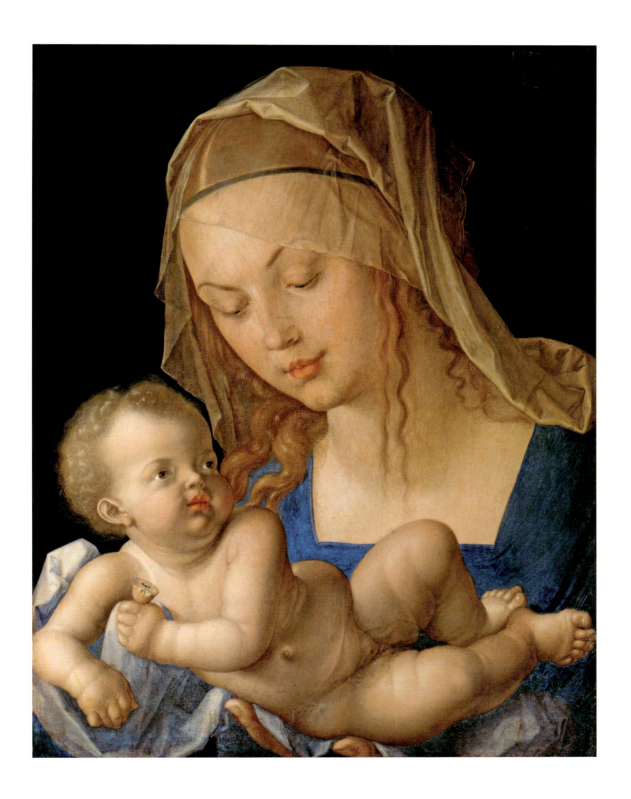

The Pear That Terrorized a King

that was the case (such was the implication of his defence), the court could censor any image, simply because they claimed that it looked like the king. To illustrate the consequences, Philipon drew a series of sketches that showed the king's face metamorphosing into a pear in four steps. His gamble was to appeal to the court's sense of the absurd: how could a pear possibly represent a king? But it was a gamble that would not pay off: the court, unimpressed with Philipon's reasoning, rejected his case, and imprisoned the editor for six months at Sainte-Pélagie prison.

On his release, Philipon commissioned his finest cartoonist, Honoré Daumier (1808–1879), to make an official version of the king-to-pear drawing to adorn the cover of the magazine that Philipon had founded in 1832, *La Charivari*. From Louis Philippe's perspective, the very worst possible thing happened next: the pear became a meme.

A meme is a cultural phenomenon, such as a fashion, image, saying or mode of behaviour, that spreads widely and takes on a life of its own. Philipon's pear was an unbelievable success in these terms. Cartoonists made images of pears in all sorts of politically suggestive contexts. The literary critic Sébastien-Benoît Peytel published a book titled *Physiology of the Pear* in 1832 – purportedly a gardening book, but actually an extended satire of the king, which instantly sold out. In Paris the pear became a viral graffiti tag.[44] The English novelist William Makepeace Thackeray, who visited the city

BELOW LEFT Honoré Daumier, *Les Poires (Transformation caricaturale du roi Louis Philippe)*, Le Charivari, 17 January 1834.

The origin of the pear meme of the 1830s.

BELOW RIGHT Honoré Daumier, Untitled illustration from *La Caricature morale, politique et littéraire*, 19 July 1832.

Cartoonists could sidestep censorship and imply regicide with the aid of the symbolic pear.

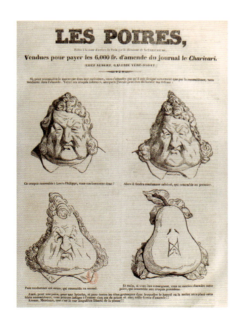
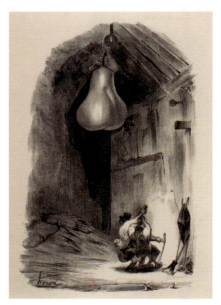

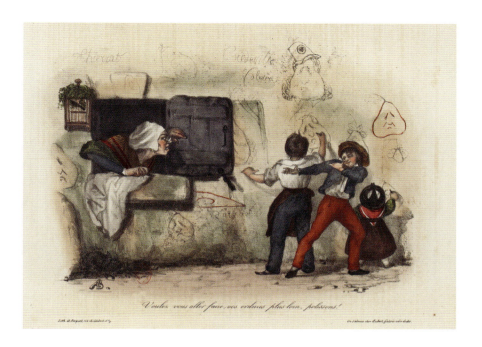

Auguste Bouquet, *Voulez-vous aller faire vos ordures plus loin, polissons!*, illustration from *La Caricature morale, politique et littéraire*, 17 January 1833.

The pear became a notorious anti-monarchy graffiti tag in Paris by the middle of the 1830s.

in the mid-1830s, even mentioned 'the famous "poire" which was chalked upon all the walls of the city and which bore so ludicrous a resemblance to Louis-Philippe.'[45] The city of Auxerre went so far as to ban the visual representation of pears entirely.

As the meme evolved, so it became ever darker in tone. Daumier drew a pear being hanged. The cartoonist Charles-Joseph Traviès showed one having its head sliced off. Explicitly encouraging regicide was a grave crime – but the language of symbols allowed it to be expressed unpunished.

In 1835, Louis Philippe passed the 'September Laws', which clamped down on free speech and outlawed any reference to the monarchy. *La Caricature* was forced to close down, and the golden age of French satire was, it seemed, at an end.[46]

But Louis Philippe would be forever associated with pears. The indignity caused by Philipon's battle with the censors played a major role in delegitimizing the king. His unpopular reign came to an end in 1848, when a revolution deposed him and France became a republic.

Between 1831 and 1835, pears had been transformed from a fruit into a weapon of political subversion with the power to undermine a king. There may be no better example of how symbols can be a tool to energize people's opinions, unite a cause and alter the conditions of a nation.

The Pear That Terrorized a King

The Reason **Lions** Rule

Symbolic lions are so common that it's easy to become blind to them. They are everywhere in towns and cities once you start looking out for them: on governmental buildings, civic monuments, guarding entrances to homes and adorning flags and emblems. They have embedded themselves in the fabric of civilized life as an international symbol of wise rule and restrained power. It's been this way for millennia – lions are the world's unquestioned motif of mighty monarchies, republics and transnational superpowers. Lions were particularly synonymous, for example, with the British empire.

An estimated 24 per cent of the world's land mass was ruled by the British at the peak of the empire, in around 1924. In April of that year, the British Empire Exhibition opened in Wembley, a pageant of British imperialism staged on a grand scale and including enormous 'palaces' of industry, engineering and the arts, as well as a funfair. And there were lions everywhere: monumental art deco lions in front of the most important buildings; lions on commemorative stamps, spoons and tea caddies; souvenir lion statuettes and lion-themed advertising posters. Obviously, lions are not native to the British Isles. But they were accepted without question by tourists at the exhibition as the natural symbol of an empire as mighty as Britain's.

Why are lions so popular with powerful governments and empires? The answer might be quite simple. Lions, with their golden fur, luxuriant manes and noble faces, have a regal bearing, and they sit at the top of the food chain.[47] Humans' fascination with the animal goes back a long way, with prehistoric art, such as the 'Lion Man' statuette from Germany (*c.* 38,000 BCE)

Cover of the British Empire Exhibition guide, 1925

Lions were the key symbol of imperialism at the British Empire Exhibition of 1924.

68 THE HIDDEN LANGUAGE OF POWER

OFFICIAL GUIDE
BRITISH EMPIRE EXHIBITION 1925

PRINTED & PUBLISHED BY
Fleetway Press Ltd.

PRICE ONE SHILLING
COPYRIGHT

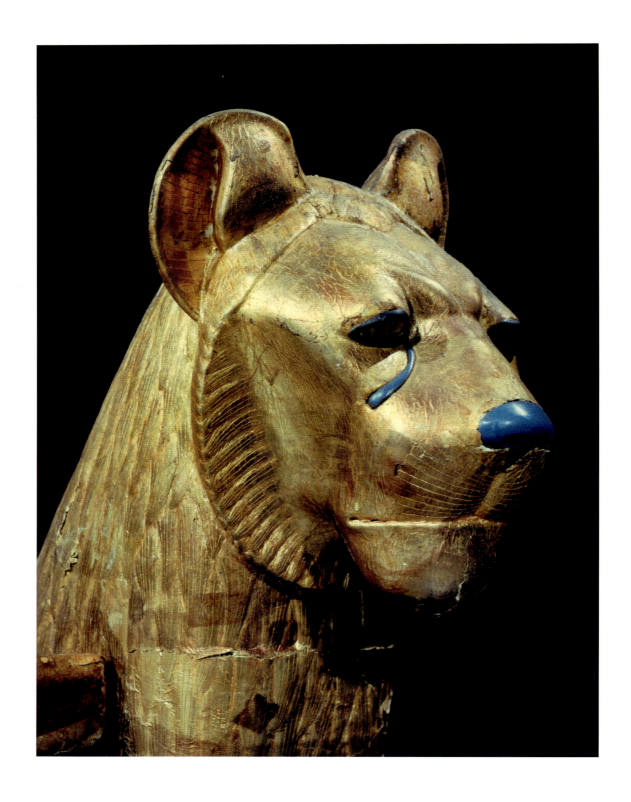

and paintings from the Lascaux caves in France (*c.* 15,000 BCE), indicating a deep reverence and fear.

Lions were prominent in the mythology of ancient Egypt. They acted as sentries, and sometimes possessed benign characteristics. For example, Aker was a lion-shaped god who guarded the underworld and protected the sungod as he travelled through it. Sekhmet was a goddess with a lion's head, and another fearsome deity, usually guarding the pharaoh in warfare. Such was her esteem in the Egyptian pantheon that Amenhotep III (r. *c.* 1386–1353 BCE) created seven hundred identical statues of her for his funerary sanctuary. Lions had an equally important role in Mesopotamia, starring in artworks from at least the third century BCE. However, here lions usually had a more ferocious part to play, symbolizing nature's wrath. The culmination of this attitude is reflected in the massive relief sculptures that adorned the walls of the palace

OPPOSITE Lion head, detail from the ritual bed of Tutankhamun, Egypt, 18th dynasty, 14th century BCE. Gilded wood, glass, overall 161 × 228 × 91 cm (63½ × 89⅞ × 35⅞ in.)

The lion as a symbolic guardian of kings dates back to ancient Egypt.

RIGHT Guardian lion, China, Tang dynasty, *c.* 600 CE. White marble, height 78.8 cm (31⅛ in.)

Sculptures of lions guarding doorways are a feature of architecture across Eurasia, including China.

The Reason Lions Rule

Detail of wall panel with Ashurbanipal killing a lion, Neo-Assyrian, Nineveh, Iraq, 645–635 BCE. Gypsum, overall 165.1 × 114.3 cm (65 × 45 in.)

The ultimate test of brave leadership: outwitting and slaying a noble lion.

of Ashurbanipal (668–631 BCE), which show lion hunts, a pretext for symbolizing the king's authority over nature and, by extension, dissenting foes.[48] The lion was depicted as an equal but opposite force to Ashurbanipal – both are heroic and powerful, but the lion's wild savagery is contrasted with the king's civilized heroism. The image of the lion hunt persisted in the region, influencing later Sasanian art, in which leaders were still judged by their ability to subdue nature (symbolized by wild lions) well into the first millennium CE.

The British empire was clearly one of very many that saw the lion as the ultimate symbol of power. But the creature was also adopted in the iconography of religions. For example, lions were an icon of Emperor Ashoka of India (304–238 BCE – see also the entries on **columns**, pp. 45–49, and **wheels**, pp. 92–95) and his Buddhist beliefs. Lions are mentioned frequently in the Bible in terms of power, with Christ himself interpreted as the kingly 'Lion of Judah'. St Mark the Evangelist has a lion as an attribute, since his was the 'voice of the one who cries in the wilderness' like a lion.

THE HIDDEN LANGUAGE OF POWER

Dish with King Hormizd II or Hormizd III hunting lions, Sasanian, Iran, 400–600 CE. Silver gilt, overall 4.6 × 20.8 cm (1⅞ × 8¼ in.)

Lion hunting became a long-lasting symbol of leadership in Iran.

Medieval heraldry also influenced the British Empire Exhibition's emphatic lion motifs. King Henry I of England (r. 1100–1135), son of William the Conqueror, was the first to use a lion as his symbol, and henceforth it became synonymous with England – visible to this day in the royal coat of arms of the United Kingdom and the logos of the England cricket and football teams.

The British Empire Exhibition closed in October 1924. The event was marked by events staged in Wembley Stadium on an ominously cloudy and wet day. Over the ensuing decades, the buildings of the exhibition were dismantled, repurposed or destroyed. The most impressive of the monumental lions from Wembley were the ones that guarded the British Government Pavilion, representing the mighty dominion's highest seat of power. Those stone beasts escaped demolition – they now stand sentinel at the gates of the Woburn Safari Park in Bedfordshire. The lions of empire have been put out to pasture.

The Reason Lions Rule

THE HIDDEN LANGUAGE OF FAITH

OPPOSITE The Hinton St Mary mosaic (detail), Romano-British, early 4th century CE. Ceramic, 8.1 × 5.2 m (26 ft 6⅞ in. × 17 ft ¾ in.)

The 'Chi Rho' symbol haloing the head of this figure, believed to be Jesus, was one of the key icons of a new empire of ideas in the 4th century CE: Christianity.

PAGE 76 Bartolomeo Bulgarini, *Saint Catherine of Alexandria*, c. 1335–40. Tempera on panel, 73.5 × 40.5 cm (29 × 16 in.)

The palm leaf was exalted in ancient Egypt and in Greek mythology before it became a symbol of martyrdom to Christians.

On 12 September 1963, a Mr W.J. White was digging the foundations of a small outbuilding in Dorset, England, when he discovered fragments of a mosaic. It was later established to be Roman, and dated to the early fourth century CE. In the central portion, a man is flanked by two pomegranates and haloed by a symbolic monogram. This is now believed to be one of the first depictions of Jesus. The design behind His head is known as a 'Chi Rho' symbol, and it is made up of the first two letters of the word Christ in Greek (X and P). In the early first millennium CE, 'Chi Rho' symbols could be found all over the western world, adorning rings, lamps, cups, and mosaics from north Africa to north England, and Spain to Turkey. It was one of a new set of symbols for an emerging empire: an empire of Christian ideas.

Like political empires, religions must unify the beliefs of their followers. Symbols give spiritual ideas a physical shape, and communal ideas a visual identity. As the following twelve entries demonstrate, symbols transcend languages and have the power to communicate religious beliefs to diverse and even illiterate followers.

Why does a butterfly represent the soul? How did a dove become an internationally recognized symbol of peace? When did a lily become the attribute of the Virgin Mary? The stories that these symbols tell take us across continents, and connect otherwise seemingly far-flung cultures. The halo, a standard signifier of divinity across many religions, was cross-pollinated by the Roman empire, conquering armies in Central Asia and merchants trading goods along the Silk Roads. The lotus, palm branch, wheel and

OPPOSITE Barbara Dietzsch, *A Branch of Gooseberries with a Dragonfly, an Orange-Tip Butterfly and a Caterpillar*, 1725–83. Gouache over graphite on prepared paper, 28.7 × 20.4 cm (11⅜ × 8⅛ in.)

A butterfly symbolizes the soul in several art traditions.

grape all also span multiple religions. The optimistic vision of a rainbow has been a symbol of a range of faiths beyond religions – it represents a belief in the power of art and science, and has become a symbol of the freedom of identity, too.

Here we also look at symbols less commonly represented in art, like eggs, rabbits and goldfinches. The fact that these things held sacred significance demonstrates how divinity was once perceived in all the products of nature, no matter how common or lowly.

THE HIDDEN LANGUAGE OF FAITH

Why Do Jesus, Buddha, Mithra and Vishnu All Have **Haloes**?

In the fifth century CE, the circular disc halo was an early icon of globalization. If you had the means to travel in that period, you could see them around the heads of holy figures in China, India, Iran and Rome. This kind of halo did not exist in religious art before the first century BCE. How had it managed to conquer the whole of Eurasia in such a short time, leaving behind a piece of religious iconography that has lasted to the present day?

Haloes of one kind or another have been around for a very long time. The Indus Valley civilizations had used what looks to us like haloes in the third

Frédéric-Auguste Bartholdi, *The Statue of Liberty Illuminating the World*, 1875. Charcoal, heightened with white chalk, 85 × 130 cm (33½ × 51¼ in.)

The Statue of Liberty wears one of the world's most famous haloes.

THE HIDDEN LANGUAGE OF FAITH

Bimaran reliquary, Darunta, Afghanistan, *c.* 1st century CE. Gold, height 6.5 cm (2⅝ in.)

An early adoption of the disc-halo motif in Buddhism.

millennium BCE, on stone seals used to imprint motifs on soft clay, probably as a record for traders. However, they tended to represent auras of rayed light around the entire bodies of figures and not just the head. In ancient Egyptian art you can find circular motifs that look like haloes, such as the disc that defines the sun-god Ra – but this is represented above his head rather than behind it. A close relative is the kind of halo seen in some ancient Greek art that shows light apparently radiating from the head of divinities.[1] You still see some examples of this type of rayed halo in other contexts, for example on the Statue of Liberty, and flaming, whole-body haloes can be found in some examples of Ottoman, Mughal and Persian art in the Islamic tradition. But the circular disc halo is quite distinctive, and it sped across the Eurasian landmass at breakneck speed.

It probably originated as an attribute of the god Mithra, in the religious art of Persia. Mithra was a Zoroastrian deity of light, and it is understood that the halo was a technique for demonstrating Mithra's sun-like radiance. It is symbol of 'Khvarenah' – the Persian term for divine glory, which was intimately linked with Mithra.[2] The iconography of Mithra travelled outwards from Persia with the expansion of various empires.

Two examples of empires that swept eastwards from Persia were the nomadic Indo-Scythians, and the Kushans from Bactria in Afghanistan.[3] As they expanded into the further reaches of Pakistan, Afghanistan and northern India in the first century CE, they brought with them coins stamped with the symbols of the Zoroastrian religion. Mithra was a highly appealing figure to behold: attractive and youthful, and his crown-like circular halo instantly signifying his godly authority. His image was soon influencing artists of other religions. Buddhist artists, who had previously mainly used aniconic symbols (see **wheels**, pp. 92–95), soon began to show Buddha with a disc halo derived from images of Mithra. The Bimaran reliquary (late first century CE) is an early example of this adaptation of religious symbolism.

In the west, Mithra was also becoming popular with members of the invading Roman empire, and a cult around him – Mithraism – developed into one of the major Roman religions. Later, the style of presentation of

Why Do Jesus, Buddha, Mithra and Vishnu All Have Haloes?

ABOVE Apse mosaic, Santa Pudenziana, Rome, late 4th century CE.

A masterful representation of Christ with a disc halo, recognizable by people of the time as the attribute of an emperor.

OPPOSITE Buddha, Khyber-Pakhtunkhwa province, possibly Takht-i-bahi monastery, ancient region of Gandhara, Pakistan, 3rd century CE. Schist, height 92.7 cm (36½ in.)

One exquisite example of a haloed Buddha from the studios of Gandhara.

Mithra and his halo would be attached to another god in the Roman empire: the sun-god Sol. Worship of Sol became popular among members of the higher echelons of society, and especially the Roman emperors, as he was connected with the power of the sun and represented an ideal of youthful masculinity. Emperors up to the time of Constantine (r. 306–337 CE) began to represent themselves in the guise of Sol, appropriating his disc halo for official portraits.[4]

When the once peripheral Christianity became widely accepted in the Roman empire, after the rule of Constantine (see **dragons**, pp. 30–33), it was on its way to becoming one of the most powerful institutions in the western world. The newly promoted religion needed artists to make suitably grand images to enhance it further. As a result, images of Jesus were made to resemble portraits of the emperors. A key part of the iconography was the halo, by then a widely recognized and highly authoritative symbol of power.

In India, various religions lived alongside each other in relative peace in the first millennium CE. Artists making images for worship in Jain, Hindu

80 THE HIDDEN LANGUAGE OF FAITH

and Buddhist contexts shared ideas, techniques and styles, including elements of iconography.[5] This included the halo, which you can see adorning the sculptures of all three religions. The reason for the halo's transmission across Asia to China and Japan is mainly due to the spread of Buddhism and Hinduism eastwards in the first millennium CE.

The two great centres of art production in India at this time were Gandhara, on the border of Pakistan and Afghanistan, and Mathura, 90 miles (145 kilometres) south of Delhi. Both places pioneered the use of haloes in Indian religious art, but Gandhara happened to lie at the centre of a web of trade links that spread across Eurasia from the Mediterranean to China. These

Seated Buddha, ancient region of Gandhara, Pakistan, 1st to mid-2nd century CE. Bronze with traces of gold leaf, height 16.8 cm (6⅝ in.)

An early bronze Gandharan Buddha with a dazzling halo.

82　　THE HIDDEN LANGUAGE OF FAITH

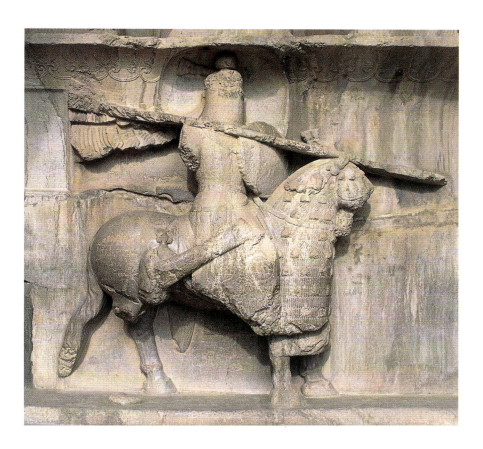

Equestrian Statue of Khosrow II, Taq-e Bostan, Iran, *c.* 4th century CE. Rock relief, approx. 7.45 × 4.25 m (24 × 13 ft)

By the 4th century CE, the halo was part of an internationally recognized language of symbols, used here to dignify the last Sasanian king of Iran.

highways were instrumental in transmitting the ideas of Buddhism outwards. Merchants found that Buddhist monasteries were ideal places of rest on their long-haul journeys, and soon the monasteries became like religious versions of caravanserais, where people could get a night's rest, a good meal, as well as having their spiritual needs tended to.[6] The monasteries facilitated the spread of Buddhist art and so, before long, Buddhist imagery and figures with haloes around their heads could be found in China, Korea and Japan. Hinduism also spread through similar means and, through maritime trading, reaching Indonesia, Malaysia, Cambodia and many other areas in southeast Asia.

The 'Silk Roads', as these widespread arteries of trade were known, aided the dissemination of the halo to the east, while the Christianized Roman empire cemented it in the western world. The symbol started its life as a Zoroastrian signifier of divinity in Iran, but it became a universal icon because of empire, trade and the power of faith.

Why Do Jesus, Buddha, Mithra and Vishnu All Have Haloes?

Why Your Soul Is a **Butterfly**

Once, Zhuang Zhou dreamed he was a butterfly, a butterfly flitting and fluttering about, happy with himself and doing as he pleased. He didn't know that he was Zhuang Zhou. Suddenly he woke up and there he was, solid and unmistakable Zhuang Zhou. But he didn't know if he was Zhuang Zhou who had dreamt he was a butterfly, or a butterfly dreaming that he was Zhuang Zhou. Between Zhuang Zhou and the butterfly there must be some distinction! This is called the Transformation of Things.[7]

Written in China around 300 BCE, the *Zhuangzi* is considered a seminal text in Daoism, and 'Zhuang Zhou Dreams of Being a Butterfly' is the most famous of its stories. It perfectly demonstrates the author's uninhibited and anti-establishment philosophy, which scorned humanity's egotism

BELOW Attributed to Ma Quan, *Flowers and Butterflies*, China, Qing dynasty, 18th century. Handscroll; ink and colour on paper, 27.9 × 248.9 cm (11 × 98 in.)

The *Zhuangzi* influenced Chinese artists in emphasizing the dreaminess of butterflies.

OPPOSITE François Gérard, *Cupid and Psyche*, 1798. Oil on canvas, 1.86 × 1.32 m (6 ft 1¼ in. × 4 ft 4 in.)

Psyche, the Greek goddess of the soul, and the origin of the word 'psychology', is symbolized by a butterfly, here fluttering above her head.

THE HIDDEN LANGUAGE OF FAITH

and put the 'Dao' – the great 'Way' or 'path' of nature – centre-stage. The butterfly's whimsy was a perfect prompt for questioning the consistency of human consciousness and our perception of reality. Where butterflies appear in later Chinese art, they often do so in reference to this seminal tale, to symbolize dreaminess and the dissolving of human egotism into nature. As well as being a light-hearted and optimistic creature, the butterfly is also connected with old age in China. The Chinese word for butterfly is *hudie* – a pun for the age of seventy.

A connection between butterflies and the soul was also a feature of ancient Greek thought. Aristotle (384–322 BCE), tutor of Alexander the Great, developed this association in his treatise *The History of Animals*, which was written only a few short decades before Zhuangzi's riddling tale. Aristotle's text is the first recorded instance of the word 'psyche', meaning the human

Maria van Oosterwijck, *Vanitas Still Life*, 1668. Oil on canvas, 73 × 88.5 cm (28¾ × 34⅞ in.)

The red admiral on the book symbolizes the brevity of life. The white butterfly on the bouquet likely represents heaven and salvation.

THE HIDDEN LANGUAGE OF FAITH

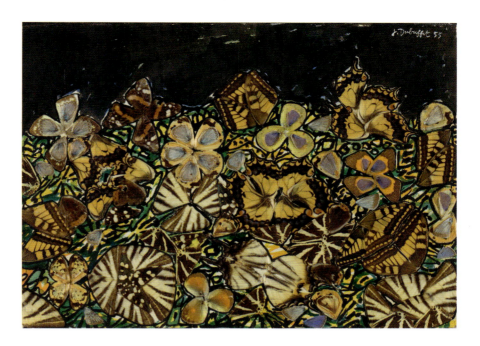

Jean Dubuffet, *Bibi Trompette's Garden*, 1955. Butterfly wings, gouache, and watercolour on wove paper mounted to paperboard, overall 22.1 × 32.1 cm (8¾ × 12¾ in.)

In the 1950s, critics thought that Dubuffet's hasty collages of real butterfly wings symbolized aggression and cruelty.

spirit or soul, in reference to a butterfly.[8] Since a butterfly's life is preceded by a benighted pre-existence as a caterpillar and a sepulchral stasis in a cocoon, it became a metaphor for the human 'anima' (soul) liberating itself from the body after death. Even the butterfly's skittish and unpredictable style of flight was taken as a representative of the freedom of the human spirit.

The longevity of Aristotle's book kept this symbolism going for centuries in the western world. In Christian art, for example, the butterfly could stand for the resurrected Jesus, metamorphosed from an earthly to divine incarnation. Not all artists, however, saw butterflies as creatures of light and beauty. In the sixteenth century, the wings of various butterflies, including small tortoiseshells, meadow browns and swallowtails, were attached to the bodies of satanic creatures in the work of Hieronymus Bosch (1450–1516) and Pieter Bruegel the Elder (*c.* 1525–1569). Red-coloured butterflies, like red admirals, were linked with the fiery coals of damnation in Dutch still-life paintings of the seventeenth century, whereas the immaculate cabbage white was a symbol of divine grace, and they were paired to underline the fact.[9]

Between Zhuangzi, Aristotle and the great artists of the eastern and western traditions, the dainty butterfly has carried among the heaviest of symbolic meanings: the great mysteries of existence, the nature of the psyche and the metamorphosis of the carnal body into ethereal spirit after death.

Why Your Soul Is a Butterfly

How the **Palm** Branch Triumphed

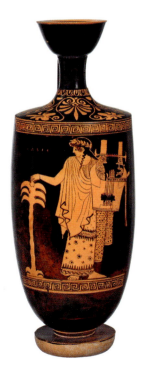

Attributed to the Nikon Painter, *lekythos*, c. 460–450 BCE. Terracotta, height 38.1 cm (15 in.)

Leto beside the palm tree where she gave birth to Apollo.

Even the gods suffer in childbirth. According to Greek mythology Leto, a female Titan and a paramour of Zeus, endured a labour that lasted for a nerve-shredding nine days. The pain was unbearable, and sweat ran over her body in torrents as she writhed on the desolate foothills of Delos's Mount Cynthus. At last, 'she clasped her arms round the palm-tree, and braced her knees against the soft meadow grass, and the earth beneath her smiled.'[10]

The safely delivered child became a true hero of the pantheon of Olympian gods – the devastatingly beautiful and much-admired Apollo. And in his older age one of Apollo's key attributes, alongside the **laurel** tree (see pp. 40–44), was the palm he was born under.

For the ancient Greeks, Delos, the island of his birth, became a site of pilgrimage. It also later became the meeting place of the Delian League, the union of all Greek city-states. Once every four years Delos also held a religious festival and athletic games in honour of Apollo. In one of these festivals in the late fifth century BCE, the hosts had a novel idea: they awarded the winners in the games a symbolic palm branch, in honour of Apollo's sacred tree.

The tradition caught on. Within a few decades, artists were using palm branches to represent victory on vases and coins, and the symbol eventually evolved into the main attribute of Nike, the goddess of victory. Later historians of the Hellenic world, such as Livy (*c.* 59 BCE–17 CE) and Plutarch (46–119 CE), described how the palm branch, symbolically handed to victors in sport and warfare, had been adopted by the Romans in their own various allegories of triumph. Palm branches had hit the iconographic mainstream.

PAGE 89 Bartolomeo Montagna, *Saint Justina of Padua*, 1490s. Oil on canvas, 48.6 × 37.5 cm (19⅛ × 14¾ in.)

In Christian art, a palm leaf indicates a saint who was a martyr.

BELOW Wall panel with banquet scene, Neo-Assyrian, Nineveh, Iraq, 645–635 BCE. Gypsum, 58.4 × 139.7 cm (23 × 55 in.)

The date palms in this scene are fruiting, which is not possible in Assyria, where it was made. Therefore, it is probably a symbol of the temperate territories that the ruler Ashurbanipal had conquered, such as Elam.

In the contest for the best symbol of victory, the palm branch had to fight off some stiff competition to ensure a victory of its own. In bigger and more prestigious ancient Greek games the victorious athletes were crowned variously with wreaths of laurel, pine, wild celery or parsley. Like so many other dominant and long-lasting symbols in history, the palm of victory probably owes its success to its distinctive silhouette and association with a place of origin that was mysterious and exotic: in this case, the Fertile Crescent.

Both the ancient Egyptians and the various civilizations of ancient Mesopotamia, which predated the ancient Greeks and Romans, considered the date palm to be an exalted tree. For the Egyptians the palm branch was a symbol of eternity, and the date palm was no less than the 'tree of life' in Mesopotamian symbolism. And it is no surprise why: date palms were ubiquitous in these regions and, as an agricultural staple, had a very explicit link to the welfare of the people. The palm tree is also evergreen even in harsh desert environments, making it a natural icon of resisting decay and death. In Mesopotamia it became associated with the fearsome goddess Inanna, and her later incarnation Ishtar, as a symbol of abundance. This tree of plenty prospers in tropical and subtropical regions, so even slightly northern areas cannot support them. Thus, in ancient Mesopotamia, northern peoples like the Assyrians frequently depicted palms in artworks, but much of the time as a symbol of the southerly cities that they had managed to fight and conquer.[11] The 'victory' that the palm tree symbolizes may sometimes be the triumph of imperialism.

The same may be said of palms in the city of Rome. The first specimen palm trees were planted in Rome after Egypt became a province of the

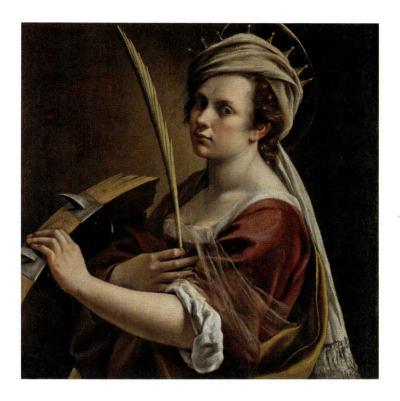

Artemisia Gentileschi, *Self-Portrait as Saint Catherine of Alexandria*, c. 1615–17. Oil on canvas, 71.4 × 69 cm (28⅛ × 27¼ in.)

In this painting of St Catherine, which may be a self-portrait, the figure meaningfully presses the palm of martyrdom to her chest.

Roman empire in 30 BCE, affirming the symbolism of palms as a trophy of conquest. They flourished in the city until the decline of the empire in the late fifth century CE. They were not seen again in Rome until the late nineteenth century. This coincided with Italy's programme of colonization in the 'scramble for Africa', once again making palms civic symbols of colonization.[12]

Palms play a significant role in Christianity. When, in his final days, Jesus made his triumphant entry to Jerusalem, the people of the city brandished palm branches as symbols of victory, joy and longevity. The event has been enshrined in the Christian calendar as 'Palm Sunday', celebrated on the Sunday before Easter, and nowadays customarily involving small crosses fashioned out of palm fronds.

In fact, the palm is a holy tree in many religions stemming from the Mediterranean and the Middle East, including Judaism and Islam. For the visual culture of Christianity, palm branches are especially closely connected with martyrs of the faith. For these saintly men and women, who had died for their beliefs, the palm leaf is a symbol of their ascendant faith. It represents the ultimate victory: the defeat of death itself.

How the Palm Branch Triumphed

The **Wheel**'s Revolution

Around 243 BCE, a polished sandstone column, 10 metres (33 feet) tall, appeared in Sarnath in northern India, featuring a large wheel at its summit. It was one of many such columns, decorated with symbols and inscriptions, that had suddenly materialized in the region. They had all been commissioned by the Mauryan Emperor Ashoka (304–238 BCE) to broadcast his political philosophy and unify his vast kingdom in the Indian subcontinent. It was an extraordinary act, partly because of the scale of the project, but mostly because of the message contained in the columns' inscriptions and visual iconography. Rather than the more expected statements of submission to the might of Ashoka, they were preaching a message of peace and harmony to the people.

Today, a wheel is emblazoned on the flag of India, and the Ashoka capital (minus the wheel, which is now missing) is the country's official emblem. Of all things, why did Ashoka use a wheel as his symbol of faith and authority? And how did it become so influential to India?

It is cliché that the wheel is humanity's greatest invention, but the claim is backed up by the prehistoric iconography. For millennia before Ashoka, the wheel was a symbol of power, due to the status of those who rode chariots. The wheel motif also carried associations with the sun in prehistoric cultures, with its spokes conveniently resembling rays of light. The Celts (first millennium BCE) in Europe made a vast quantity of wheel-themed jewelry items and carvings, and buried elite individuals with their wagons.[13] The wheel, having the capacity to convey people far and wide, was a symbol of the power of human invention – an emblem of humankind's supremacy over nature.

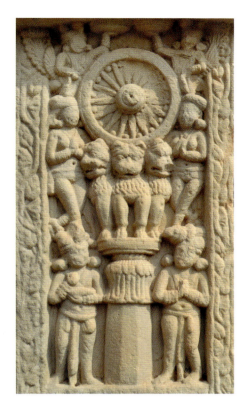

ABOVE LEFT Depiction of the four-lions capital surmounted by a Wheel of Law, Satavahana period, south gateway of Stupa 3 at Sanchi, Madhya Pradesh, India, *c.* 1st century BCE

A depiction of a pillar of Ashoka, topped by four lions and a wheel, like the one at Sarnath.

ABOVE RIGHT Vajrapani attends the Buddha at his first sermon, ancient region of Gandhara, Pakistan, *c.* 2nd century CE. Schist, 28.6 cm × 31.1 cm (11⅜ × 12¼ in.)

The Buddha represented with a wheel to symbolize his teachings.

In India, the *cakkavatti* was the name given to an ideal leader – the word translates as 'turner of the wheel', to denote a person with the mastery and mobility to rule over a vast kingdom. It was a notion developed by the Mauryan dynasty. Previously it had accompanied fearsome gods like Surya, linked in the Vedas with both the sun and chariot-riding, and Vishnu, whose control of the universe was symbolized by a wheel. The wheel icon was then adopted as a symbol of the Buddha who, from the fifth century BCE, was seen by his followers as the new master of enlightenment.

Before becoming 'Buddha' – the 'awakened one' – Siddhārtha Gautama (500s–400s BCE) was a wealthy prince. His path to enlightenment involved finding a way to escape the earthly cycles of reincarnation and achieve *nirvana*. The key element of this route was his realization of the insubstantiality of material possessions, the ego and every other imprisoning, man-made mental construct that we cling to in life. A guide to how to achieve enlightenment was established with the Noble Eightfold Path of Buddhism, part of which defined an ethics of kindness and upstanding behaviour.

The Wheel's Revolution

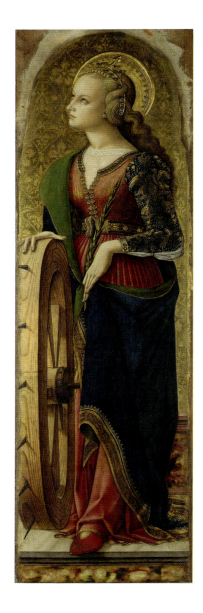

Carlo Crivelli, *Saint Catherine of Alexandria*, 1476. Tempera on poplar, 137.5 × 40 cm (54¼ × 15¾ in.)

In European art, the wheel is a symbol of oppression when it appears as the instrument of Saint Catherine's martyrdom.

In the following centuries, Buddha's insights attracted an ever-growing school of adherents. Eventually it became necessary to create artworks to focus the minds of followers. But how were artists to represent Buddha? One of the earliest Buddhist texts, the *Sutta Nipāta*, considered any attempt completely futile: 'he, who [like the sun] has gone to rest, is comparable to nothing whatsoever. The notions through which his essence might be expressed are simply not to be found. All ideas are nothing as bearing upon him'.[14] According to this influential school of thought, Buddha was simply beyond representation.

Ultimately, Buddhists overcame the taboo against direct depiction and artists began to represent him in human form from the first century CE. But in the meantime, the solution to the problem was to harness the power of symbols. This could trigger *thoughts* about Buddha, while sidestepping the necessity to *depict* him. This artistic tactic, known as 'aniconic' symbolism, would also later be used by early Christians, as the next entry describes.

The *dharmachakra* (wheel of law) was one of the key aniconic symbols of Buddha. It represents the casting in motion of his doctrines of enlightenment, which were taught for the first time at Sarnath. The wheel shows the dynamism of Buddhist teachings, and Ashoka's wheel is a symbol not only of educating the people about the laws of *dharma*, with its benevolent set of ethics, but also a symbol of strong leadership. The message was symbolically spun outwards, with the spokes of the wheel symbolizing the centrifugal outward force of the Buddhist law, with Sarnath at the centre.

In later Buddhist art, a wheel would represent *samsara* – the cycles of reincarnation that only end with true enlightenment. In Europe a similar image of the wheel of fortune, which had its origins in Italian Etruscan symbolism, shows the fluctuations of life, offering a moral lesson about the rise of the powerful and wealthy, and their inevitable fall to disrepute and poverty.

Ashoka had had a personal spiritual revolution not long before raising his pillars. In his youth he had been a fearsome king, leading bloody campaigns to spread his empire across the Indian subcontinent. Then, in 261 BCE, following the brutal battle of Kallinga with its death-count numbering in

94 THE HIDDEN LANGUAGE OF FAITH

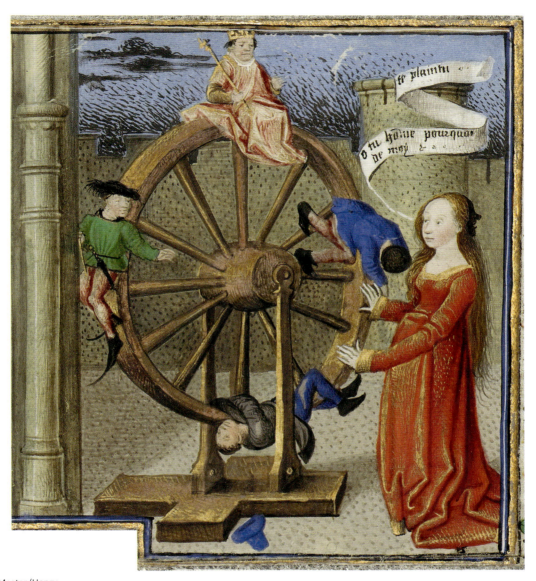

Coëtivy Master (Henry de Vulcop?), *Philosophy Consoling Boethius and Fortune Turning the Wheel*, MS. 42, leaf 1v, c. 1460–70. Tempera colours, gold leaf and gold paint, leaf 7.3 × 17 cm (2⁷⁄₈ × 6¾ in.)

In other contexts in European art, the wheel can be a symbol of the rise and fall of luck and power.

the hundreds of thousands, Ashoka reportedly spurned the life of an all-conquering general. Discovering Buddhism, he set out his new beliefs in a large-scale public relations campaign: columns that incorporated Buddhist iconography and inscriptions preaching peace, compassion and kindness. The influence of the wheel in India is partly due to religious faith, as the wheel is significant to Jains and Hindus as well as Buddhists, but it is also a symbol of the ultimate leader: strong, indefatigable and compassionate.

The Wheel's Revolution 95

The Power of Doves

Christianity can be said to be one of history's most successful campaigns in uniting people through shared symbols. The dove is one of Christianity's oldest examples, and it remains an important symbol of the faith to this day. Doves are members of the *Columbidae* family of birds, which also includes pigeons, and are blessed with strong navigational abilities. As such they have historically been associated with helping humans convey messages to one another, and in Christian iconography this became the transmission of the messages of God to saints.

In its early years, Christianity followed the Jewish custom of worshipping without using visual art, since the second of the Ten Commandments outlawed 'graven images'. But Clement of Alexandria (150–215 CE), a leading early theologian, suggested that aniconic symbols (ones that didn't depict their subject directly) may be permitted. These included a **fish** (symbol of Jesus and baptism, pp. 212–25); a ship (representing the Christian soul's journey); a lyre (an attribute of Jesus as the Good Shepherd); an anchor (for the hope of salvation); or a dove (the Holy Spirit).[15]

The Holy Spirit is the third part of the Holy Trinity, alongside God the Father and God the Son. The Holy Spirit is an invisible force of holy communication, and therefore seemingly impossible to visualize in an image. However, the Bible described the Holy Spirit as a dove that descended upon Jesus as he was baptized (John 1:32). It coincides with the story in the Book of Genesis that tells how Noah sent out a dove from the ark to see if there was land nearby. The dove that returned with an olive branch in its mouth is a separate Christian symbol, once again a divine messenger, this

Laurent Girardin, *The Trinity*, c. 1460. Oil on wood, 114 × 94.5 cm (45 × 37¼ in.)

The dove as a Christian symbol of the Holy Spirit, one part of the Trinity.

THE HIDDEN LANGUAGE OF FAITH

ABOVE LEFT Mural with Noah leaving the ark, St Peter and Marcellinus Catacombs, Rome, late 3rd century CE

An early Christian representation of the dove reaching Noah with an olive branch.

ABOVE RIGHT Pablo Picasso, *Dove*, 1949. Lithograph on paper, 56.7 × 76 cm (22⅜ × 30 in.)

The symbolic dove that Picasso designed for the 1949 Paris Peace Congress.

OPPOSITE Marble grave stela of a little girl, Greek, c. 450–440 BCE. Marble, height 80.6 cm (31¾ in.)

This grave marker shows a young girl tending her pet doves. In ancient Greece, a dove was the symbol of Aphrodite, goddess of love, but in grave markers they could signify the departed soul.

time conveying the peace that God had decided to offer mankind. The symbolism of the dove with the olive branch was given additional weight in *De Doctrina Christiana* (397 CE), written by the Algerian-born Christian theologian St Augustine (354–430 CE). The book, which is an aid to interpreting biblical scripture by considering its use of symbols and figurative language, was influential in setting the dove as the ultimate symbol of peace for generations henceforth.

The story of the Great Flood in Genesis derived from the much earlier *Epic of Gilgamesh*, which was originally written by the Sumerians in the second millennium BCE, and which also mentions using doves to check for safe land. Also from these early times comes the association of doves with divinity.[16] Several ancient Mesopotamian goddesses, such as Astarte and Ishtar/Inanna, were depicted with doves, which went on to be associated, alongside **pearls** (pp. 252–57) and **roses** (pp. 222–27), with Aphrodite, Greek goddess of love.[17]

The white dove of spiritual purity and divine communication had an unexpected revival in the twentieth century. In 1949, Surrealist poet and editor Louis Aragon (1897–1982) visited Picasso's studio to select an image for the poster for the World Peace Congress, which was to be held in Paris later in the year. Aragon found a lithograph of a dove that Picasso had made a few months before and had no hesitation in picking it out as the ideal image: a universally understandable motif of peace from the hand of the twentieth

century's most famous artist.[18] Picasso became a member of the Communist party after the ending of the Second World War, and he developed his dove symbol, which an became increasingly famous icon of peace, throughout the 1950s and 1960s for the posters of various peace congresses held in Paris, Berlin, Rome and Moscow, among others. The dove once again rose to unite people of disparate beliefs and nationalities.

The Power of Doves

Why the **Lily** is the Purest Flower

After a life of persecution under the Romans, the Syrian-born St Apollinaris (d. 97 CE) enjoyed a benign afterlife in the gardens of heaven, where neatly arranged clumps of pure white lilies grew from the ground. At least, that's how the mosaic artists of Classe represented him in the nave of the Church of St Apollinaris in the mid-sixth century CE. Following from an early Christian prohibition against images (see p. 96), the fourth century onwards saw an expansion of church buildings and a wave of new symbols to represent Christian beliefs.

While the idea of showing a saint in paradise didn't necessarily catch on in later Christian art, the idea of the lily being the flower of purity did. The origins of the attitude come from the Bible, Song of Songs 2, where the lily is the embodiment of beauty and spiritual grace: 'I am the flower of the field, and the lily of the valleys. As the lily among thorns, so is my love among the daughters.' Other passages in the Bible, such as Ecclesiastes and the Gospels of Matthew and Luke, reaffirm the connection. Later Christian theologians such as the Venerable Bede (*c.* 672–735 CE) and Paul the Deacon (*c.* 720s–*c.* 799 CE) popularized the notion and made a link to the Virgin Mary. Through the medieval period and the Renaissance, the lily became her key attribute and was commonly represented, alongside the **dove** (see pp. 96–99), in scenes of the Annunciation, which captures the moment that the angel Gabriel announces the Virgin birth to Mary. From that point onwards, the lily would be the flower most closely associated with Mary.

When we look at the interpretation of flowers like the lily and how they were understood by people in pre-modern times, we need to see the natural

Detail of mosaic from the apse of the Church of St Apollinaris, Classe, Italy, 6th century CE

The lily is being used as a symbol of heavenly purity here, before it became closely associated with the Virgin Mary in Christian art.

world through their eyes. Animals and plants were understood as God's creations, so it stood to reason that nature contained divine messages that could be interpreted by the pious. The religious explanation of flowers and creatures proposed in the medieval period sometimes stretched credulity. For example, a religious text of around 1200 called the *Vitis Mystica* explained that the lily's six petals stood for six reasons why virginity was a desirable quality, and that the lily's (roughly) triangular-shaped pistil head symbolized the Holy Trinity.[19]

Unbeknownst to them, these European writers were not the first to have looked at the lily with a sense of awe. The earliest representations of lilies were made in the second millennium BCE by the highly sophisticated, art-loving Minoan civilization, which flourished in the Cycladic islands of Greece between about 3000 BCE and 1100 BCE (see **labyrinths**, pp. 170–73). Minoan artists repeatedly depicted the flower as a decorative element in

Why the Lily is the Purest Flower

THE HIDDEN LANGUAGE OF FAITH

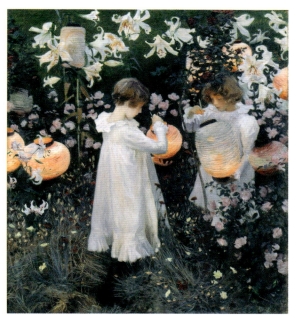
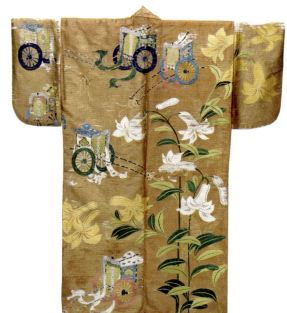

OPPOSITE ABOVE Fra Filippo Lippi, *The Annunciation*, c. 1435–40. Tempera on panel, 1 × 1.61 m (39³⁄₈ × 63½ in.)

Lilies became associated with annunciation scenes in Christian art.

OPPOSITE BELOW The 'Springtime Fresco' from Akrotiri, Thera, c. 1500 BCE

The Minoans regularly depicted lilies, but their meaning is still a mystery.

ABOVE: LEFT John Singer Sargent, *Carnation, Lily, Lily, Rose*, 1885–86. Oil on canvas, 1.74 × 1.54 m (5 ft 8½ in. × 5 ft ⅝ in.); RIGHT Nuinaku (Noh costume), Azuchi-Momoyama period, Japan, 16th century

In the late 19th century, many European artists became infatuated with Japanese art, and the previously unknown *Lilium auratum* became a symbol of the exotic east.

colourful landscapes, and on the stylized crowns and jewelry of significant figures in Minoan frescoes from the palace of Knossos on Crete.[20] Their evident infatuation with lilies makes it likely that the flower had some sort of ritual function.[21]

Mirroring the later Christian notion of the lily being a flower of purity is the much earlier story from Greek mythology about Hera, the Queen of the Gods. Eratosthenes (c. 275–194 BCE), a Greek scientist and poet, described in his verse *Hermes* how Hera's breast milk spilled into the sky, to become the Milky Way, and onto the ground, where lilies magically appeared. The *Geoponica*, a Byzantine text on plants written in the tenth century CE, popularized the tale, influencing the high praise of later artists, poets and horticulturalists for the pure white *Lilium candidum*.

Charlemagne (748–814 CE), King of the Franks (from whom the name of France was derived), was an admirer of lilies. In a set of decrees titled *Capitulare de Villis* (c. 800 CE) he commanded all his royal households to grow them. In the fourteenth century, at a time when it was already seen as the holy flower of the Virgin, the lily was converted into a royal emblem of the kings of France – the fleur-de-lis ('flower of the lily'). The Valois kings even insinuated that the motif, which linked the monarchy to the divine, had been designed in the age of the legendary Charlemagne.[22]

Why the Lily is the Purest Flower

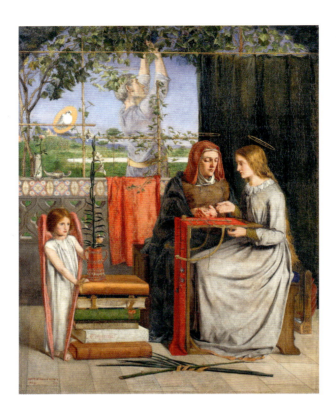

Dante Gabriel Rossetti, *The Girlhood of Mary Virgin*, 1848–49. Oil on canvas, 83.2 × 65.4 cm (32⅞ × 25¾ in.)

A young Virgin Mary studies the lily with the attentiveness of a good artist.

Artists continued to follow the traditional symbolism of the lily well into the nineteenth century. The English poet and painter Dante Gabriel Rossetti (1828–1882) represented the young Mary as a biddable art student copying the stately lily of purity from life in *The Girlhood of Mary Virgin* (1848–49). But the iconography also had to adapt to the appearance of spectacular non-native breeds of lily from America, China and Japan. The Japanese lilies – *Lilium auratum* – in the American John Singer Sargent's (1856–1925) *Carnation, Lily, Lily, Rose* (1885–86) are as ethereal and flamboyant as butterflies in the warm summer air. Their whiteness complements the theme of childhood innocence in the image, but also exemplifies the contemporary fad for all things exotic and eastern: Japonisme.

Throughout its journey as a symbol in art, the lily proves the enduring potency of flowers in religions. Lilies have reassured the faithful that spiritual purity can exist – the proof is in the immaculate beauty of this majestic flower.

The Hidden Depths of a **Lotus**

Between the ninth and fifteenth centuries CE the city of Angkor in modern-day Cambodia was the capital of the mighty Khmer empire, and the largest human settlement of the pre-industrial world. The citizens of Angkor, travelling along its logical grid-system of streets, were able to admire stupendous temples, some with gold-tipped roofs that reached the height of skyscrapers. A closer look at their highly decorated surfaces reveals that lotus flowers were a recurrent architectural motif, especially in the biggest temple in the city: Angkor Wat. They festoon the ceilings of its extensive galleries, and its silhouette, defined by its five tall towers, distinctly resembles the lotus bud. For the Khmer people, the flower was unrivalled in expressing the material and spiritual conditions of their world.

The Khmer were not alone in finding symbolic depth in the flower. The lotus is undoubtedly the most widespread flower symbol in eastern cultures, and its history goes back a very long way indeed. As early as 3000 BCE in ancient Egypt, the blue lotus (*Nymphaea caerulea*) was seen as a symbol of fecundity and spiritual purity. Lotus flowers garland the waters of the Nile, and were linked with the river's annual flooding, which fertilizes the soil and makes it prime agricultural land. The blue lotus responds to the sun – at dawn the buds emerge from the cool waters and unfurl into blade-like petals, and at dusk they close up and sink back into the deep. This correspondence between the land and sky meant that lotuses were associated with gods including Ra, Osiris and Horus.[23] They were also linked with the origins of the universe. The idea that a lotus looks so perfect, and yet its roots are stuck in the dank slime of the riverbed, provided

BELOW Angkor Wat, Siem Reap, Cambodia, c. 1110–50 CE

The five tall towers of Angkor Wat in Cambodia resemble lotus buds.

OPPOSITE Shiva as the Lord of the Dance, Tamil Nadu, India, c. 950–1000 CE. Copper alloy, 76.2 × 57.1 × 17.8 cm (30 × 22½ × 7⅛ in.)

A lotus flower forms the base of this sculpture from India, depicting the dance of the Hindu god Shiva in which the universe is destroyed and re-created.

an exquisite metaphor for the appearance of the pure human soul in an otherwise imperfect world.

The lotus was to have a correspondingly significant role to play in the far-distant religions of India. In the Vedas – transcripts of ancient hymns that were only set down in writing in about 1500 BCE – lotuses are described as being present at the dawn of the cosmos.[24] One story relates how Brahma was born out of a lotus that grew from Vishnu's navel – an astoundingly similar type of story about divinity emerging from primeval chaos to the one that the Egyptians had believed in. In the earliest surviving visual art from India, the lotus was also linked with female deities, with the lotus symbolizing female fecundity. One archaic goddess, for example, had a lotus flower for a head, and was usually represented in a birthing or sexually available pose with legs akimbo, exposing her vulva.[25] The Vedas are the most ancient holy texts of Hinduism, but the veneration of the lotus was sustained also in Buddhism, which emerged in the sixth or fifth centuries BCE. In Buddhist art the flower has an even more heightened symbolic importance. It represents the enlightened soul, purified and uncontaminated by the affairs of the world. It is common to see lotuses as stand-alone symbols of the Buddha, or as his throne, or the seat of the enlightened but earth-bound Bodhisattvas.

The lotus has attained a significance in India that transcends even religions – the second highest civilian award in the country, the Padma Vibhushan, has a stylized lotus inscribed on its medal. In China, lotus flowers were held high as the epitome of beauty and purity in poetry, Confucianism and Daoism,

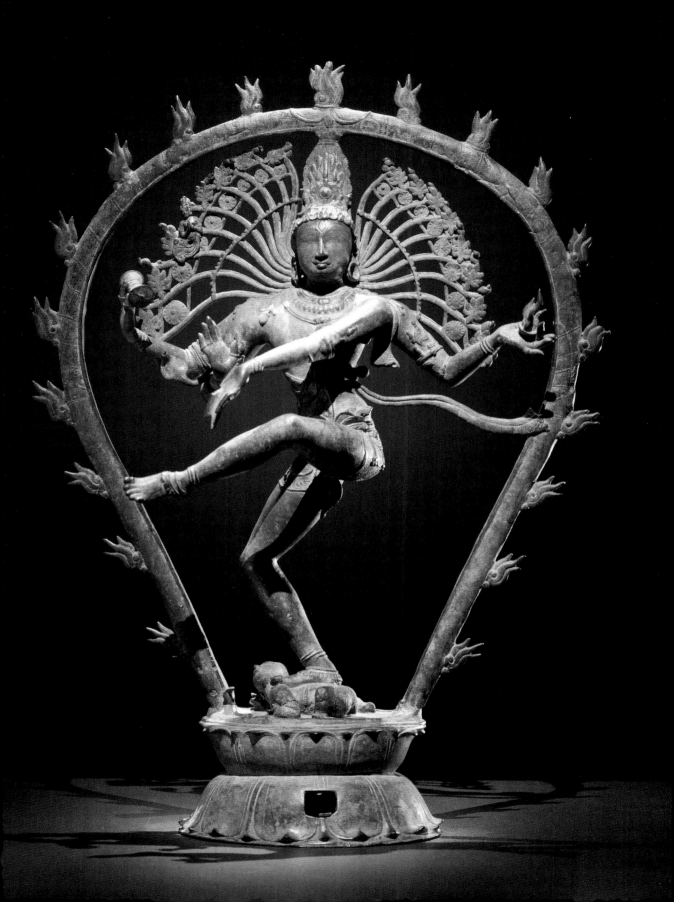

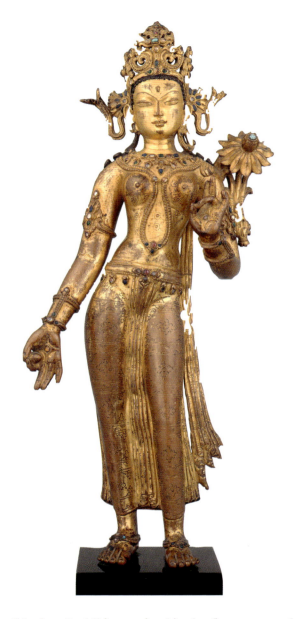

Tara, the Buddhist Saviour, Kathmandu Valley, Nepal, 14th century. Gilt copper alloy with colour, inlaid with semiprecious stones, 59.1 × 26.7 cm (23 3/8 × 10 5/8 in.)

The significance of the lotus flower to Buddhism is on full display in this Nepalese sculpture: Tara holds a lotus bud in her right hand and has a blooming lotus on her left shoulder.

well before Buddhism arrived in the first or second centuries CE, and were established as an oft-repeated motif on decorative items such as porcelain and silk. As you can see, the lotus is probably the flower that has carried the most exalted symbolic associations in the history of world art.

The significance of lotuses to Angkor exemplifies this. Some 19 miles (30 kilometres) north of the city, in the humid jungle uplands of the Kulen mountain range, is the wellspring of two of Cambodia's major rivers, the

Siem Reap and the Puok. Priests from Angkor came here to venerate the waters, and artists carved the rocks with scenes of the gods who protected them. At a key rock channel, the tributary at Kbal Spean, is a sculpture of Brahma being born from a lotus stemming from Vishnu's navel.

The Kulen mountains were rightly regarded as the source of Khmer power. The very survival of Angkor was based upon control of water, which inundated the region during the monsoon season and disappeared for long periods of time in the dry season. Khmer engineers designed an ingenious system of vast reservoirs and canals to control the flow of water from the Kulen tributaries and store it for future use, so that the rural Khmer people could grow enough surplus rice to sustain the empire's population. One of these hand-cut reservoirs had a 12-billion-gallon capacity, and still irrigates surrounding fields today.[26] First and foremost, this was an engineering marvel, but the citizens of Angkor would also understand the waters on a religious basis, as symbolic of the primal, life-sustaining sea of Hindu origin myths.

The architecture of Angkor Wat is the ultimate synthesis of the religious and political symbolism of water and the lotus to the Khmer people. Its function was probably twofold: to be a mausoleum of King Suryavarman II (1112–1150) but also a temple to Vishnu. This fitted with the Khmer kings' self-defined status as deified rulers who embodied the authority of Hindu gods. Suryavarman II was the first to associate himself with Vishnu rather than Shiva, and the decision is manifested in the architecture of Angkor Wat: a metal sculpture of Vishnu stood in a sanctuary beneath the central lotus tower. This tower not only recalls the source of life from which Brahma emerged, but simultaneously represented one of the five peaks of Mount Meru, the holy mountains that mark the centre of the world in Hindu mythology. The 5-mile (8-kilometre) long moat that surrounds the temple symbolizes the oceans that surround the world, making the entire structure a manifestation of Hindu cosmology, with the holy lotus of creation at the very centre.

Like the lotus, Angkor was a city built upon and sustained by water, floating above the stagnant world with grace and divinity. And like a lotus at the day's end, Angkor also eventually receded from view. The Khmer empire fell apart around the fifteenth century; Angkor was abandoned, and slowly reclaimed by the jungle. The parts of the metropolis that were not built with stone were completely subsumed by nature, and strangler fig trees dramatically engulfed the remaining temples.

Hippopotamus ('William'), Egypt, 12th dynasty, c. 1961–1878 BCE. Faience, 11.2 × 20 × 7.5 cm (4½ × 7⅞ × 3 in.)

The earliest beliefs about lotus flowers representing purity and regeneration originated in ancient Egypt.

The Hidden Depths of a Lotus

Of **Eggs** and Origins

Piero della Francesca's (d. 1492 CE) Brera Altarpiece, or *Brera Madonna* (1472–74), is a renowned Renaissance masterpiece. It also contains what is probably the most famous egg in the history of art. Conventionally understood to represent an ostrich egg, it has provoked decades of scholarly argument over its hidden meaning. Is it a symbol of virginity? Eternity? New life? Is it linked to Christian tradition, or inherited from classical mythology?

The painting is an example of a type of altarpiece known as a *sacra conversazione* – a 'sacred conversation', depicting various saints gathering around the Virgin and Christ child. In line with Piero's other paintings, the composition is a meticulously planned operation, governed by simplicity, balance and the systematic repetition of shape, pose and gesture. It is believed to have been painted for the tomb of Federico da Montefeltro (1422–1482), duke of the Italian city of Urbino. Federico paid for the painting and is represented in it, dressed in full armour and kneeling in front of Jesus and Mary. In the context of the commission and the subject matter of the Brera Altarpiece, the egg seems like a slightly surreal intrusion.

The egg is one of those symbols that means the same thing across innumerable cultures because of its essential function and appearance. Eggs' flawless geometric form, an everyday marvel of the natural world, inevitably makes them an attractive proposition to artists. As a receptacle of new life, they invite a symbolic connection with birth and creation. The ancient Egyptians referred to the egg as the origin of all existence in their Books of the Dead. Chinese and Hindu creation myths also feature eggs as the incubators of divinities or of the cosmos.

Piero della Francesca, *Madonna and Child with Saints, Angels and Federico da Montefeltro (Brera Altarpiece)*, 1472–74. Tempera on panel, 2.51 × 1.72 m (8 ft 2⅞ in. × 5 ft 7¾ in.)

Scholars have battled over the hidden symbolic meaning of this egg.

THE HIDDEN LANGUAGE OF FAITH

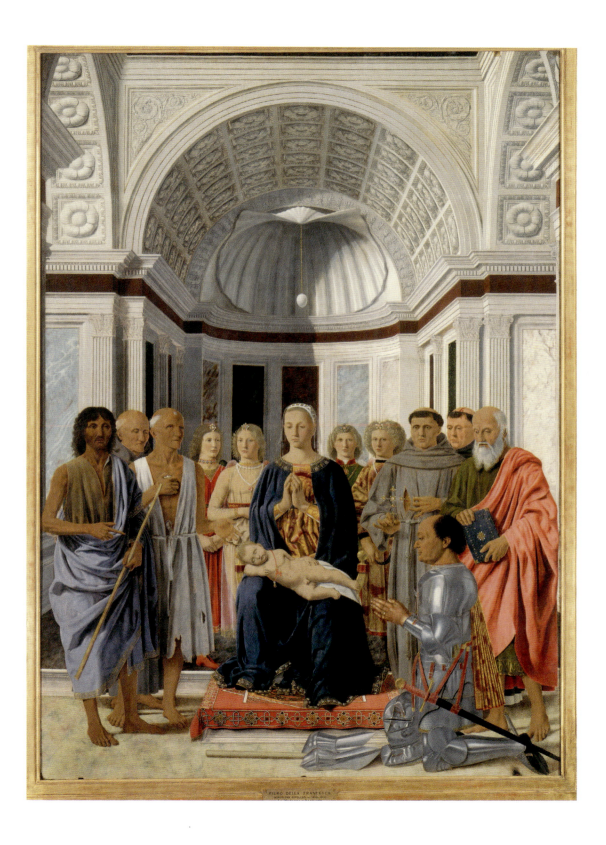

Ostrich eggs have long been prized by humans – hand-decorated examples discovered in South Africa are believed to be 60,000 years old.[27] Ostrich eggs found in Europe from the Bronze Age (around the fourth millennium BCE) provide evidence of ancient trading networks that connected the continent with the creature's natural habitat in the Middle East and North Africa. Among the most extraordinary examples come from Italian Etruscan tombs dating from the seventh century BCE, which are delicately inscribed with scenes of lotus buds, soldiers, wild beasts and sphinxes. For the Etruscans, the egg was a recurring motif in funerary art and symbolized the tomb: both were a seemingly solid and stony carapace that held a soul captive.[28]

This identification between eggs and rebirth did not become part of the mainstream iconography of Europe until the medieval period, when we first have evidence of people decorating and exchanging small bird eggs at Easter to symbolize Christ's rebirth. Eggs in religious art continued to be rare, and large, white ostrich eggs – such as the one hanging above Mary's head in the Brera Altarpiece – were rarer still.

However, ostrich eggs were owned by some churches, and were sometimes displayed alongside other exotic curios to amuse and delight congregations. The French theologian Bishop Durandus (1230–1296) wrote about this practice in his popular text *Rationale Divinorum Officiorum* (*c*. 1285–91). He also related a fanciful story that had originated in the *Physiologus*, an influential compendium of animal lore written in Alexandria in about 200 CE. Ostriches, so the legend goes, leave their eggs to incubate in the hot sand, and make them crack open by staring at them intently. This story had been developed in medieval bestiaries to suggest ostriches' hidden Christian significance, with the egg symbolizing the Christian soul, breaking open when exposed to the radiant gaze of the Lord.[29]

Durandus's observations are often cited to explain the Brera Altarpiece's centre-stage ostrich egg. Clearly, it does not support the interpretation that the egg represents either a classical myth or the quality of virginity, which some art historians have claimed.[30] Durandus provides two possibilities: either the egg is a non-symbolic rarity, on display to wow bored visitors to the church, or it is a symbol of divinely ordained spiritual rebirth. The second option feels like a plausible interpretation of the egg in the Brera Altarpiece, especially bearing in mind the

Vessel (decorated egg), Phoenician/Punic(?), 625–600 BCE. Ostrich eggshell, height 15.2 cm (6 in.)

Ostrich eggs were once symbolically linked to tombs.

THE HIDDEN LANGUAGE OF FAITH

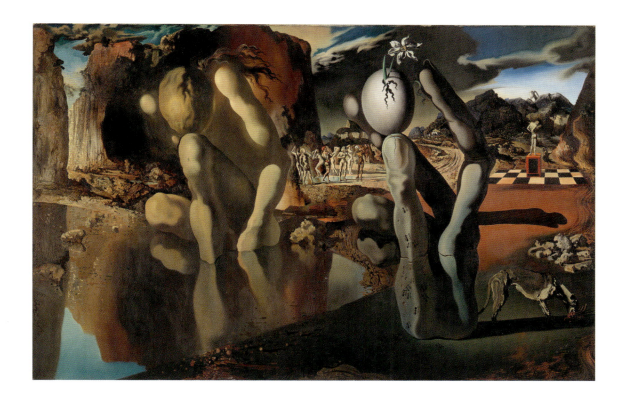

Salvador Dalí, *Metamorphosis of Narcissus*, 1937. Oil paint on canvas, 51.1 × 78.1 cm (20⅛ × 30¾ in.)

According to classical myth, the beautiful Narcissus fell in love with his own reflection and, unable to move from his spot, metamorphosed into a flower. In Dalí's painting, the figure on the left transforms into a hand holding an egg, from which blooms the narcissus flower.

painting's probable function to decorate Federico da Montefeltro's tomb. The reclining body of the infant Jesus, who is asleep but in a pose that foreshadows his later death and, by extension, his resurrection, reiterates the message.

But there is also a way in which the egg reflects the artist's, rather than the patron's, ideals. At the same time as painting the Brera Altarpiece, Piero wrote a treatise on art called *De prospectiva pingendi* (On the Perspective of Painting), which discussed such values as *disegno* (the artist's line drawn around solid objects), *commensuratio* (the arrangement of objects in the scene – composition) and *colorare* (the correct representation of colour as it responds to conditions of light and shade).[31] The Brera Altarpiece exemplifies these qualities, as well as Piero's artistic principles of equilibrium, proportional harmony and representing objects with volumetric accuracy. The egg, dangling above everyone, is the only organic object in the man-made environment, and seems to remind us of the minimalistic perfection of natural (and divinely ordained) design. As well as symbolizing spiritual rebirth, the egg effortlessly exemplifies Piero's own principles of formal clarity, balance and visual rightness.

Of Eggs and Origins

113

The Mystical, Multi-dimensional **Rabbit**

Federico Gonzaga (1500–1540) stood in his Mantuan Ducal Palace in early 1530, admiring a freshly unveiled Titian painting, now known to us as *The Madonna of the Rabbit*. There were many things that could have arrested his gaze: his own portrait in the guise of a shepherd; the lovingly rendered St Catherine and Christ Child; or Mary herself. However, for the duke, the most unusual, thought-provoking and poignant element of the painting would have been the white rabbit, sat peaceably upon the Virgin's robe.

Rabbits aren't an especially common symbol in European religious art. The reason for this lies in the Bible's attitude to the animal, which is very mixed, to say the least. Rabbits are referred to as impure creatures in the books of Leviticus and Deuteronomy, and only afforded faint praise in Proverbs and Psalms, where they are described as weak, but with a modicum of intelligence. It was much more common to see rabbits as symbols in classical mythology, as one of the many attributes of Venus, the goddess of love.[32] The reason that Federico Gonzaga was so moved by the rabbit in Titian's painting must stem from some alternative, non-biblical tradition of rabbit symbolism that was being made relevant to the Christian faith.

According to ancient naturalists, rabbits had two superpowers. The first, noted by classical authors including Aristotle (384–322 BCE) and Herodotus (*c.* 484–*c.* 425 BCE), was their ability to breed with astonishing and impressive rapidity. The second was the apparent capability of female rabbits to give birth without copulating, a feat that is now known as 'superfetation', the ability to develop an embryo from two separate menstrual cycles simultaneously. These impressive qualities ultimately led to two

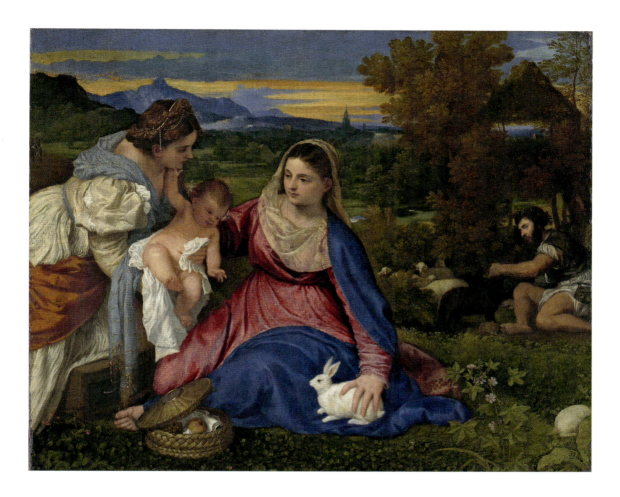

Titian, *The Madonna of the Rabbit*, c. 1520–30. Oil on canvas, 71 × 87 cm (28 × 34⅜ in.)

The symbolic meaning of the white rabbit in this painting is not immediately obvious.

mutually exclusive symbolic roles for rabbits: they are icons of both virginity and rampant fornication.

Whereas the link between Mary's virginity and a rabbit did not appear until the medieval period, the rabbit attribute of Venus was developed in antiquity. It is also believed that other pre-Christian religions in Europe used rabbits as symbols of fecundity. For example, they were a symbol of a Teutonic goddess named Oestra, whose key festival occurred in springtime. Modern-day traditions associated with the celebration of Easter, including the ubiquitous and otherwise unexplainable Easter Bunny, are sometimes traced back to Oestra and her ancient spring celebrations.

The Bible's characterization of rabbits as 'wise' is shared by many other non-western cultures, such as those developed by some Native American and Central African peoples, where rabbits are tricksters. It is also striking how

The Mystical, Multi-dimensional Rabbit

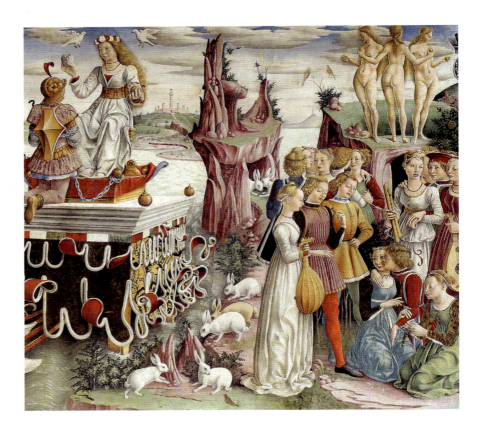

ABOVE Francesco del Cossa, *Allegory of April: Triumph of Venus* (detail), 1476–84. Fresco, overall 5 × 3.2 m (16 ft 4⅞ in. × 10 ft 6 in.)

In Cossa's Italian Renaissance allegory of the month of April, rabbits symbolize fecundity.

OPPOSITE Eliezer Sussman ben Solomon, panel with three hares, from a synagogue originally in Unterlimpurg, Germany, 1739

The 'three hare' symbol is an unexplained, cross-cultural phenomenon.

many disparate cultures from across the world link rabbits to the moon – an association no doubt inspired by the belief that rabbits are nocturnal.

Across cultures, rabbits are frequently interchangeable with hares in art. An intriguing puzzle in the study of this branch of symbolism is the circular 'three hare' motif that can be found in astonishingly wide-ranging locations across Eurasia. There are examples in English and French medieval parish churches, German synagogues from the eighteenth century, Islamic pottery from Egypt and Syria from the thirteenth century and terracotta plaques from the Swat Valley in Pakistan dating from the ninth century. The earliest surviving example is in the Dunhuang caves, Buddhist temples in China dating from the late sixth century CE. However, its origins are guessed to lie in ancient Indian religious beliefs and Buddhist tales of the 'hare of selflessness', making it a symbol of regeneration and prosperity.[33] The presence of the symbol across vast distances is irrefutable evidence of transcontinental cultural contact in the pre-industrial world. Exactly how those exchanges worked in practice is yet to be explained.

116 THE HIDDEN LANGUAGE OF FAITH

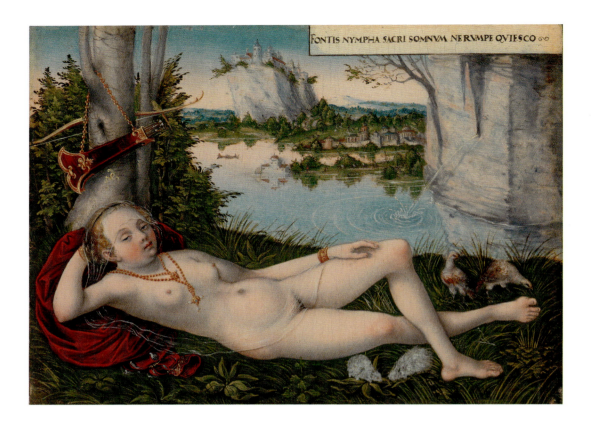

Lucas Cranach the Younger, *Nymph of the Spring*, c. 1545–50. Oil on beech panel, 15.2 × 20.3 cm (6 × 8 in.)

A later artist added the white rabbits to this scene, to symbolize fertility, lust and procreation.

So, what did the pure white rabbit in Titian's painting mean to Federico Gonzaga: was it the virginal rabbit of Christianity, or the fertile rabbit of classical and pagan mythology? The duke was thirty when he commissioned Titian, and not yet married. In 1528, his betrothal to Maria Paleologa (from the leading family of Montferrat) had been annulled, and at the time he commissioned and received *The Madonna of the Rabbit* in 1530 he was expecting to marry Julia of Aragon. However, in March of that year that contract, too, was annulled. It seems possible that the painting alluded to Federico's fluctuating matrimonial situation.

It could be that *The Madonna of the Rabbit* is a description of what Federico would consider ideal feminine qualities in a wife: the humble, pure virgin at the hearth. But it could also connote his desire to create an heir for the illustrious Gonzaga family, which would mean that the rabbit symbolized fertility and the regeneration of a dynasty.[34]

Could it be both at the same time? Take a look at the gaze of the shepherd, and judge for yourself.

The Covert Importance of **Goldfinches**

The Madonna of the Goldfinch was painted by the Italian Renaissance artist Raphael (1483–1520) as a wedding gift for Lorenzo Nasi, a Florentine wool merchant. In the eyes of the happy couple, celebrating their marriage in February 1506, the painting must have seemed like the epitome of visual simplicity and clear storytelling. There's a delightful absence of anything to distract the eye, compared to some of the overwrought religious art of the gothic and early Renaissance periods: just the streamlined setup of three figures (Mary, John the Baptist and Jesus) in a graceful landscape setting. It is a lot like the Brera Altarpiece (see **eggs**, pp. 110–13) in its minimalism, but also in its use of symbolism: like the egg in Piero's painting, the bird at the centre of Raphael's makes the modern viewer pause and think.

Goldfinches are a surprisingly common symbol in Italian Renaissance art, usually reserved for images – like Raphael's – of the infant Christ or infant John the Baptist with Mary. The scene is an appealing one even without the religious context: goldfinches used to be popular pets for children, and the birds anyway show off the fine handiwork of nature, with their vivid red masks and splash of yellow across their wings. However, when art historians attempted to trace the original significance of goldfinches in art of the medieval and Renaissance periods, they didn't find a neat, singular explanation. In fact, they discovered the opposite.

The earliest examples of art that combines the goldfinch with the infant Christ are sculptures made in France in the mid-thirteenth century.[35] Small birds, as well as **butterflies** (pp. 84–87), have long been associated with the human soul. The goldfinch's specific relevance to Jesus derives from a

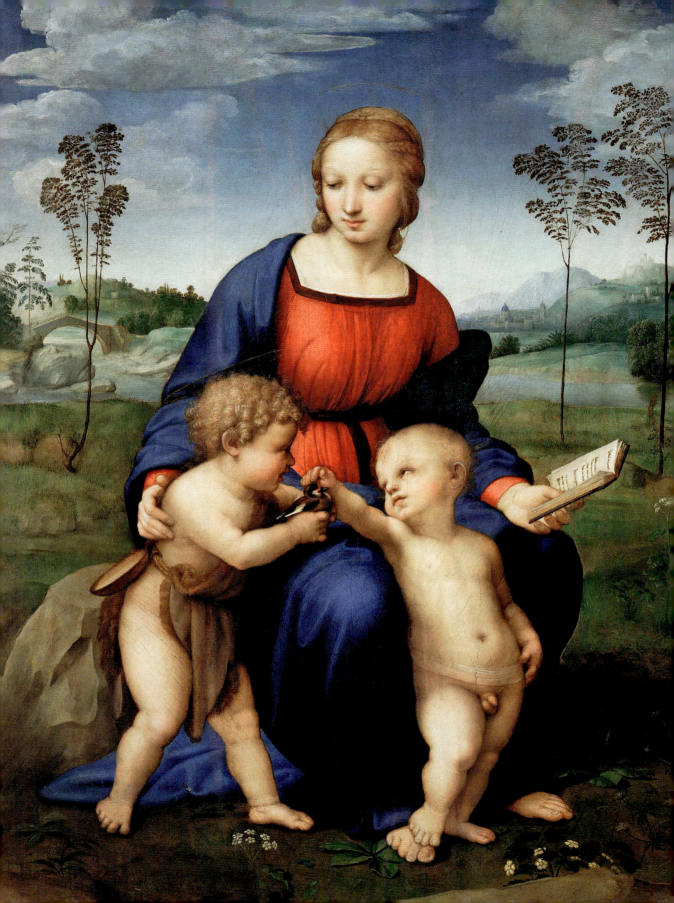

OPPOSITE Raphael, *Madonna of the Goldfinch*, 1506. Oil on panel, 107 × 77.2 cm (42¼ × 30½ in.)

Goldfinches appear in many depictions of the Virgin Mary and Christ-child.

BELOW LEFT Statue with Virgin and Child, North French, *c.* 1350. Ivory, overall (with base) 26.7 × 7.5 × 4.3 cm (10⅝ × 3 × 1¾ in.)

The earliest representations of Jesus and Mary with a goldfinch come from medieval French art.

BELOW RIGHT Carlo Crivelli, *Madonna and Child*, *c.* 1480. Tempera and gold on wood, 37.8 × 25.4 cm (15 × 10 in.)

Jesus protectively cradles a goldfinch away from a fly, symbol of sin.

medieval legend recounting how one had flown down to pluck a thorn off Jesus's crown during his crucifixion, and a drop of holy blood had caused the permanent red markings on its face. Although the origins of this legend are hard to pinpoint, the symbolism is palpable in many images, with the bird symbolically foreshadowing Jesus's torture.

However, in the 1940s, the American ornithologist Herbert Friedmann (1900–1987) traced a separate tradition linking goldfinches to the ability to cure illness.[36] This idea was initiated with Honorius of Autun's book of sermons *Speculum Ecclesie* of the early twelfth century, which describes a mythological bird called a chalandrius that could recognize disease in a human being. Later bestiaries, including a particularly famous one written by the poet Philippe de Thaon in 1119, furthered this story and eventually the capability of detecting disease was linked to the goldfinch. In a period when plague was a perennial threat, protective symbols like the goldfinch would have had great power in art.

The Covert Importance of Goldfinches

Carel Fabritius, *The Goldfinch*, 1654. Oil on panel, 33.5 × 22.8 cm (13¼ × 9 in.)

Fabritius's goldfinch feels like a piece of observed reality, but may have held a deeper symbolism for contemporary viewers.

Historian Evelyn Faye Wilson proposed a link between goldfinches and motherhood – a correlation she claimed was caused by a quirk of linguistics.[37] One of the Latin names for the goldfinch in medieval France was *lucinia*, which translates as 'bringer of light'. To the medieval mind, human history divided into the epochs of darkness and lightness, respectively the times before and after the arrival of Christ. The goldfinch was therefore appropriate as a symbol of the young Jesus. To compound the symbolism of the bird, Lucina was also a Roman goddess of childbirth. Thus, the goldfinch can be seen to attain a double appropriateness to holy mother-and-child scenes.

Even seemingly secular artworks from later periods that feature goldfinches may carry religious meanings. The Dutch artist Carel Fabritius's (1622–1654) famous painting of a goldfinch chained to a wall may seem like an uncomplicated snapshot of everyday life, but could also have signified so much more to a contemporary viewer who was more steeped in visual symbolism than we are today.

Rainbows: Art, Unity and Optimism

Symbols of earthly and divine power, such as **horses** (pp. 16–20), **falcons** (pp. 21–25) and **haloes** (pp. 78–83), are often unattainable, majestic, overawing or expensive. Rainbows are not like that: they are symbols of the heavenly bridging with the everyday. They are splendid but intangible, rare but not exclusive. Rainbows express religious faith, but on certain occasions also faith in the values of liberty, science and art.

Exhilarated by artistic inspiration, the painter in Angelica Kauffman's *Colour* (1778–80) dips her paintbrush directly into a rainbow. Kauffman

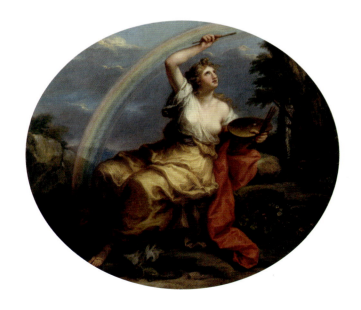

Angelica Kauffman, *Colour*, 1778–80. Oil on canvas, 1.26 × 1.49 m (4 ft 1⅝ in. × 4 ft 10½ in.)

A rainbow symbolically offers this female artist a natural cornucopia of colour.

123

(1741–1807) was a Swiss-born artist, and among the most successful female painters in the eighteenth century. She was a founding member of the British Royal Academy, one of only two women (and thirty-four men) to achieve such an honour. *Colour* was painted for the Council Rooms of the Royal Academy, and it summarized the teachings of its president, Joshua Reynolds (1723–1792), in concert with three other paintings: *Invention*, *Composition* and *Design*.

Kauffman's commission, with its requirement to devise allegories for uncommon subjects like 'colour', must have presented a challenge, and the artist was inventive with her depiction. The chameleon at the bottom of the image, for instance, is a rare piece of symbolism. But so too were rainbows in this context: they do not appear as an attribute of either 'painting' or 'art' in the *Iconologia* of Cesare Ripa (1555–1622), which was a major source of visual allegories at the time. Rather, the inspiration for the rainbow is likely to have been books on art theory published in the seventeenth century. Both Leonardo da Vinci's *Treatise on Painting* (which was written in the late fifteenth century, but only published in 1632) and Karel van Mander's *Het Schilder-Boeck* (1604) discuss rainbows as nature's lesson to artists on how to deploy colour, and especially how to shade tones seamlessly into one another.[38] The female figure in *Colour* is putting that theory very literally into practice as she gathers nature's hues for her palette. In her classical clothing she also looks very similar to the Greek goddess Iris who, as messenger of the gods, was represented with a rainbow in art, arcing from the heavens to the earth.

This characterization of the rainbow is present in innumerable global belief systems, including Hebrew and Christian scripture: God placed one in the sky in the aftermath of the Great Flood to show Noah that he would never purge the world in the same way again. Rainbows are also a feature of Christian paintings of the Last Judgment, where it functions as a throne of Jesus, following a description in the Book of Revelation.

In the post-Renaissance world, rainbows also became a subject of logical scrutiny. The French philosopher René Descartes (1596–1650) explained the conditions required for rainbows to appear, based on the journey of a beam of light when it enters and exits water. Yet Descartes' insights, which seem purely scientific, may themselves have been inspired by art.

In 1610 a visitor to the Villa d'Este in Tivoli, Italy, described a man-made fountain, deliberately placed in relation to the sun and designed to generate enough mist to conjure an artificial rainbow. It was one of a number of newly invented 'rainbow fountains', designed to delight audiences with nature's wonders.[39] In the Renaissance, hydrotechnological skills improved rapidly,

Pierre-Narcisse Guérin, *Morpheus and Iris*, 1811. Oil on canvas, 2.51 × 1.78 m (8 ft 2⅞ in. × 5 ft 10⅛ in.)

The mythological Iris, messenger of the gods, is often represented in conjunction with a rainbow to symbolize the heavens connecting with the earth.

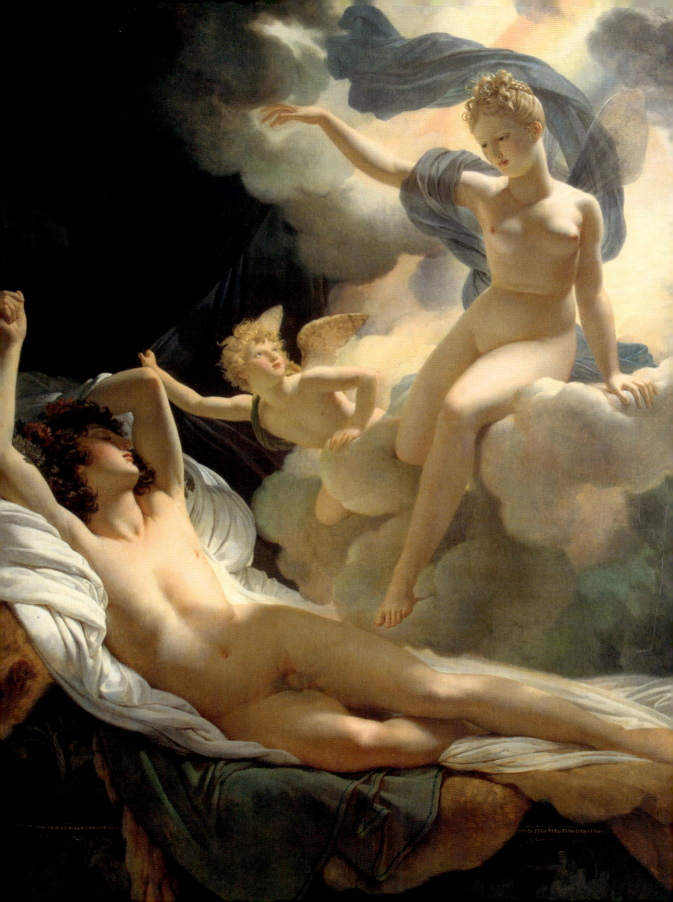

leading to many better designed and more ornate fountains in Europe's public squares and palatial gardens (see pp. 200–205). Descartes's analysis of rainbows was dependent on his ability to study these recently conceived fountains and investigate the angles at which the light and the spectator had to co-ordinate for a rainbow to exist.[40]

As we now know, you can only see a rainbow if you are standing with your back to the sun and with water droplets in the air in front of you. When the sun is no higher than 42 degrees above the horizon line, it is reflected within the spherical droplets. The refraction when it enters the air again makes white light visible as a spectrum of colour.

It was Isaac Newton (1643–1727) who first articulated the idea that a spectrum of colour is contained within all white light. Newton's insistence on the presence of seven colours (where there is actually an infinity of gradations) affected Kauffman's eventual representation of the rainbow at the end of the eighteenth century, which has seven clear hues.

A rainbow flag is most famous nowadays as an emblem of the LGBTQ community, invented by the US gay rights activist and drag queen Gilbert Baker in 1978. The flag was principally adopted because of its strong graphic identity, although it possesses all the qualities that have always attracted artists and designers to rainbows – its rarity, its optimism and its suggestion of the unity of diverse but collectivized elements. As Baker himself commented about the rainbow, 'it's a natural flag – it's from the sky!'[41]

Rainbows are a democratic symbol, belonging to nobody and everyone, being made of light rather than solid substance. In art they demonstrate how a symbol can mutate through history from representing the miraculous to the mechanical, and from inspiration to sexual identity. It shows us the changing places that society puts its faith: from religion to culture, from science to the freedom of expression.

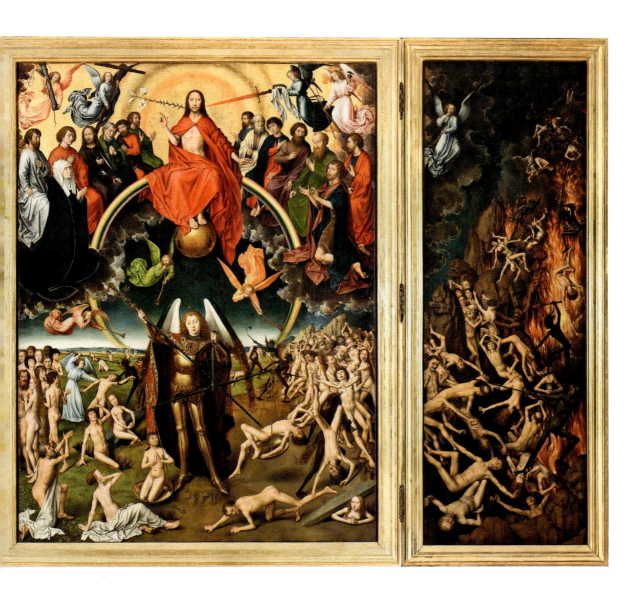

Hans Memling, *The Last Judgment*, 1467–71. Oil on wood, 2.21 × 1.61 m (7 ft 3 in. × 5 ft 3 3/8 in.) (central panel), 223.5 × 72.5 cm (88 × 28 5/8 in.) (each wing)

The heavens and earth are also connected in Christian art with a symbolic rainbow, throne of Christ in judgment.

Rainbows: Art, Unity and Optimism

Holy Grail, Holy **Grapes**

The Antioch Chalice, Byzantine, 500–550 CE. Silver, overall 19.6 × 18 × 15.2 cm (7¾ × 7⅛ × 6 in.)

This cup, once believed to be the legendary Holy Grail, is festooned with grapevines.

Chicago's 1933 World's Fair was a pageant of modern inventions and dazzling entertainments, including modernist architecture, rollercoaster rides and mechanical dinosaurs. But one of the most hotly discussed (and more serious) marvels on display was the 20-centimetre (8-inch) tall, 1,300-year-old Antioch Chalice. The alleged stories about the chalice would have drawn visitors to examine the cup's gilded silver surface in close and silent awe, to study the beautifully sinuous network of grapevines that framed various figures and animals, including Jesus, his disciples, a rabbit and an eagle. Most of them would believe that they were looking at the true Holy Grail – the sacred wine cup, credited with magical properties, that Jesus Christ used during the Last Supper.

Grapes, grapevines and wine are all fundamental to Christian iconography and the Bible makes numerous references to them, most famously in the words of Jesus himself: 'I am the true vine' (John 15:1). Throughout the Bible, grapes consistently allude to fertility: the wine connotes lifeblood and the vine loyalty. In the Christian rite of the Eucharist, wine and bread are consumed in commemoration of the miraculous events of Last Supper, where Jesus shares his cup of wine and proclaims 'This is my blood of the covenant ... I will not drink from this fruit of the vine from now on until that day when I drink it new with you in my Father's kingdom' (Matthew 26: 28–29). In countless Christian paintings, and in the architectural decoration of thousands of churches

Gerard David, *The Rest on the Flight into Egypt*, c. 1510. Oil on panel, 41.9 × 42.2 cm (16½ × 16⅝ in.)

The grapes in this painting foreshadow the Last Supper, and wine symbolizes the blood of Christ.

worldwide, grapes (often in conjunction with sheaves of corn, to stand for the bread of the Eucharist) symbolize Christ and his resurrection. Grapes also feature in the books of the Old Testament – Genesis 49:22, Numbers 13:23, Isaiah 63:3, to name but a few. In fact, grapes are the most frequently mentioned fruit in the Bible. Why?

Grapevines were originally cultivated by humans between the 4000s and 6000s BCE in the Caucasus (where modern-day Georgia, Armenia, Azerbaijan

Holy Grail, Holy Grapes

ABOVE Fragment of a tomb relief with Christ giving the Law, Byzantine, late 4th century CE. Marble, 49.5 × 134 × 15.2 cm (19½ × 52⅞ × 6 in.).

A festoon of grapevines decorate the top of this early representation of Christ.

BELOW Interior of the tomb of Sennefer, Thebes, Egypt, 18th dynasty, c. 15th century BCE

The vines and grapes in this Egyptian tomb symbolize life after death.

and regions of Southern Russia lie), and over the subsequent millennia were gradually propagated across the Mediterranean region.[42] The impact of viniculture on religious beliefs in these regions was profound. In ancient Egypt, grapevines were linked to Osiris, the god of agriculture and the afterlife. In ancient Greek culture, they were linked to Dionysus (known in Rome as Bacchus), the god of wine, fertility and festivity. Like Osiris, Dionysus/Bacchus was a god who died and was reborn. It seems likely that the common association between grapes and resurrection echoes the yearly ritual of winemaking: the vine is barren through winter, but always comes back to life in spring; the grape is crushed underfoot, but then rematerializes as wine. Wine's alcoholic effects were also linked to religious ecstasy, and its dark red colouration is naturally suggestive of blood, the sacred and mysterious liquid of life itself.

The death-and-rebirth symbolism of grapes is made most evident in burial sites: Egyptian tombs were sometimes decorated with vine motifs, as were sarcophagi from Italy – at first from Etruscan burials (in the first millennium BCE), and then in the Roman empire (from the first century BCE). In the classical period, grapevines were also a common decorative emblem for scenes representing Dionysus/Bacchus, as well as a decorative feature for monuments and architectural detailing. Wherever the empires of these times stretched, so too did grapevine emblems. They appear in sculptures made across the Roman empire, from North Africa to northern Europe and the Middle

Hans Memling, *Virgin and Child with Saints Catherine of Alexandria and Barbara*, early 1480s. Oil on wood, 67 × 72.1 cm (26½ × 28½ in.)

The grapevine arbour was a later symbolic addition, perhaps to satisfy the growing popularity of the rite of the Eucharist at the time.

East, and even as far as Gandhara, in modern-day Pakistan, which had been introduced to Greek culture after the eastward invasions of Alexander the Great in 327 BCE.[43]

In Roman Europe, Christianity took root in the fourth century. Stonemasons and artists making decorations for this burgeoning religion could take the grape motifs from their copybooks (which had previously illustrated Bacchic festivities) and repurpose them to illustrate scenes with Christian meanings. The design of the Antioch Chalice, for example, was copied from a widespread motif in Roman sculpture that set figures and birds in among interweaving vines.[44]

The claim that the Antioch Chalice is the Holy Grail has since been debunked by academics. Yet the popular fascination with the legend of the Grail and its connection to the symbolism of divinely blessed wine, grapes and vines shows that ancient legends, beliefs and behaviours die hard, even in the modern world.

Holy Grail, Holy Grapes

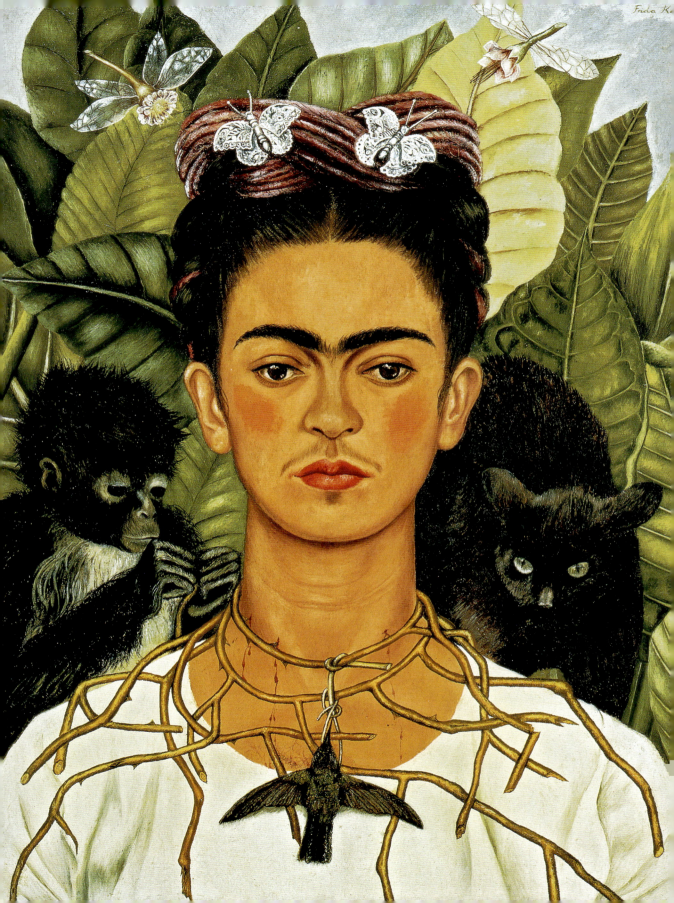

THE HIDDEN LANGUAGE OF UNCERTAINTY

When Frida Kahlo (1907–1954) painted *Self-Portrait with Thorn Necklace and Hummingbird* in 1940, she was suffering from various medical complications and the fallout of her divorce from her artist husband, Diego Rivera (1886–1957). Kahlo expressed these experiences of emotional and physical pain through symbolic objects and animals in her painting. They represent a mixture of iconographic traditions: hummingbirds, for example, were sacred to the Aztec god Huitzilopochtli, associated with war and human sacrifice,[1] and the thorn necklace seems to be a reference to Jesus's crown of thorns, commonly represented in European art. Kahlo, daughter to an indigenous Mexican mother and a German father, was heir to a hybrid of cultural reference points, and had taken possession of symbols from both backgrounds to give a powerful voice to her emotional distress.

As the previous two sections have shown, symbols are an essential means of uniting people behind systems of power and religious faith. This section's emphasis is on icons of people's sense of uncertainty, sorrow, sin and evil. In many cases, as with *Self-Portrait with Thorn Necklace and Hummingbird*, this has been to expurgate negative feelings and take control of a sense of trauma. But in other examples (such as with owls and swastikas), symbolic images have fulfilled a much more negative role, consolidating feelings of discrimination and persecution against minorities.

All the examples that follow are symbols that have survived through history. From their point of origin (such as ancient Egypt, Mesopotamia, Greece, Rome or Mesoamerica), many were revived or further developed in the medieval period and the Renaissance. In new historical contexts, their

Frida Kahlo, *Untitled (Self-Portrait with Thorn Necklace and Hummingbird)*, 1940. Oil on canvas mounted to board, 62.5 × 48 cm (24⅝ × 19 in.)

In this and other paintings, Kahlo used a symbolic language to communicate suffering.

RIGHT Serpent labret, Aztec, 1300–1521 CE. Gold, 6.7 × 4.4 × 6.7 cm (2¾ × 1¾ × 2¾ in.)

In Aztec culture, snakes were considered mystical and powerful, but in other cultures they are a symbol of sin.

BELOW Man Ray, *Ce qui manque à nous tous*, 1963. Clay pipe with glass ball, 37.5 × 20.3 × 8.9 cm (14¾ × 8 × 3½ in.)

Bubbles are a long-standing symbol of the brevity of life.

OPPOSITE Albrecht Dürer, *Adam and Eve*, 1504. Engraving printed in black ink on laid paper, 26.4 × 20.3 cm (10½ × 8 in.)

A cat is a symbol of sin in Dürer's engraving.

relevance and meaning has adapted, and most of them continue to be recognizable in the present, whether that be in art, folklore or popular culture. For example, the stories behind the modern meaning of poppies and swastikas demonstrates a revival of extremely ancient symbols.

Some of the symbols in this chapter tap into our primordial fears. There are reminders of the shortness of life and the inevitability of death, such as skulls, scythes and bubbles. Other anxieties are represented too, such as how the powers of a spirit world could be accessed through a mirror, the intrusive power of surveillance as represented by an eye, and the claustrophobic threat of a labyrinth. It may come as a surprise that some of the symbols in this section were ever considered evil. Yet in the past and in different cultures, owls, cats and foxes were all creatures of the devil, summoned into works of art to evoke sinister forces. A few of the symbols in this section are only considered fearful in certain contexts. Snakes exemplify this most emphatically. In the wild, they provoke a dramatic fear/fascination response in humans and are therefore a highly ambivalent symbol in culture: awesome in positive and negative senses, but predominantly a symbol of evil in the Christian west.

THE HIDDEN LANGUAGE OF UNCERTAINTY

Black **Mirrors**

In the past, people did not look at mirrors in the same way as we do today. Whereas nowadays we treat them as tools of utility when driving or applying makeup, mirrors were once items of utmost rarity, and they were believed to be magical. This is captured in the word itself. 'Mirror' in English stems from the Latin *mirare*, which is also the root of the word 'miracle'. At many times in history, mirrors were believed to connect us with the realm of spirits – either as portals for communicating with an otherworldly realm, to repel evil essences, or to aid the human life-force through the underworld. The design of mirrors incorporated these symbolic associations, and artists have frequently been fascinated with them as subjects. They also do the same semi-divine job as an artist, of recreating the visual world.[2]

The earliest manufactured mirrors to have been discovered come from tombs in the Neolithic settlement of Çatalhöyük in Turkey, dating from around 6000 BCE. Burying the dead with mirrors is a mysteriously common trait in human cultures, practised by ancient Egyptians, Etruscans, Celts and Scythians, as well as the ancient Chinese and Japanese. Why was this such a popular practice?

For the ancient Egyptians, it was a matter of prestige as well as spirituality. Egyptian craftsmen developed the technology to make bronze mirrors from around 2900 BCE. As well as being simple tools for applying cosmetics (used by men as well as women), mirrors were considered magical. The Egyptian word *ankh* means 'life', but it also means 'mirror'.[3] When mirrors

OPPOSITE Bronze mirror with face of Hathor, Egypt, New Kingdom. Bronze, height 21 cm (8⅜ in.)

For the ancient Egyptians, mirrors had magical connotations.

ABOVE Mirror with four spirits and companions, China, Han dynasty, 206 BCE–220 CE. Bronze, diameter 19 cm (7½ in.)

In Han China, mirrors were prestige objects, and some had intricate designs, such as this stylized map of the universe, on the reverse.

were buried with the dead, it was partly because they were an expensive item that would be useful in the afterlife – but mirrors were also sometimes mummified like human bodies. At other times, they were explicitly dedicated to the deceased person's *ka*, or spirit.

In China, mirrors were also considered magical and signalled good fortune. It is likely that bronze mirrors were manufactured in the region from the third millennium BCE, with particularly sophisticated and beautiful examples being produced from the Han dynasty (206 BCE–220 CE). At this time, the reverse side of the mirror would be decorated with personalized emblems showing religious stories or creating a mandala – a diagram of the cosmos. Mirrors were buried alongside their owners because it was believed that they could guide the dead safely to the otherworld.

Why were mirrors thought to be so powerful? The highly developed attitude to mirrors in the Americas provides some insight. The earliest ones were made by the Olmecs of Mexico between around 1200 and 1000 BCE,

Black Mirrors

BELOW John Dee's magical mirror, 14th–16th century(?). Obsidian, wood and leather, diameter 18.4 cm (7¼ in.)

Dee used his obsidian mirror for occult purposes.

OPPOSITE John William Waterhouse, *The Lady of Shalott*, 1894. Oil on canvas, 142.2 × 86.3 cm (56 × 34 in.)

Superstitions surrounding mirrors persisted for centuries: according to Alfred Lord Tennyson's poem, the Lady of Shalott's death is portended by her mirror cracking from side to side, immediately after she sees Sir Lancelot in it.

but later peoples, such as the Mayans, perfected their manufacture from pyrite, iron ore and haematite. They are thought to have been symbols of the elite class, who used them for 'scrying' by reading reflected images and thus contacting the spirit world. For the Maya, the glinting light reflected off a mirror was a sign of life, equated with the shininess of the human eye. Mirrors, like eyes, were the threshold to an inner life and could be read only by shamans and kings.[4]

The English occultist, mathematician and astronomer John Dee (1527–1608) owned an Aztec mirror, which he called his 'shew-stone'. He attempted to use it like the Mayans and Aztecs had, to communicate with the spirit world. His mirror had arrived in England from the New World following the Spanish invasion of the continent. It was one of several artefacts brought back by the conquistadors (including **sunflowers**, pp. 243–47, and **pearls**, pp. 252–57) that would have a lasting impact on the imaginations of European scholars, writers and artists.

However, there was an existing, sometimes paradoxical symbolism attached to mirrors in the Old World. They could be used allegorically of the sin of vanity, but also the virtues of truth and purity (an extension of the earlier use of a mirror as an attribute of the goddess Venus to indicate her supreme beauty). Mirrors were also used for fortune-telling, although such practices were officially banned by the Church.[5]

138 THE HIDDEN LANGUAGE OF UNCERTAINTY

OPPOSITE Joan Jonas, *Mirror Piece I*, 1969. Chromogenic print, 101.6 × 56.5 cm (40 × 22¼ in.)

Jonas devised uncanny distortions of the human body using mirrors in this performance piece.

ABOVE Adrian Paci, *Per Speculum (Girl)*, 2006. Colour photograph, 80 × 120 cm (31½ × 47¼ in.)

The nature of perception is the subject of Paci's video piece. In a bucolic landscape a group of children smash a large mirror, and then each child takes a fragment and sits in a tree, making it pulsate with light.

In Japan, mirrors have a similarly ambiguous symbolism: they could attract evil spirits, but they also had the power to repel them. When Amaterasu, the Shinto goddess of the sun, appointed her grandson as the ruler of Japan she gave him a holy mirror so that he always had access to divine light.[6] This very mirror is one of the Three Sacred Relics of Japan, and it is still used in the investiture ceremony of the emperor.

In the Enlightenment period (from around the eighteenth century), scientific rationalism increasingly displaced superstitions, and thus the symbolic potential of mirrors receded. In tandem came the improvement of mirror-making technology, first in the form of silvered mirrors in the sixteenth century, then their mass-manufacture in the nineteenth. New, crystal-clear mirrors had none of the suggestive haziness of their ancestors. It was the end of the miraculous life of mirrors: what had once been invested with magical powers in art was now relegated to the role of a humdrum tool.

Black Mirrors

The Rise of the **Skull**

BELOW Michael Wolgemut, *Dance of Death*, leaf from *The Nuremberg Chronicle*, 1493. Woodcut and letterpress text, 46 × 31.7 cm (18⅛ × 12½ in.)

A woodcut print depicting the 'Danse Macabre'.

A human skull in signage, logos and works of art is about as straightforward as a symbol gets. It is instantly understandable as an emblem of death across every nation and culture.

It is also an example of iconography that crosses over the divide between art and daily life – skulls can be observed in Dutch still-life paintings and electricity substations, Shakespeare's *Hamlet* and on a packet of rat poison. Yet while it may seem obvious, perhaps even inevitable, that a skull should be the universal signifier of mortality, this hasn't always been the case. In fact, this modern western symbolic convention owes its existence to a pivotal art commission from 1424.

The desolate Cemetery of the Holy Innocents, set right in the heart of Paris, was the final resting place of most poor citizens in the city in the Middle Ages. Space was severely limited, so it was customary that the dead were only buried for as long as it took for the flesh to decompose, at which point the bones were dug up and stacked in a purpose-built structure known as a charnel house. This repository of skulls and other ossified bones inspired a new genre of painting, known as the 'Danse Macabre'.[7]

A Danse Macabre is a scene showing skeletons cavorting with citizens from all social classes – lords, peasants, children, even the Pope himself – to show death as the great equalizer. Such was the popularity of the image that it was copied and reproduced elsewhere. Before the end of the

PAGE 143 Jan Gossaert, *Carondelet Diptych* (verso), 1517. Oil on wood, 53 × 37 cm (20⅞ × 14⅝ in.)

This skull painted on the back of the portrait miniature of Jean Carondelet, archdeacon of Besançon Cathedral in France, served as a reminder of humility.

ABOVE Bernt Notke, *Danse Macabre*, late 15th century. Oil on canvas, 1.6 × 7.5 m (5 ft 3 in × 24 ft 7¼ in.)

A painted 'Danse Macabre' involving the wealthiest members of society.

century, versions of the Danse Macabre could be found in the far distant cities of Lübeck (Germany), Tallinn (Estonia) and Hrastovlje (Slovenia).

It is true that skeletons and skulls appeared in art from before this – examples exist from Roman times, for example. In Christian art, skulls were depicted at the base of the cross, because in the Gospel of St Mark the site of Christ's burial, Golgotha, was named 'the place of the skull'. Non-biblical writings subsequently identified this same place as the burial site of the first man, Adam. Byzantine art began to feature Adam's skull beneath the cross, with Christ's blood dripping onto it to absolve the first man's sins, from at least the seventh century CE, and western Christian art followed this iconography from a slightly later date, possibly by the tenth or eleventh centuries.[8] But generally speaking, skulls were rare in western art until the fifteenth century, and they flooded mainstream visual culture in the sixteenth.

Danse Macabre scenes were popular because they could be read on more than one level depending on the viewer: as sinister spectacles satirizing the wealthy, protests against materialism or rallying cries to 'seize the day'.[9] The culminating masterpiece of the genre was Hans Holbein's (1497–1543) *The Dance of Death*. Each image from this brilliant series of woodcut prints shows a different class of citizen being boisterously tormented by a deathly skeleton.

The sixteenth century witnessed an increasing interest in gruesome themes inspired by the Danse Macabre. There was a fad for miniature ivory sculptures and prayer beads of decaying human skulls, designed for the pious to perpetually reflect upon their mortality. Albrecht Dürer (1471–1528), one of the Renaissance's greatest artistic geniuses, mentioned purchasing one of these trinkets in his journal. The skull was well on its way to becoming an iconic symbol in art history.

There is some dispute about why this morbidity in visual culture emerged at this particular time in Europe. Was it connected with the Black Death, which took hold in 1346 and is estimated to have wiped out a third of the continent's population? Was it linked to the mass deaths of the Hundred

Years' War, or the generally low life expectancy of the period? Or the frequent spectacle of public executions?

An alternative view is that it may have been a response to an escalation in wealth rather than death. As capitalism emerged in Europe, new middle-class citizens became increasingly affluent, and avid consumers of luxury goods. This made people from all levels of society rethink the extent to which pursuing worldly pleasures was compatible with a good Christian life. The wealthy themselves experienced a sense of guilt in their newfound riches. *Memento mori* (reminders of death) were tokens of their humility.[10]

Nowhere was this demonstrated better than the prosperous, mercantile, Protestant Dutch Republic, where 'vanitas' paintings were extremely popular. Vanitas scenes built upon the *memento mori* theme – this time in the form

Memento mori floor mosaic, Pompeii, Italy, *c.* 1st century BCE

This mosaic, once on the floor of a Roman dining room in Pompeii, is an ancient reminder of the inevitability of death.

The Rise of the Skull

145

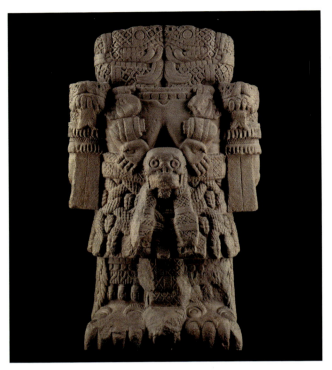

ABOVE LEFT Coatlicue statue, Aztec, Mexico, c. 1500. Basalt, height 2.57 m (8 ft 5¼ in.)
Skulls were a frequent theme in representations of the fearsome Aztec goddess Coatlicue.

ABOVE RIGHT A Guardian of Shiva, Karnataka, India, 13th century. Chloritic schist, overall 113.3 × 49.2 × 29 cm (44⅝ × 19⅜ × 11½ in.)
A snake slithers through the eye socket of the skull of Brahma, impaled on a staff to demonstrate Shiva's powers.

OPPOSITE Allegory of death, known as *La Mort Saint Innocent*, c. 1520–30. Alabaster, 120 × 55 × 27 cm (47¼ × 21¾ × 10¾ in.)
A representation of death from the Cemetery of the Innocents in Paris.

of still-life paintings, usually with a skull as the centrepiece. Yet skulls were also becoming more widespread in representations of religious figures in Catholic countries too, in the hands of death-contemplating saints like Mary Magdalene, St Jerome and St Ignatius of Loyola.

Skulls played a prominent role in non-western art too. They are a common motif in Mesoamerican sculpture: a monumental sculpture of Coatlicue from Mexico City's National Museum of Anthropology is a famous example. Coatlicue, the mother goddess, is represented with a skull on a necklace along with severed human hands and disinterred hearts. Some Indian deities, such as Kali, Durga and Bhairavi, are also shown with necklaces or headdresses festooned with skulls – albeit often for life-affirming reasons, such as to show conquest over death and the destruction of one's attachment to ego.

After the Spanish conquest of the Americas in the sixteenth century, many Aztec sculptures, including the monolithic Coatlicue, were buried by the invaders, who considered their iconography (including **snakes**, pp. 174–78, and spilled blood as well as skulls) diabolical. All these elements were readily visible in Christian art, but to the conquistadors, seeing the symbols in an unfamiliar context, they were beneath contempt.

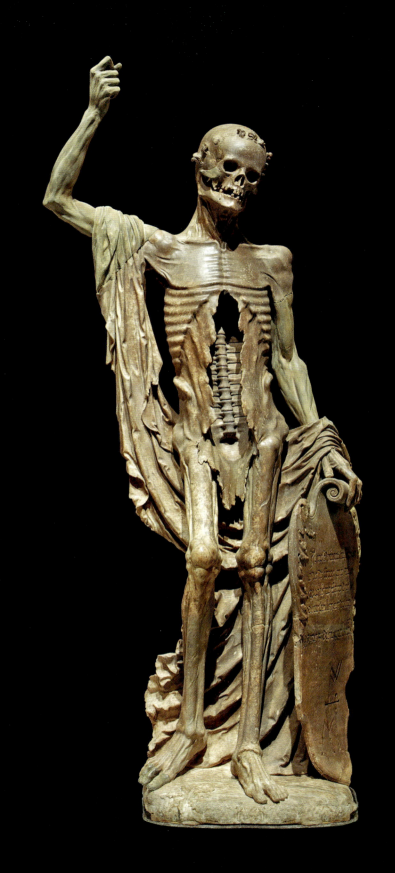

Wise **Owl**?

Going on the evidence of Disney movies and *Harry Potter*, owls are friendly, perhaps fusty, but above all intelligent birds. The 'wise old owl' is an example of popular animal symbolism that goes unquestioned in everyday life.

The association is very strange. Especially so if you look back at the way owls have appeared symbolically in culture in the past, because they were largely used to represent ignorance, as well as a host of other unpleasant qualities, such as darkness, evil and uncleanliness.

The Burney Relief, a sculpture from Babylon dating from the nineteenth century BCE, shows a goddess flanked by owls. They are believed to demonstrate her sinister qualities, connecting her with misfortune and evil. One scholar has suggested that the relief may have served as an altar at an ancient brothel.[11] We don't know conclusively which of the ancient Mesopotamian goddesses this represents, although likely candidates are Ishtar, Lilith or Ereshkigal. If it is Lilith, this would corroborate with her characterization as a demon-goddess in the Hebrew Bible (Isaiah 34), where she is mentioned as having an owl companion. The Book of Psalms (102:6) furthered this damning verdict of owls, influencing subsequent generations to see them as semi-satanic inhabitants of darkness and wastelands.

Medieval European bestiaries (books that compiled knowledge of animals and their symbolism, often accompanied by images) therefore tended to show owls as creatures of the shadows, with an eerie, funereal hoot. This characterization was backed by the attitudes of revered Roman writers like Pliny the Elder (d. 79 CE) and Ovid (43 BCE–*c.* 17 CE), who emphasized the owl's unpopularity among humans, its shrieking voice and role as harbinger of bad

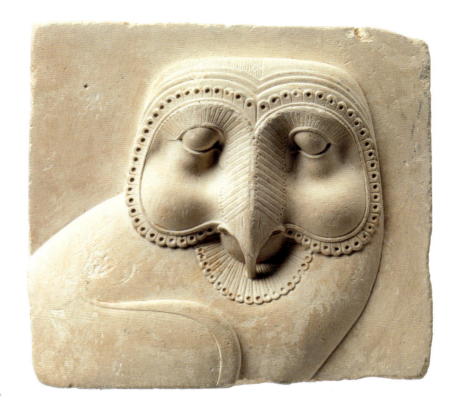

RIGHT Relief plaque with face of an owl hieroglyph, Egypt, Late Period–Ptolemaic Period, 400–30 BCE. Limestone, 10.3 × 11.1 cm (4 1/8 × 4 3/8 in.)

An ancient Egyptian representation of an owl, a bird usually associated with grief and death.

BELOW Figure of an owl, Peru, 3rd–6th century CE. Bone and cinnabar, height 4.1 cm (1 5/8 in.)

The Moche people of Peru probably worshipped owls for their skills in hunting prey.

luck. Bestiaries frequently show owls as grotesque and ignorant creatures of darkness, who would be attacked by the other birds if they dared to appear in daylight. The Latin for owl was *bubo*, a word that in Greek means a swelling of the groin, and a symptom of plague. As such, owls also became unfairly associated with dirt and disease.

Based on these wholly negative associations, owls became a symbol of cruelty and prejudice. This is captured in the imagery of woodblock prints made in England in the sixteenth and seventeenth centuries in which marginalized Jewish, Catholic and Puritan communities were connected with the bird to emphasize their impurity.[12]

At least one civilization, from a land far distant from England, was obsessed with owls. The Moche people, who thrived on the western edge of Peru between about 200 and 900 CE, saw in these nocturnal birds something powerful and godlike, and they frequently represented them on ornaments, weapons and drinking vessels. It is believed that the Moche venerated the owl's unparalleled ability to operate in the night, hunting and devouring lesser creatures with a surgical efficiency.

Wise Owl?

RIGHT Salvator Rosa, *Scenes of Witchcraft: Day*, c. 1645–49. Oil on canvas, diameter 54.5 cm (21½ in.)

Rosa has depicted owls as the witches' mode of transport.

BELOW Attributed to the Brygos Painter, *lekythos*, Greek, c. 490–480 BCE. Terracotta, height 32.7 cm (12⅞ in.)

Athena, accompanied by an owl of wisdom.

OPPOSITE The Burney Relief, Old Babylonian, Iraq, c. 19 century BCE. Fired clay, 49.5 × 37 cm (19½ × 14⅝ in.)

The owls were intended to be symbols of sinister powers in this sculpture.

So, how did the owl come to represent wisdom in the west?

The answer comes from the classical world. In Greece, artists started to include owl designs in sculpture, on drinking cups known as *skyphoi*, and on Athenian *tetradrachm* coins from the sixth century BCE.[13] It is possible that the Greeks considered the owl to be a protective, apotropaic creature who could repel the evil eye. Slightly later, Athena, the goddess of tactical warfare and patron goddess of the city of Athens (to whom she gave her name), also began to be represented in art with an owl as an attribute.

The owl-decorated coinage and *skyphoi* were traded far and wide, disseminating the symbol (and its later association with the wise goddess Athena) across the Hellenic world.[14] During the Renaissance, many features of the classical past were revived (see **laurel wreaths**, pp. 40–44), including their iconography. From that point onwards, owls were less frequently depicted in culture as dirty, benighted creatures of misfortune and disease, and became the bird of knowledge. So whenever you see a Hollywood film presenting the owl as elderly and wise, you are witnessing the faint echoes of an idea that was forged in a Mediterranean city in the sixth century BCE.

Cat Lovers: Don't Read This

Cats, like **falcons** (pp. 21–25), feature in art as mediators between the human and animal kingdoms. They are more inclined towards independence than **dogs** (pp. 232–37); as Rudyard Kipling put it, cats are 'not a friend … and not a servant'[15] to their human companions. Like dogs, however, cats are sometimes seen as a link to the gods, but they are represented as allies of both evil and good forces: they are the slayers of foes in some cultural depictions, but the emissaries of evil forces in others; they can heal and read the future, but can also imply bad luck.

Around 8000 BCE, humans began to domesticate livestock and cultivate crops in the region known as the 'Fertile Crescent', which stretches from the Nile in Egypt to the Tigris and Euphrates in Iraq. The surplus grain and cereals harvested by these early farmers were always subject to interference from pests. Over time, the local wildcats learned that a ready supply of rodents could be caught in these stores. Their behaviour adapted to hunt in these conditions, and meanwhile humans began to realize their potential as pest-control. It was the beginning of a 10,000-year love affair between cats and people, and what one scientific paper has called 'one of the more successful "biological experiments" ever undertaken'.[16] Over time cats adapted their wild ways, and humans learned how to cohabit with them, enabling the development of the domesticated cat – *Felis catus*.

Ancient Egyptian art captures the transition of cats from wild beasts to domesticated pets. Bastet, a cat goddess who had previously only been depicted as wild, was given a new, tame persona during the Middle Kingdom (*c.* 1500s–1000s BCE). Many later statuettes in the form of elegantly poised

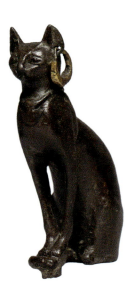

BELOW Bronze cat statue, Egypt, 26th dynasty or later, 664–30 BCE. Bronze and gold, overall 9.2 × 2.3 × 5.5 cm (3⅝ × 1 × 2¼ in.)

An offering to Bastet, the Egyptian cat deity.

THE HIDDEN LANGUAGE OF UNCERTAINTY

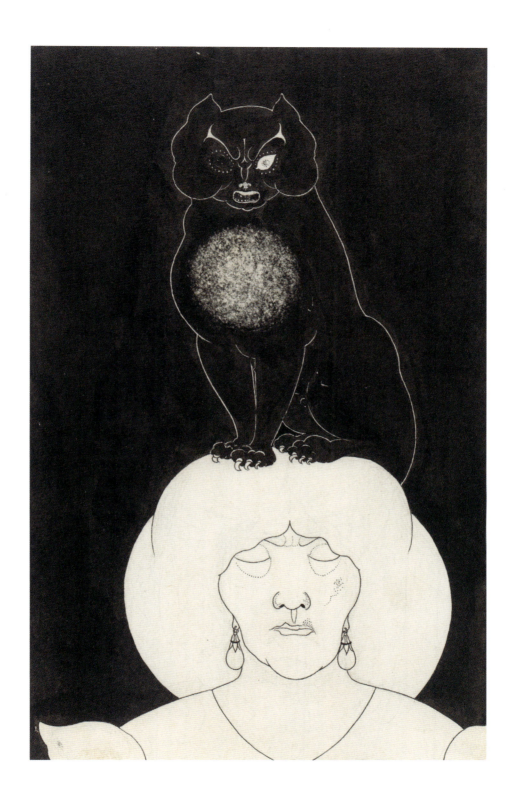

cats were created as offerings to Bastet, as were the mummified remains of real cats in the many shrines dedicated to her cult throughout Egypt. Bastet was the daughter of the sun-god Ra and – in a scene reflecting the real duties of cats as guardians against pests in the household – was often represented killing Apep, a malicious **snake** who threatened Ra's daily passage through the underworld (see pp. 174–78).

In Europe, medieval bestiaries characterized cats as useful pest-deterrents and hunters of vermin, but also criticized their perceived lechery. In this period, cats were also maligned as satanic. Gregory IX's 1233 Papal Bull 'Vox in Rama' called for the abolition of bizarre satanic cults that involved the worship of black cats. This apparently included depraved ceremonies culminating in the ritual kissing of the cat's anus.[17]

Where did this demonization of cats come from? It may be related to their nocturnal habits, or their reptilian eyes, with vertical slit pupils and ability to see in the dark. Or it could be related to their worship in the pagan religions, such as Norse mythology, where the goddess Freya travelled

PAGE 153 Aubrey Beardsley, *The Black Cat*, illustration for Edgar Allan Poe's *Tales of Mystery and Imagination*, 1895–96. Pen, brush and India ink over graphite, 25.4 × 16.2 cm (10 × 6½ in.)

Edgar Allan Poe's story about an evil black cat drew upon centuries of hostile superstitions about felines.

ABOVE Miniature with cats, from *Bestiary*, MS. Bodl. 764, 1226–50.

Cats are cunning night-time hunters in this bestiary image.

RIGHT Hendrick Goltzius, *The Fall of Man*, 1616. Oil on canvas, 104.5 × 138.4 cm (41¼ × 54½ in.)

A cat was present at the very moment sin was brought into the world, according to this painting.

154 THE HIDDEN LANGUAGE OF UNCERTAINTY

Federico Barocci, *The Madonna and Child with Saint Joseph and the Infant Baptist* (*The Madonna of the Cat*), c. 1575. Oil on canvas, 112.7 × 92.7 cm (44⅜ × 36½ in.)

Barocci represents a sly cat aiming to pounce on a goldfinch (symbol of Christ's Passion) held by an infant John the Baptist.

around in a chariot drawn by a team of cats. Either way, domesticated cats are never mentioned in the Bible, so Pope Gregory had a liturgical pretext for associating them with evil.

In later centuries, cats would appear as the familiars of witches. They are also sometimes seen in the company of Judas in art to symbolize his evil, such as in Pietro Lorenzetti's *Last Supper* in the Lower Church of San Francesco in Assisi (1320) and Domenico Ghirlandaio's *Last Supper* (1480) from the convent of San Marco in Florence. Even in a painting like Federico Barocci's *Madonna of the Cat* (1575) the dual nature of the feline is expressed: it is a domesticated plaything of children, but it also has the capacity to kill an innocent bird. The **goldfinch** (pp. 119–22) in Barocci's painting alludes to Christ's ultimate martyrdom, and also the human soul, to which the cat is the symbolic predator.

Cat Lovers: Don't Read This

The Illuminati, the Masons and the **Eye of Providence**

The Eye of Providence is one of the most misunderstood symbols. In modern times it has become linked in the popular imagination with the international secret society of Freemasons and it is also rumoured to be an emblem of the world's most famous non-existent power elite, the Illuminati. Among the modern celebrities who have been accused of covertly using Illuminati iconography (including the Eye of Providence) are pop icon Madonna and rappers Jay-Z and Kanye West.

Fuel to this conspiratorial fire is the relative ubiquity of the symbol in public institutions – in churches and Masonic buildings, and also, most famously, on the reverse of the American one-dollar bill and the Great Seal of the United States. Unravelling the origins of the Eye of Providence will help to explain why it is such a beguiling motif. It may also show us how it has come to be associated with the Freemasons and the Illuminati.

The Eye of Providence was not originally invented as a secret-society symbol. It began life as a sign of the Christian God and His protection, and its earliest public iterations, in the seventeenth century, only ever appear in a religious context. In the Italian painter Pontormo's *Supper at Emmaus* (1525), the Eye famously hovers in the space above Jesus as he makes his miraculous reappearance after dying. It was actually a later addition to the painting, but it complements an image whose luminous colouration, awkward poses and attenuated bodies already had a decidedly surreal aspect. The triangle, echoed in the shape made by the heads of the three foremost characters, was a Christian visualization of the Trinity (Father, Son and Holy Spirit), and its subtly evoked rays of light symbolized God's radiance. The

Pontormo, *Supper at Emmaus*, 1525. Oil on canvas, 2.3 × 1.73 m (7 ft 6⅝ in. × 5 ft 8⅛ in.)

An early appearance of the Eye of Providence.

THE HIDDEN LANGUAGE OF UNCERTAINTY

TOP Coffin of Ameny, Egypt, 12th dynasty, c. 1981–1802 BCE. Painted wood, 62.5 × 52 × 2.9 cm (24⅝ × 20½ × 1¼ in.)

The decorative eyes and 'doorways' on this coffin were designed to allow the deceased to enter the afterlife.

ABOVE Leon Battista Alberti, *Self-Portrait*, c. 1435. Bronze, 20.1 × 13.5 cm (8 × 5⅜ in.)

Alberti drew upon hieroglyphics to create his personal symbol – a winged eye, positioned just below his mouth.

disembodied eye of God, however, was a novelty in a Christian context.

No one would deny the innate psychological power of an image of an isolated eye. This motif has a very long history, which stretches back to the earliest known religions. The ancient Egyptians, for example, painted a pair of eyes on coffins to allow the dead to see in the afterlife, and the Eye of Horus is one of the most famous of Egyptian icons. This was a combination of a human eye and a falcon's, including the bird's distinctive dark eyebrow and cheek markings. It was thought of as a protective symbol, so Egyptians wore miniature Eye of Horus amulets as security against misfortune.

The Italian scholar Leon Battista Alberti (1404–1472), who developed sophisticated art theories that would inspire many later legends of the Renaissance, used a single eye with a wing attached as his personal emblem. It appears on a bronze medallion showing his profile – an image often described as the first independent self-portrait. It was likely inspired by Egyptian symbols like the Eye of Horus. During the European Renaissance, scholars and artists had a fascination with hieroglyphs, mostly because no one had figured out how to translate them and they represented a tantalizing enigma.[18] One of the most famous attempted translations appeared later in the Renaissance, in a romance of 1499 titled *The Dream of Poliphilo*. In this work, an Egyptian single eye symbol was transcribed as the word 'God'.[19]

This may be how the eye was incorporated into the triangle as a symbol of God for European Christians. One of the most influential seventeenth-century emblem books, used by countless artists to attain the correct allegories, was Cesare Ripa's *Iconologia*, first published in 1593. Later editions of the book depicted the Eye of Providence as an attribute of several allegories, including the personification of 'Divine Providence' (i.e. God's benevolence).[20] As the name of the symbol and its early usage suggest, it was invented as a sign of God's compassionate watchfulness over humanity. In the engraving, the personification of Divine Providence reclines on a cloud, holding aloft a sceptre crowned with an eye in a triangle. The design of the symbol had a power that made it famous in the eighteenth century, and allowed it to be reused in divergent, often secular contexts.

ABOVE LEFT After Gottfried Eichler the Younger, *Providentia Divina*, from 1758 edition of Cesare Ripa's *Iconologia*

The allegory of Divine Providence with her Eye of Providence sceptre.

ABOVE RIGHT Willey Reveley, Panopticon design, 1794

The Eye of Providence as a symbol of legal justice at the end of the 18th century.

It appeared, for example, in Jean-Jacques-François Le Barbier's 1789 *The Declaration of the Rights of Man and of the Citizen*, positioned above a list of radical new principles established in post-revolutionary France and thus symbolizing an egalitarian authority protecting the state.[21] A slightly different use of the Eye of Providence is to be found in the English architect Willey Reveley's 1794 logo for Jeremy Bentham's 'Panopticon'. The Panopticon was a revolutionary new prison, designed with a central observation room encircled by cells, intended to allow the superintendent uninterrupted surveillance of every cell. Reveley ignored the religious origins of the symbol, transforming it into the unblinking eye of the law.[22]

The Great Seal of the United States of America was designed in 1782. A competition to create the seal had inspired the Founding Fathers Thomas Jefferson, Benjamin Franklin and John Adams to propose ideas. However, the winner was Charles Thomson, Secretary of the Continental Congress. He and a young lawyer named William Barton proposed the Eye of Providence positioned above a pyramid. The uncompleted pyramid was supposed to signify 'strength and duration', with thirteen storeys to represent the thirteen original American states.[23] The Eye of Providence was selected – as it had been in the other two examples from contemporary Britain and France – because it was a conventional symbol of God's protection.

In the same period, Freemasons sometimes used the Eye of Providence to symbolize the Supreme Architect (God). But this was not unique – many

The Illuminati, the Masons and the Eye of Providence

Carlos Victor Ochagavia, cover of Robert Shea and Robert Anton Wilson's *Illuminatus Part II: The Golden Apple*, 1975

In the 20th century, conspiracy theorists linked the Eye of Providence with the Illuminati.

other churches were doing the same, and, as we have seen, it was a symbol that had been bent to a range of different functions in the late eighteenth century. Conspiracy theories claim that the design of the Great Seal is evidence of the Freemasons' secretive influence over the United States government. But this is mistaken, not only because of the ubiquity of the symbol in the period, but more fundamentally because neither of the Great Seal's designers were Masons.

The Illuminati were once a real group, founded in Bavaria in 1776 and disbanded in 1787. It is possible that they were influenced by Freemasonry, but the group's original membership and beliefs are relatively obscure, and there's no proving how important visual symbols were to them. The exclusive association of the Illuminati with the Eye of Providence is just as spurious as it is with Freemasons, mostly inspired by popular fiction, like Robert Shea and Robert Anton Wilson's fantastical *Illuminatus! Trilogy* (1975). However, there is no denying the Eye of Providence's brilliance as a piece of design. Its fame and its ability to inspire conspiracy theories are nothing if not a testament to its visual strength.

Here's Why You Never Trust a **Fox**

At some point in the early fourteenth century CE, an artist working in the Augustinian Priory of St Bartholomew in Smithfield, London, put the finishing touches to his painting of a fox: three long orange dashes for the claws, and one for his snake-like tongue. The fox he had summoned into existence was no loving study of nature. Dressed in a bishop's mitre and standing upright with the aid of a crosier, this fox is the devil incarnate, poisoning the minds of a congregation of birds including a stork, some geese, a swan, and a very sceptical cockerel. A fox, you see, is a deceptive animal and should never, ever be trusted.

Foxes were associated with the devil in Christianity much earlier than **cats** (see pp. 152–55) were. Attitudes to them were formulated, as with so many other symbolic animals in this book, by the accounts of the classical past that filtered through into medieval bestiaries. Originating with the Greek poet Archilochus in the seventh century BCE, foxes had suffered from over a millennium's accretion of fables about their slyness, by such writers as Aristotle,

Miniature with Reynard the Fox, from *The Decretals of Gregory IX*, Royal MS 10 E IV, fol. 49v, c. 1300–40

A fox conning other animals in a medieval depiction of Reynard the Fox.

BELOW LEFT Bottle in the shape of a fox, Moche culture, Peru, 5th–7th century CE. Ceramic, slip, 31.8 × 16.5 × 20.3 cm (12⅝ × 6½ × 8 in.)

The Moche people of Peru admired the hunting talents of foxes and often anthropomorphized their depictions of the animal.

BELOW RIGHT Netsuke of fox, Japan, Edo period, 19th century. Ivory, 7 × 3.5 × 2.7 cm (2⅞ × 5⅜ × 1⅛ in.)

A similarly humanized fox from Japan.

OPPOSITE *Birds on a Dead Fox*, Ms. Ludwig XV 4, fol. 84v, 1277 or later. Tempera colours, pen and ink, gold leaf and gold paint, 23.3 × 16.4 cm (9¼ × 6½ in.)

Medieval bestiaries portrayed foxes as being like the devil, tempting the unwary into mortal danger.

Herodotus and Aesop, as well as in an influential animal compendium known as the *Physiologus*, written around 200 CE by an unknown author.[24]

Foxes were linked to the devil in bestiaries from at least the twelfth century. These works inform us that, unlike cats and dogs, foxes were untameable beasts that resorted to deceptive stunts to trap their prey. They described how, if a fox is unable to kill anything to eat, he will roll around in red-coloured mud and lie motionless on the floor. When carrion birds, thinking him dead, swoop down, he will pounce upon them. Satan, warns the bestiaries, has the same conniving nature.

From the medieval period also came the fables of *Reynard the Fox*. Although on the surface this wily trickster's adventures appear to be light-hearted cautionary tales, they often functioned as coded satires on human society. Our Smithfield painter copied and adapted the Reynard fables for his manuscript imagery, visualizing stories about foxes dressing in human clothing, duping other animals and sometimes even foiling humans.

The outlandish spectacle of a fox in human clothes clearly delighted artists elsewhere in time and place. For example, an artist working in northern Peru in the period between 400 and 600 CE crafted a highly charismatic clay fox clad in the equipment of a warrior. This statuette discloses a Moche belief that foxes were sacred because of their superior hunting prowess, much like **owls** (see pp. 148–51).

162 THE HIDDEN LANGUAGE OF UNCERTAINTY

rostrū suū z auū suū. tram. z uoluit se sup
aquā fundit. hec serpē eā q̄ sī mortua. z retinet
tiū oua nescuntur z mor intra se flatū suū. z
ticina z ex eis gratissimū tra se isflat ut penit'
cibū deportat nidis suis. nō respiret. Aues uo

Vulpis est aīal do guā ei aperto ore fo
losū. z nimis frau ris eiectā. putāt eam
dulentū. z igeniosum. ee mortuā z descendt
Cū esurit. z nō iuenit z sedēt super eā. Illa ū
quod māducet. uadit rapit eas z deuorat.
ubi est rubea tra z uol Vulpis enī figurā hz
uit se super tram. tra dyaboli. Oībz scdm
ut quasi cruenta appa carnē uiuētibz fingit
reat tota z piat se in se mortuū ee. Cū enī

BELOW LEFT Utagawa Kuniyoshi, *No. 2 Broom Tree*, Japan, Edo period, 1845–46. Woodblock, 36.6 × 24.3 cm (14½ × 9⅝ in.)

A shape-shifting fox unwittingly reveals her true identity as her shadow is cast against a screen.

BELOW RIGHT Tsukioka Yoshitoshi (engraved by Noguchi Enkatsu), *The Cry of the Fox*, Japan, Meiji era, 1886. Colour woodcut, 39.4 × 26.7 cm (15½ × 10½ in.)

As in the European Reynard the Fox fables, here a cunning fox wears the clothing of a priest.

Sneakily disguised foxes can also be found in Asian art. A woodblock print by Utagawa Kuniyoshi (1797–1858) made in 1845 in Tokyo, then known as Edo, shows one such fox: Kuzunoha. According to Japanese folklore, Kuzunoha transformed into a woman and became a loyal wife for many years, before her true identity was discovered. Like the Smithfield painter and the Moche sculptor, Kuniyoshi had created an image of a supernatural fox in human guise. The true nature of the woman in the image is only perceptible in the shadow cast upon a screen set in the centre of the composition.

Japanese attitudes to foxes were inherited from China. There, beliefs about the animal's black magic became developed in the second century CE, and myths about their capacity to shape-shift into the guise of beautiful women appeared from the fourth century CE.[25] These stories were linked to the Daoist philosophy of the Yin and Yang, which defined harmonic opposites in nature (such as dark and light, female and male, and moon and sun). The fox was a Yin animal, and therefore female, and naturally sought out masculine principles for balance. Foxes, transmogrified into women in

164 THE HIDDEN LANGUAGE OF UNCERTAINTY

Miniature of Pope Celestine V kneeling in prayer, from *Vaticinia de Pontificibus*, f. 3, Harley 1340, 2nd quarter of the 15th century

In an ultimate statement of the satanism of foxes, they were sometimes depicted as preying upon the Pope.

these stories, seduced naïve young men (often a double-crossed Buddhist monk), dispossessing them of their vitality and dignity. According to legend, foxes could even infiltrate the highest levels of society, such as was the case with Tamamo-no-mae. She was a fox-woman who, having been recruited as a courtesan in the Japanese Imperial court in the eleventh century CE, managed to seduce a retired emperor. Kuzunoha was another one of these famously malign female foxes, whose collective name was *Kitsune*.[26]

Not many animals in global art history have been so routinely represented dressed in human clothing or infiltrating the upper echelons of society. It is true that in the twentieth century foxes earned a better presentation in popular culture, in the form of Roald Dahl's *Fantastic Mr Fox* (1970) and the debonaire lead in Disney's *Robin Hood* (1973). But farther back in history, whether in northern Peru, Tokyo or Smithfield, the sly, shape-shifting and devilishly clever fox was clearly not an animal to be trusted.

Here's Why You Never Trust a Fox

The **Scythe** of Time and Death

A scythe is brandished by 'Death', the spectral allegory sometimes referred to as the 'Grim Reaper', or as the elderly figure of 'Father Time'. These figures and their implements of doom appear in both the traditional arts and popular culture, linking Bruegel and *Bill & Ted's Bogus Journey* (1991).

Scythes are agricultural tools used for threshing grass or crops. Their history may go back as far as pre-classical times, but they became particularly widespread in Europe from the early medieval period (from around 700 CE) through to the nineteenth century.

Father Time is commonly represented with a scythe because of an art historical mix-up. Its invention and evolution are the subject of an essay by one of the most accomplished art historians of the twentieth century, and certainly one of the best-known writers about symbols, Erwin Panofsky. In his *Studies in Iconology* (1939), Panofsky traced the story back to a reaper figure who originally had no associations with time at all: Kronos, a titan from ancient Greek mythology (later to become Saturn in the Roman pantheon). Kronos was the patron of agriculture, so he was represented holding a sickle for reaping crops. In Roman times, a coincidental similarity between the sound of the Greek god's name, Kronos, and the Greek word for time, *chronos*, led to a reinterpretation of the god as the overseer of time.[27]

It was this linguistic mishap that ensured that later representations of Father Time had a cutting blade. When scythes became popularized in the farming practices of medieval Europe, Father Time's sickle was replaced with this new agricultural tool.

Illustration from *Poncher Hours*, France, c. 1500. Tempera colours, gold, and ink, 13.8 × 9.8 cm (5½ × 3⅞ in.)

In this illuminated Book of Hours, 'Death' brandishes a bunch of scythes – tools of rebellion during various peasant revolts in Europe.

THE HIDDEN LANGUAGE OF UNCERTAINTY

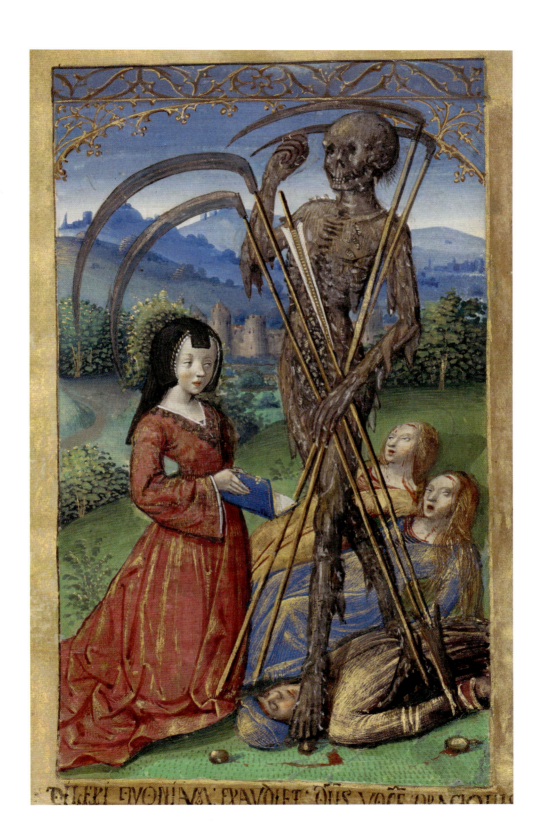

How about the figure of Death – the 'Grim Reaper'? Looking through historical representations of this sinister personification, you can see that until the sixteenth century artists had given him a whole range of attributes. Most popular was a spear or an arrow, which were weapons used by contemporary armies and thus probably more appropriate for representing death at the time. But scythes were only used by lowly farmer workers: how did Death earn such a humble agricultural attribute from around the sixteenth century onwards?

Maybe scythes were taking on new symbolic associations during the period. If so, it was probably due to the deluge of peasant revolts that occurred across the continent in the late medieval period. France experienced aggressive rebellions by the rural poor in 1320, 1358 and 1384, England in 1381, 1497 and 1513, and Germany between 1524 and 1525. During these rebellions, which became synonymous with violent disruptions to people's sense of the natural social order, labourers armed themselves with the things they had at hand: agricultural tools. The most vicious and effective ones at their disposal were scythes. Thus, scythes became synonymous in art with apocalyptic disruptions and a sudden, nasty death.[28]

Winslow Homer, *The Veteran in a New Field*, 1865. Oil on canvas, 61.3 × 96.8 cm (24¼ × 38⅛ in.)

The man's jacket in the bottom right reveals that he is a Union veteran from the American Civil War; the scythe is an ancient symbol of death.

THE HIDDEN LANGUAGE OF UNCERTAINTY

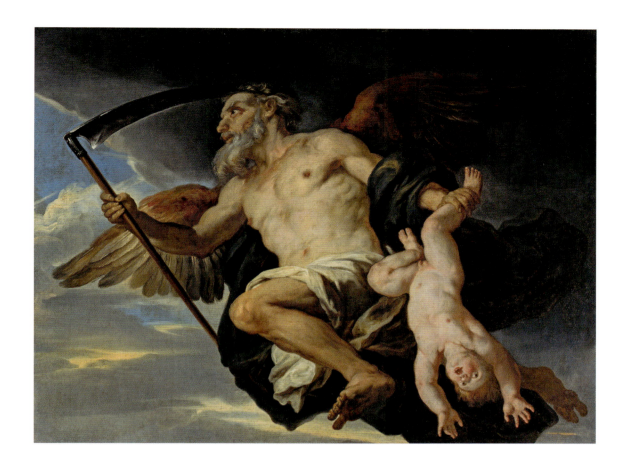

Giovanni Francesco Romanelli, *Chronos*, 17th century. Oil on canvas, 94 × 123 cm (37⅛ × 48½ in.)

The Greek titan Chronos, represented in classical art with a sickle, and here with a more modern scythe.

In *Studies in Iconography*, Panofsky did not merely explain the symbolism of Father Time's scythe, but used it as a gateway to discuss deeper issues relevant to the Renaissance, particularly the way that artists of the period adapted both classical and medieval symbols to reflect their present-day intellectual concerns. And Panofsky was right: delving into the symbolism of the scythe teaches a lesson in classical mythology, agricultural developments, and social upheavals in history. You don't need to fear the reaper … you *can* learn from him.

Lose Yourself in a History of **Labyrinths**

Commuters who descended into the London Underground in February 2013 were greeted by a new symbol adorning their station's walls: an unexplained image of a black and white labyrinth. Each example was unicursal, meaning that there were no false turns into or out of the maze – just a circuitous pathway from the centre to the edge.

This design is extremely ancient, but was resurrected by the artist Mark Wallinger as part of a commission to mark the transport network's 150th anniversary. Each of the 270 Underground stations was given a unique labyrinth, rendered in vitreous enamel, the recognizable format of official transportation signage. Except this was an icon with no purpose, other than to connect London's commuters with the deep history of the labyrinth's symbolic associations, including imprisonment, ingenious design, pilgrimage, divine order and the hero's quest.

The hero most closely associated with labyrinths is Theseus, from the mythology of ancient Greece. Theseus travelled from Athens to navigate the labyrinth of King Minos and slay the bull-headed, child-butchering Minotaur who lived there (see **bulls**, pp. 58–62). According to the tale, the labyrinth was devised by the king's chief inventor and artist, Daedalus. As well as being a crafty piece of human design, the labyrinth was a place of darkness and dread – an inescapable trap to unwitting mortals where the further you enter, the harder it is to escape. Theseus was able to prevail only because the king's daughter, Ariadne, had fallen in love with him and supplied him with a ball of red thread. With one end tied to the entrance, and the rest spooled behind him, Theseus's

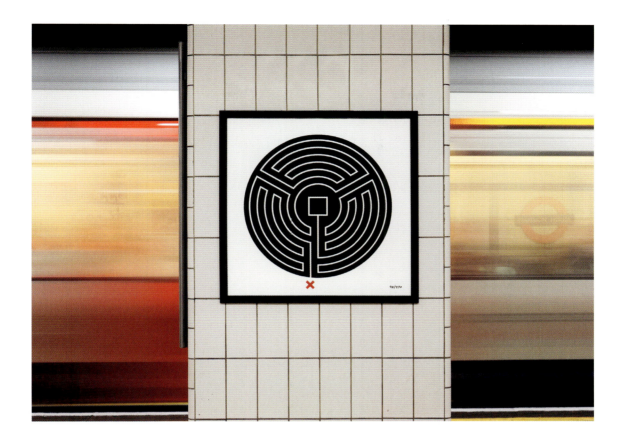

Mark Wallinger, *Labyrinth # 98/270 Mansion House*, 2013. Vitreous enamel on steel plate, powered coated black frame, 63.5 × 63.5 cm (25 × 25 in.)

One of the 270 labyrinth artworks in London's underground rail network.

escape route was laid out for him – so long as he managed to face and defeat the Minotaur.

Images of labyrinths dating from the fifth century BCE are present on coins minted on Crete, the Greek island that was supposedly the home of King Minos. Yet Minos was not the first king to be associated with labyrinths in the classical world. Herodotus (*c*. 484–*c*. 425 BCE), the eminent Greek historian, wrote a description of a gigantic tomb made for twelve kings in Egypt. Some five hundred years later, Pliny the Elder (d. 79 CE) described this tomb as a superhuman labyrinth of three thousand maze-like rooms, endless pitch-black corridors, and lurking crocodiles.[29] Only a true hero could traverse those gloomy and forbidding corridors.

Theseus's famed victory over the Minotaur and escape from Daedalus' fiendish labyrinth is recorded in the writings of Roman authors such as Ovid (43 BCE–17 CE) and Virgil (70 BCE–19 BCE). The Romans' fascination with the story is preserved in floor mosaics from countless villas and baths

Lose Yourself in a History of Labyrinths

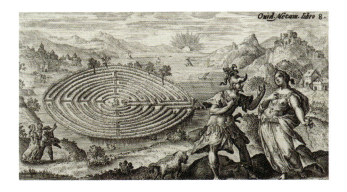

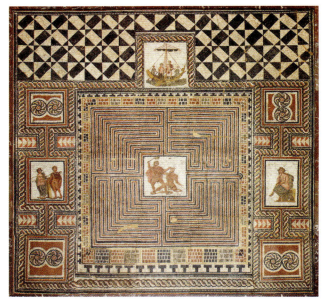

TOP Crispijn van de Passe the Younger, *Theseus and Ariadne*, 1602–7. Engraving, 8.3 × 13.3 cm (3³⁄₈ × 5¼ in.)

Theseus and Ariadne outside the labyrinth.

ABOVE Theseus mosaic from a Roman villa, Loigersfelder, near Salzburg, 300–400 CE

Minos's labyrinth was a popular subject in Roman floor mosaics.

featuring labyrinths with a Minotaur at the centre.[30]

The further we crawl back down the corridors of time, the more the truth of historical labyrinth symbolism fades into the shadows. Labyrinth designs can be found on Neolithic pottery and rock carvings, but other labyrinths discovered by archaeologists are not clearly datable – including walkable open-air ones in Scandinavia and islands in Russia's White Sea, and temple wall inscriptions and tribal artefacts with maze-like designs from India and the Indonesian islands Java and Sumatra. Likewise, the Native American O'odham peoples from Arizona constructed their own distinctively angular labyrinths, but the true origins and original dates of these designs are devilishly hard to pinpoint. Equally mysterious, but more easily datable, are the labyrinths cut from turf that appeared in Britain and Germany in medieval times, such as the ones at the English towns of Wing, Rutland and Saffron Walden.

Large, intricately designed labyrinths were also inscribed on the floors of European cathedrals, although there is some dispute over their original function. The most famous of these is on the floor of Chartres Cathedral in France, built in the early thirteenth century. Its design is symbolically Christian, with its circularity connoting perfection and its roughly cross-shaped form that alludes to the crucifix. The fad for church labyrinths began in Italy between the tenth and eleventh centuries, and spread to France by the twelfth or thirteenth centuries. It is typically believed that they symbolized the soul's pilgrimage through life, but there is evidence that they may have also suggested Christ's descent into and out of death.[31]

Joe Tilson, *Delphic Oracle*, 1980. Screen print, collage, mixed media and metal, 74.9 × 63.5 cm (29½ × 25 in.)

Tilson's screen-print exemplifies his interest in the deep history of classical subjects and symbols, including the labyrinth.

It is also possible that the labyrinth designers were thinking about how mazes changed their nature depending on perspective. From the inside, labyrinths are dark and ominous, but from above they are reconciled into a satisfying and beautiful pattern. This is a metaphor about the journey of human life: while we navigate it with our own confused and earth-bound senses, the elegance and order of the overall design can only be seen from God's elevated vantage.[32]

Mark Wallinger was interested in the symbolism of unicursal labyrinths, and for him it represented the outward and return journey of a Londoner's daily commute. After each heroic quest into the subterranean maze-machine of the London Underground is the exit to ground level: the puzzle solved.

Lose Yourself in a History of Labyrinths

Snakes: The Good, the Bad and the Ugly

Snakes, like dragons, roses, owls, cats and foxes, are an ambivalent symbol: they can be seen as either positive or negative, depending on context. A salt cellar, made in the early sixteenth century by the Sapi peoples of Sierra Leone, exemplifies this ambiguity. It is the product of a unique cross-fertilization of cultures, epitomized by its iconography.

In the wake of the navigation and explorations of the western coast of Africa in the fourteenth century, Portugal enjoyed close trading links with various peoples of sub-Saharan Africa. Among the artefacts imported into Europe were intricately carved African ivory statuettes. These had been created specifically to cater to Portuguese tastes by blending recognizable symbols with indigenous ones. Among many other figures and emblems, the salt cellar features the coat of arms of the Portuguese royal family, which strongly suggests that it was made for a senior member of the court, or perhaps even stood on the king's own table.[33] But the most prominent figures are a Madonna and Child at the top, and four snakes, which loll languidly from a set of cushions in the lower half.

For the Sapi peoples, as for many other disconnected cultures of the world, the snake was a divine animal. Their habits and habitats suggest mystical, boundary-transgressing abilities: they slide in and out of holes, which makes them seem as if they can access the underworld at will, and they can also slither off riverbanks and through the water, making them masters of two elements. This is in addition to their ability to shed their skin (which seemed

OPPOSITE Salt cellar, from Sierra Leone, 1490–1530. Ivory, 31 × 13.8 × 13.5 cm (12¼ × 5½ × 5⅜ in.)

Four snakes wilt in the presence of the Madonna and Child in this salt cellar, made in Sierra Leone.

ABOVE Asclepius-Hygieia Diptych, Roman, 400–430 CE. Ivory, 31.3 × 27.8 cm (12⅜ × 11 in.)

The symbols of the ancient Greeks gods of medicine and health were snakes.

to indicate immortality) and a fearsome capacity to kill with venomous fangs. It has even been suggested that the Sapi associated snakes with their Portuguese trading partners, who were believed to have come from the land of the dead and possess supernatural powers.[34]

Art from around the world frequently shows snakes as symbols of wisdom and mystical energy, even from the earliest cultures. In ancient Egypt, the female snake-goddess Wadjet was the guardian of the pharaohs, which led to a tradition of representing rearing cobras – the *uraeus* – on royal headgear. In ancient Mesopotamia, snakes as symbols of awesome powers and fertility are numerous. The symbol of two entwined snakes (to represent the copulation of these powerful underworld beings) was connected to the male fertility god Ningizzida. In ancient Greece, this symbol re-emerged as an emblem of Asclepius, the god of healing.[35] His rod with entwined snakes is another classical symbol to have survived into the modern world, as one of the most recognizable global emblems of medicine, the caduceus. In Hinduism and Buddhism, snakes and snake-like beings called *nagas* are often represented

Snakes: The Good, the Bad and the Ugly

ABOVE Vishnu in his cosmic sleep, Uttar Pradesh, India, 11th century CE. Sandstone, 36.8 × 55.9 × 11.4 cm (14½ × 22⅛ × 4½ in.)

As Vishnu created the world during his sleep in the primordial waters, he slept upon the multi-headed snake Ananta, king of a race of snake deities called *nagas*.

OPPOSITE Lucas Cranach the Elder, *Adam and Eve*, 1526. Oil on panel, 117.1 × 80.8 cm (46⅛ × 31⅞ in.)

The evil serpent in the Bible's account of the Garden of Eden shaped negative attitudes to snakes in the Christian world.

in scenes where they play a beneficent role, such as the serpent Mucalinda, who protected the Buddha during a storm, and Ananta, who supported the sleeping Vishnu while he slumbered in the cosmic ocean.

The Portuguese, when looking at the Sapi salt cellar, would probably have seen things completely differently. As Christians, the snake was for them unequivocally a symbol of evil. The serpents might have been seen to be wilting in deference to the holiness of the infant Christ and his mother.

Christian attitudes towards snakes are shaped by the serpent that appears in the Book of Genesis, who tempts Eve to eat the fruit from the tree of knowledge. It is one of the most famous passages in the Bible:

> 'Now the serpent was more crafty than any of the wild animals the Lord God had made. He said to the woman, "Did God really say, 'You must not eat from any tree in the garden'?"
> The woman said to the serpent, "We may eat fruit from the trees in the garden, but God did say, 'You must not eat fruit from the tree that is in the middle of the garden, and you must not touch it, or you will die.'"
> "You will not certainly die," the serpent said to the woman. "For God knows that when you eat from it your eyes will be opened, and you will be like God, knowing good and evil."'

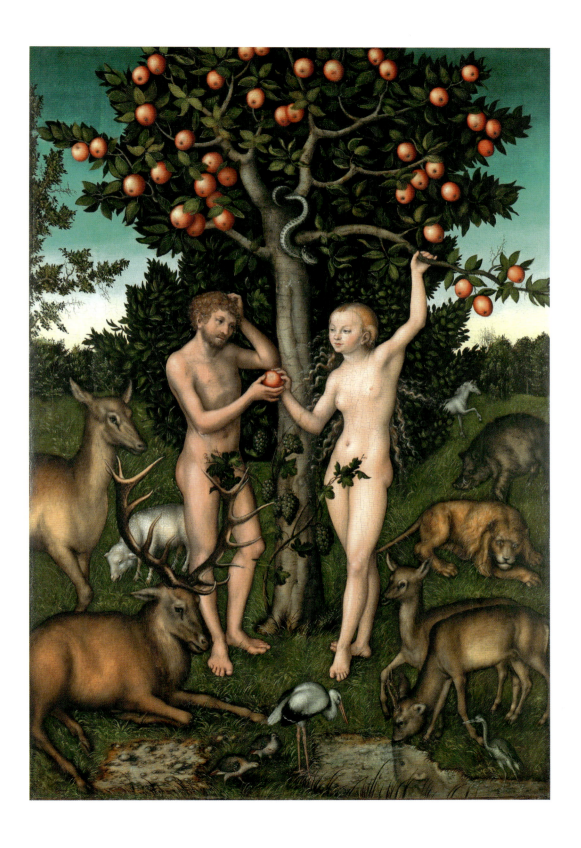

ABOVE Apep slain, from the Book of the Dead of Hunefer, Egypt, 19th dynasty. Papyrus, 43.6 × 70 cm (17¼ × 27⅝ in.)

Snakes were associated with malevolence in ancient Egypt.

BELOW LEFT Krishna dancing on the head of the snake demon Kaliya (Kaliyadamana), Tamil Nadu, India, 1301–1400. Bronze, 67.5 × 28.6 × 21.7 cm (26⅝ × 11⅜ × 8⅝ in.)

Kaliya was a poisonous *naga* (snake deity) who Krishna restrained by performing a dance on his hood.

BELOW RIGHT The Lansdowne Throne of Apollo, Roman, late 1st century CE. Marble, 154.9 × 67.3 × 86.4 cm (61 × 26½ × 34⅛ in.)

It is believed that the snake on the backrest of this elaborate throne represents the serpent Python, who was heroically defeated by the god Apollo according to classical myth.

No other animal in the Garden of Eden was capable of understanding God's intelligence, or sly enough to help endow humans with a share of that intelligence. This characteristic of snakes may have historical causes. It has been suggested that in ancient Mesopotamian rites, which could have influenced biblical scripture, snakes were considered capable of predicting future events, both positive and negative.[36]

Evil snakes also occur in Egyptian art, for example in the form of the malevolent god Apep, who lived in the underworld and tried to kill the sun-god Ra. Bastet, the **cat** goddess (see pp. 152–55), is often shown killing Apep after a deadly fight. Snake-demons also appear in Hindu imagery, such as the poisonous river-dwelling Kaliya, whom Krishna slays.

It has been argued that repugnance of snakes is a product of evolution, and a fear reaction in the presence of snakes is a long-held instinctive response of most humans. Chimpanzees exhibit a shock response in the presence of snakes even if they have never previously seen one. Studies of the subject of people's bad dreams reveal a high proportion of nightmares about snakes. No wonder so many global religions have made them central figures of awe, and no wonder that artists have consistently resorted to them as the preeminent symbols of dread.

An Elegy to the Poppy

Canadian medical officer John McCrae (1872–1918) was working seventeen-day shifts without break in his field hospital during the Second Battle of Ypres. On 3 May 1915, midway through the battle, McCrae wrote a poem that gives voice to one of the thousands of recently dead young soldiers. It was called 'In Flanders Fields', and it begins:

> In Flanders fields the poppies blow
> Between the crosses, row on row[37]

Field poppies were among the wildflowers McCrae saw growing in a landscape otherwise disfigured by the ravages of industrial-scale warfare. Blood-red poppies thrive in churned earth – their seeds, which lie dormant in the ground, germinate when exposed to sunlight.

McCrae's poem achieved international fame after it was published in *Punch* magazine in December 1915, and it went on to inspire 'remembrance poppy' badges worn in ceremonies to commemorate the end of the First World War in the United Kingdom, New Zealand, Australia and Canada.

In these countries, poppies are among the most famous floral symbols in the modern age, perhaps challenged only by the ubiquitous rose of love. And yet it has historic roots that extend far below the First World War.[38] McCrae knew the poppy as a symbol of sorrow, consolation and death – associations that had been forged in the canon of poetry (which paired poppies with a noble death) and the Victorian 'language of flowers'.

OPPOSITE Dante Gabriel Rossetti, *Beata Beatrix*, 1871–72. Oil on canvas, 87.5 × 69.3 cm (34½ × 27⅜ in.)

Here the poppy is a symbol of death through laudanum addiction.

BELOW Simon Marmion, *The Lamentation of Christ*, c. 1473. Oil and tempera(?) on oak panel, 51.8 × 32.7 cm (20½ × 12⅞ in.)

A single, drooping poppy near Christ's right hand symbolizes his death.

This language was constructed through several popular books of the nineteenth century that listed the symbolic qualities of different flowers. It influenced the romantic behaviour of young sweethearts, who sent one another cryptic bouquets: each flower carrying a hidden sentiment of love. For the Pre-Raphaelite Brotherhood, a group of artists working in Britain during the latter half of the nineteenth century, the symbolic vocabulary of flowers was taken very seriously. Dante Gabriel Rossetti's painting *Beata Beatrix* (of which he painted two versions, one 1864–70, the other 1871–72) represented the death of his wife and fellow Pre-Raphaelite Elizabeth Siddall with a white opium poppy, delivered to Siddall's cupped hands by a fiery red **dove** (pp. 96–99). Here, the symbolic flower carried a tragically personal symbolism. 'Lizzie' Siddall had died in 1862 from an overdose of laudanum, which was a popular painkiller, tranquilizer and euphoriant of the time composed of opium, alcohol, sugar and spice. Opium is the psychoactive sap extracted from *Papaver somniferum* – the 'opium' poppy.

Beata Beatrix captures one of the historic concerns surrounding opium – the fine line between its use an analgesic and addiction, and the equally fine line in dosage between rapture and oblivion. Before the nineteenth century, opium poppies' symbolism in art had frequently been tainted by the narcotic effects of their sap: induced sleep, incapacitation and death. As a result, there are few poppies in Christian art, apart from occasions where they represent the red blood of Christ or otherwise allude to death or sinister, diabolical forces.

In Roman times, a sleeping Cupid clutching a bunch of poppies was a popular type of funerary sculpture. In these 'Sleeping Eros' marbles, the

An Elegy to the Poppy

181

attribute was inherited from a family of Greek deities who were associated with poppies: Nyx, the goddess of night-time; her son Thanatos, god of Death; his brother Hypnos, god of sleep; and Hypnos's son Morpheus, god of dreams.

Such associations between poppies and sleep were clearly the result of sophisticated Greek knowledge of the medical use of poppy-derived opium. Poppies also had a culinary role, producing seeds for flavour and oil for cooking. This, in tandem with their appearance within ploughed fields of wheat, is often credited for their association with the ancient Greek harvest goddess Demeter. Poppies were among the ritual objects found in the sites of the Eleusinian mystery cults.[39] These involved acting out the myth of Demeter and her daughter Persephone's abduction by the underworld god Hades to celebrate agricultural fertility and the rebirth of nature in the springtime.

Tracing this connection between Demeter and poppies takes us back even further into Greek history. The earliest known representation of poppies in a religious context is a terracotta sculpture of a goddess from the island of Crete, made at some point in the mid-1000s BCE, an apparent precursor to

Marble sarcophagus with Selene and Endymion, Roman, early 3rd century CE. Stone, height 72.4 cm (28⅝ in.)

The handsome Endymion was subjected to ever-lasting sleep, which is symbolized by a bunch of poppy heads, directly above his reclining body at the right side of the sarcophagus.

Jean Bernard Restout, *Sleep*, c. 1771. Oil on canvas, 97.6 × 130 cm (38½ × 51¼ in.)

Bunches of poppies surround Morpheus in this painting inspired by a description in Ovid's *Metamorphoses*.

Demeter.[40] The goddess, who is 80 centimetres (31½ inches) tall and stands with a transfixed gaze not unlike Lizzie Siddall's, wears a crown decorated with poppy seed heads. It is believed the civilizations of the period – the Minoans and Mycenaeans – used opium in religious rituals. This is supported by the fact that an ivory pipe that may have been used to smoke opium was discovered alongside the 'Poppy Goddess'.[41]

In retrospect, the poppy could have evolved as a popular symbol for fertility, had the association with Demeter persisted in the western artistic imagination. As things turned out, it became linked with the negative qualities of slumber and obliteration, the purview of Nyx and her family. But how could it really have been any other way? For all its medical benefits, the opium poppy would go on to become probably the world's most destructive crop. It has influenced lives for the worse as an addictive drug, caused wars and bankrolled organized crime.

An Elegy to the Poppy

The Corruption of a Symbol: The **Swastika**

If there was ever an example to prove the terrible power of symbols it is the swastika. For many people it is an unconscionable icon, signifying Nazism and the horrors of the Holocaust. But the swastika also proves the two-sidedness of symbols. The word derives from the Sanksrit *svasti*, meaning 'well-being' or 'good fortune', and it was an auspicious symbol for millennia before the Nazis took possession of it.

A Japanese Noh costume from the Metropolitan Museum of Art in New York is one of many artefacts from global history that proves the symbol's normally benign function. Here the swastika is a Buddhist motif, and it continues to be used in Jainism, Hinduism and Buddhism as a symbol of spiritual beneficence. How it came to be corrupted in Nazi Germany and continues to be a symbol of fascist groups across the globe is a cautionary tale about placing ideology over fact, and the latent potency of iconography.

The earliest known swastika-like forms appear on mammoth-tusk carvings, including a small figurine of a bird, which were created 15,000 years ago during the Ice Age and found in modern-day Mezin, a settlement in Ukraine. The symbol also features on later artefacts from across the world, including pottery of the Neolithic Vinča peoples who inhabited south-eastern Europe, predominantly in what is now Serbia, in the fifth millennium BCE. It has been conjectured that these ancient swastikas connoted fertility, since they are often associated with female idols and phallic statuettes.[42] Swastikas have been produced by many later cultures from across the globe. To cite artefacts bearing the symbol from the ancient cities of Samarra and Susa and Indus Valley settlements, or to mention swastikas on Mesopotamian coins,

Nuihaku (Noh costume), Japan, Edo period, 2nd half of the 18th century. Silk embroidery and gold leaf on silk satin, 1.65 × 1.36 m (5 ft 5 in. × 4 ft 5⅝ in.)

This robe is covered in auspicious Buddhist symbols, including swastikas.

ABOVE Detail of the mosaic floor at the Lullingstone Roman villa, Eynsford, Kent, 100 CE

Swastikas appear across the globe in historical art, including Roman mosaics made in England and Greek ceramics (opposite).

Buddhist, Jain and Hindu objects, ancient Greek design, and European Celtic decorations would be to cover only a fraction of the examples that exist.

Popular fascination about the meaning and global extent of the symbol was kick-started in the 1870s. It followed the discovery of thousands of examples of swastikas on artefacts uncovered during the excavations of Troy led by the German antiquarian Heinrich Schliemann (1822–1890). The symbol, with its simple, geometrically concise and easily repeatable shape and associations with well-being and good fortune, became a widespread icon in modern times. Through the late nineteenth and early twentieth centuries it was used for diverse ends, including advertising beer and soft drinks, and was adopted as a logo for sports teams and the Boy Scouts. But the same period also witnessed the corruption of the meaning of the swastika, first by early right-wing groups in Germany who believed it to be a symbol of an 'Aryan' master race.[43]

This conceit was based on a distortion of fact. The term 'Aryan' came from the field of linguistics and was devised at the end of the nineteenth century to identify common traits in the roots of the Indo-European language family. The concept was then twisted to paint a picture of racial superiority among the speakers of the language that had survived through history. The swastika symbol, which was found on ancient German artefacts as well as objects from powerful civilizations across the globe, was seen as the visual equivalent of the 'Aryan' language. In 1920, the swastika flag became the

main symbol of the Nazi party in Germany, and following the party's rise to power it was made the German national emblem in 1935.

At the end of the Second World War, the swastika's reputation in the western world was apparently unsalvageable. In April 1945, Allied troops entered the concentration camps of Dachau, Dora-Mittelbau, Buchenwald and Flossenbürg, many of which bore swastikas over their entrance gates, to witness the Nazis' racist atrocities at first hand. In a now iconic piece of film footage taken in the same month, engineers of the US Army fixed explosives to the back of a colossal marble swastika that brooded over Nuremberg Sports Stadium and blasted it triumphantly to smithereens.

But the evil associations of swastikas did not evaporate from western consciousness after the end of the war. Still strongly associated with anti-Semitism and neo-Nazi groups, the European Union attempted to ban the symbol in 2007 in all EU countries. However, the law was not passed, following opposition by European-based Hindu groups, for whom the swastika was an ancient and auspicious sign. As we approach a century since the defeat of the Nazis, the swastika is still a deeply problematic symbol. Will it ever be possible to recapture it from those who use it to signal hate, and fix the corruption that distorted it in the mid-twentieth century?

Pottery *pyxis*, Greek, 700–680 BCE. Clay, height 22.6 cm (9 in.)

The Corruption of a Symbol: The Swastika

Before the **Bubble** Pops ...

In 1988, a man was rooting around a flea market in New England when he found a large oil painting depicting an obscure subject. It featured two figures – a man clutching a sheaf of papers and a woman holding a cornucopia and sitting precariously on a bubble. Whether the man knew it or not, the painting was an allegory of financial luck, with the bubble a symbol of transience and chance. As if guided by the painting's hidden message, he bought the painting for $1,000, and decided to head to the fine art auctioneer Christie's in New York that afternoon, hoping to make a $500-or-so profit.[44] But it wouldn't fit in his van. Onto the roof it would have to go, bound in place by an old piece of rope. He set off on the motorway with the 2-metre (7-foot) long canvas wobbling around in the breeze above him.

As would later be deduced, *Allegory of Fortune* (*c.* 1530) shows personifications of Chance and Fortune. Chance, the male character, holds a bunch of lottery tickets in his fist (lotteries were a new fad in Italy at the time). Fortune's appearance followed traditional iconography, including having one shoe on and the other off, signifying the states of poverty and wealth. Her bubble seat was an innovation, however, as she would normally be seated on a globe.

Bubbles as symbols are rare in art from before this period, although you do find some depictions of people blowing bubbles with soap bowls and pipes in manuscripts from the medieval period. Before the seventeenth century, you also find images of cherubs symbolically blowing bubbles, reflecting their usual function as a childhood toy. The main symbolic point was that life is as frail and vulnerable as a bubble. The clash between bubbles' metaphorical seriousness and the wide-eyed innocence of youth added extra poignancy.

Dosso Dossi, *Allegory of Fortune*, c. 1530. Oil on canvas, 1.81 × 1.95 m (5 ft 11¼ in. × 6 ft 4¾ in.)

The allegory of Fortune sits precariously on a bubble, to symbolize the instability of luck.

The origins of this popular symbol lie in a much-used phrase from ancient Rome, '*Est hommo bulla*': 'man is but a bubble'. It was a saying popularized in the Renaissance by Erasmus of Rotterdam (1466–1536) in *Adagia*, his compilation of classical sayings published in 1500.[45]

The physics of a bubble explains its structural frailty. When you blow one through an aperture with soapy water, the molecules within the soap, called surfactants, reduce the surface tension of water. This allows for the formation of the bubble's skin. However, the sphere instantly feels the effects of gravity. The water on the surface seeps to the base of the bubble, and as it

Before the Bubble Pops ...

does so, its upper pole weakens incrementally until the whole thing is unable to sustain its own weight and bursts.[46]

Bubbles as a symbol of fleeting life and transient pleasures really caught on in the seventeenth century, in Dutch 'vanitas' paintings. These were still-life scenes often containing various extraordinary objects in conjunction with *memento mori* (symbols to remind you of death such as **skulls**, pp. 142–47, or extinguished candles). They remind the spectator that the pursuit of material possessions, success and knowledge is ultimately futile, as death levels everyone, regardless of social rank and education. Probably the earliest example of the vanitas genre is a painting by Jacques de Gheyn II (1565–1629) dating from 1603, which contains a skull on a shelf with a bubble hovering over it. The root Latin word for vanitas is *vanus*, meaning empty, which corresponds with the void encased by a bubble.

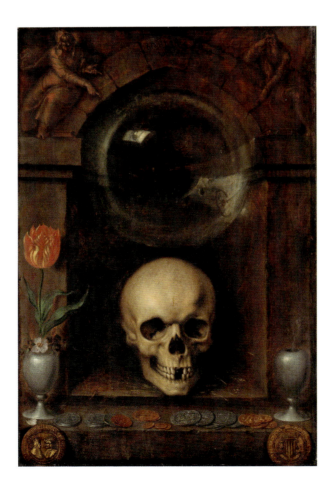

Jacques de Gheyn II, *Vanitas Still Life*, 1603. Oil on wood, 82.6 × 54 cm (32⅝ × 21⅜ in.)

Reflected upon the bubble (and barely discernible in reproduction) are other symbols of the material life, including crowns, drinking glasses, a wheel, and a backgammon board.

ABOVE LEFT Hendrick Goltzius, *Quis evadet?*, 1594. Engraving, 21 × 15.2 cm (8⅜ × 6 in.)

The symbolic bubble of fragility appears in this print, whose title translates as 'Who will be spared?'

ABOVE RIGHT Édouard Manet, *Boy Blowing Bubbles*, 1867. Oil on canvas, 100.5 × 81.4 cm (39⅝ × 32⅛ in.)

Even Manet, otherwise considered to be the father of modern art, was well versed in traditional iconography, including the significance of bubbles.

Similar associations occurred in non-western nations. Japanese literature from at least the thirteenth century (for example, the poetry of Kamo no Chōmei) connected bubbles with fleeting life and transient pleasures, even though it was completely disconnected from the European tradition of poetic allusion. However, bubbles did not appear in visual art in Japan until the Edo period (1603–1897), possibly because of recently imported European soap which could produce better bubbles, but also because Dutch vanitas images had recently been introduced to Japanese artistic circles.[47]

Although the popularity of such symbols waned in the twentieth century, various avant-garde artists of the late nineteenth and early twentieth centuries would use allegorical bubbles in their art, including Édouard Manet, John Everett Millais and Man Ray.

And how about the man with the *Allegory of Fortune* strapped to the roof of his van? When he arrived at Christie's in New York, the auction house's Old Masters expert was astounded. The painting was unmistakeably by the renowned Italian Renaissance artist Dosso Dossi (1489–1542). It went on auction in January 1989 and, as if to realize the painting's message about the vagaries of luck to its fullest, the painting sold for a cool $4 million.

Before the Bubble Pops ...

THE HIDDEN LANGUAGE OF HOPE

Bride's robe, Korea, Joseon dynasty, 18th century. Silk and paper with silk embroidery, 1.17 × 1.78 m (3 ft 10⅛ in. × 5 ft 10 in.)

This wedding gown is covered in symbols of positivity.

A gown made in Korea during the Joseon dynasty (1392–1910) features a cornucopia of positive symbols, some of which have been already discussed in this book: lotus flowers, phoenixes and butterflies. It is a garment that needed to exude good fortune because it had a very important function – it was a bridal gown. If you examine it closely, you can see lots of damage to the fabric, as well as needlework repairs and patches; it was not made for a single wedding, but re-used through several generations. It is an artefact that records the compounding of human joy over time, and the high premium that people have placed on vivid colour and symbolism to express hope.

The gown is here to show that this book shall end on an optimistic note. The last section dealt with symbols used to evoke dark superstitions, fears, sin and evil, and to propagate hateful ideologies. This one deals with icons of aspirations, beauty, companionship, magic and love.

The twelve symbols that follow exemplify a human capacity for wonder and aspiration. With peacocks, unicorns and the ouroboros symbol, it is a fascination with supernatural powers and a mystical understanding of the workings of the universe. In the case of roses, orchids and parrots it is an enthrallment with natural splendour, and the virtues of affection, intellect and wealth. Fish, dogs, carnations and sunflowers are signifiers of friendship and success. In the previous section on the symbols of uncertainty, we encountered nocturnal beings, such as owls and foxes, and artefacts that utilize darkness, like labyrinths and mirrors. In this section we are back in the daylight, contemplating colourful flowers and, rather than observing *memento mori* (reminders of death), we are seeing celebrations of vitality.

BELOW LEFT Kama with a parrot, Jambukeswarar temple, Srirangam, Tamil Nadu, India, 11th century

Kama, also known as Kamadeva, the Hindu god of love, is sometimes shown riding a parrot – an exotic and luxuriant mount.

BELOW RIGHT Karttikeya seated on a peacock, Andhra Pradesh, Madanapalle, India, 12th century. Basalt, 150.5 × 121 × 39 cm (59⅜ × 47¾ × 15⅜ in.)

The splendid peacock was the mount of Karttikeya, commander of the Hindu gods.

In the first two sections on the hidden language of power and faith, many of the symbols had an obvious influence on people, unifying them with a shared geopolitical or religious identity. The section of the hidden language of uncertainty indicated the power of sinister symbols as cautionary emblems. But if you were to think that symbols of hope are softer and less capable of effecting change in the real world, you should think again. Fountains and pearls prove that some symbols reflect deeply felt passions that have motivated grand projects, such as technological innovation and exploration.

Although it covers symbols that originated in ancient Egypt, Greece, India, China and Rome, this section best exemplifies the effect that the Renaissance and Baroque periods had on the development of symbols. The Renaissance saw the rediscovery of the ancient ouroboros symbol and the reintroduction of public fountains, as well as the firm establishment of a

194 THE HIDDEN LANGUAGE OF HOPE

The Virgin and Child in a White Rose, England, Ms. 101, fol. 63v, *c*. 1480–90. Tempera colours and gold leaf, 17 × 11.9 cm (6¾ × 4¾ in.)

The rose evolved into a highly prized symbol in Christianity.

dog as a symbol of loyalty, and particularly as a scholar's companion. The Baroque witnessed a further deepening of symbolism, as you will see in the entries on sunflowers and carnations.

Each of the following symbols shares a desire to demonstrate the inner meanings of the natural and man-made things around us, and to find in them a sense of order and significance.

THE HIDDEN LANGUAGE OF HOPE 195

The Never-ending Symbol: **Ouroboros**

Jasper intaglio with ouroboros enclosing Serapis, Roman, 2nd century CE. Jasper, 1.9 × 1.4 × 0.2 cm (¾ × ⅝ × ⅛ in.)

A Roman iteration of the ouroboros symbol.

If we understand it correctly, the message of the ouroboros is a hopeful one. It is telling us that time is infinite, that everything renews itself and death isn't the end. An ouroboros represents a snake coiling round and biting its own tail, hence the name, which means 'tail-devourer' in Ancient Greek. You can see ouroboros symbols on gravestones, medallions, jewelry and tattoos. You can also see them in art, as an attribute of Father Time (alongside his **scythe**, see pp. 166–69) and in the symbolism of alchemy. It captures the essence of eternity: the end of time meeting its own beginning.

The earliest known version of the ouroboros is from a golden funerary image for Tutankhamun dating from the thirteenth century BCE.[1] It subsequently spread to other cultures, first in Roman visual arts, such as on gemstone engravings that were considered to possess magical, evil-defying properties. Later, the ouroboros symbol ended up featuring in Gnostic and Hebrew texts and even in Viking myth.[2]

However, there's no secure evidence about what the ouroboros really meant to its original ancient Egyptian audience. Modern understanding of the symbol has been affected by two interpretations from the past. The first is by a writer known as Horapollo, who lived in the fifth century CE and who authored a book on Egyptian symbols called the *Hieroglyphica*. He described the ouroboros as an emblem of the universe, based on an ancient Egyptian notion that a guardian serpent encircled the whole world. When the

196　　THE HIDDEN LANGUAGE OF HOPE

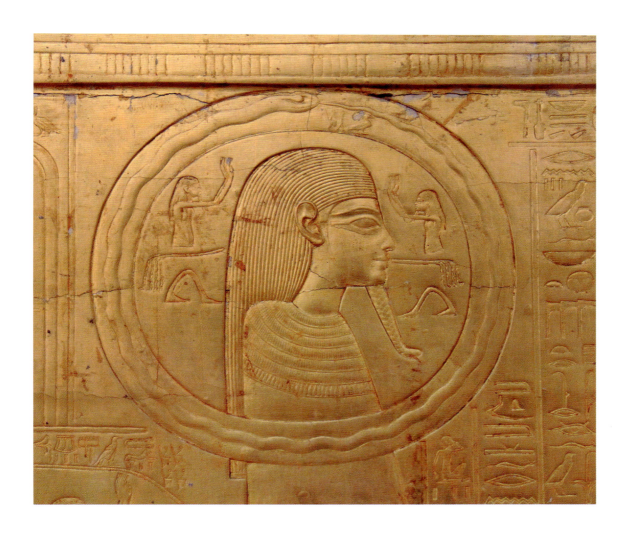

First known representation of the ouroboros, on one of the shrines enclosing the sarcophagus of Tutankhamun, Egypt, 18th dynasty

The first known representation of the ouroboros symbol.

Hieroglyphica was rediscovered in the Renaissance, it inspired the second significant interpretation of the ouroboros. This came from the writings of Marsilio Ficino (1433–1499), a humanist scholar.[3] In 1484, Ficino singled out the ouroboros as an example of what he regarded as the great intelligence of the Egyptians. Through symbols, he said, the Egyptians condensed great theories into single hieroglyphic images: the same belief that had shaped the **Eye of Providence** (see pp. 156–60). In the case of the ouroboros, it was believed that the symbol encoded a philosophy of time being a complex, dynamic and recursive system.

That is how the ouroboros is generally understood today. And it seems to correspond with the ancient Egyptian conceptualization of time, which

The Never-ending Symbol: Ouroboros

Lucas Cranach the Elder, *Portrait of the Chancellor Gregor Brück*, 1533. Oil on wood, 42.6 × 38.4 cm (16⅞ × 15⅛ in.)

The sitter, Chancellor of the Electorate of Saxony from 1519, wears an elaborate ouroboros choker.

was regarded as cyclical – a belief influenced by observations of the regular, annual flooding of the Nile (which fertilized the soil, making it ideal for farming) and the seemingly clockwork pattern of movements of the sun and stars in the sky.[4] Such beliefs informed how the ouroboros was later used in other capacities, including alchemy, where it symbolized a worldview of the interconnectedness of opposing forces in the universe. This was established first in a third-century CE text known as the *Chrysopoeia* (gold-making) by Cleopatra the Alchemist. She was reputed to have created the 'philosopher's stone' – a substance that could turn base matter into gold and cause immortality. The ouroboros symbol appears in the *Chrysopoeia* with no straightforward explanation other than some enigmatic statements, including 'All is One'. Yet the distinctive ouroboros thrived through later centuries as an alchemical symbol.

ROA, *Infinitas*, Perth, 2014

The ouroboros symbol continues to inspire artists, including Belgian-born street artist ROA.

The ouroboros is the symbol of recurrence that seems to have propagated its own recurrence through time. It has pulled off quite a trick: the mystery of its true meaning has ensured its endless meaningfulness and relevance from ancient times to the present.

Paradise, Power and Eternal Youth: **Fountains**

In art, a fountain often marks the centre of paradise, and in real life they stand in the centre of our grandest cities and parks. Symbolizing a source of pure, drinkable water, they have been linked in the Abrahamic religions (Judaism, Christianity and Islam) with spiritual vitality and God's beneficence. But they were also political statements: by commissioning fountains, rulers have demonstrated their own sense of generosity towards the general populace, while simultaneously suggesting a god-like ability to control nature.

Cities cannot exist without predictable water supplies. It was the lifeblood of the world's first urban centres in the Fertile Crescent, Indus Valley, China and Mexico.[5] Water management is still fundamental to city life in the twenty-first century, even if fountains have become display-pieces, with domestic taps being more practical sources of potable water. Yet, with an eye to history, it is possible to perceive in the quantity and design of urban fountains a barometer of developing mastery of the natural environment, of progressing engineering skills, artistry and economic prosperity. The history of fountains describes the history of urban civilization itself.

The earliest cities to pioneer sophisticated water management systems were in ancient Egypt and Mesopotamia. But the most impressive example was the Indian city of Dholavira in the Indus Valley, established in the third millennium BCE. Here a network of reservoirs, dams and aqueducts ensured that the city was fully in control of the natural supplies of water. The first sophisticated decorative fountains, on the other hand, were in the Syrian city of Mari, dating from the third millennium BCE, with Minoan Greece being an early pioneer of high-pressure fountains in the second millennium BCE,

Hubert and Jan van Eyck, *The Ghent Altarpiece: Adoration of the Mystic Lamb* (detail), 1432. Oil on oak wood, overall 3.4 × 5.2 m (11 ft 1⅞ in. × 17 ft ¾ in.)

Life-giving water springs from the fountain in the centre of a paradisical field, a symbol of purity and the grace of God.

at least one of which features a Minoan fresco.[6] Fountain engineering was further developed in classical Greece and by the Etruscans, where they typically had a ritualistic function. They were often decorated with religious iconography or stood in sanctuaries, such the Castalian Spring at the important Greek religious site of Delphi.

It was the Romans, however, who were the true masters of hydrotechnology. Fountains became a ubiquitous feature of Roman cities because of the extensive underground pipelines, aqueducts and cisterns that connected far distant natural springs with city centres. Emperors treated the construction of these water networks and fountains as a public relations exercise, but fountains also featured within private homes as a symbol of individual wealth. A number of private homes in Pompeii had fountains, and they also appear in frescoes from the city, with birds descending to drink from the gurgling water cascading up from hidden labyrinths of Roman-engineered pipe channels. Forty public fountains have been unearthed in Pompeii, and at the time of the fall of the Roman empire, in the fifth century CE, the city of Rome contained 1,352 public fountains, including ones festooned with sculpted ensembles of river gods, and another that took the form of a 3-metre (10-foot) tall bronze pine cone.[7]

Paradise, Power and Eternal Youth: Fountains

After the decline of the western Roman empire, hydraulic engineering knowledge dwindled and very few new fountains were built in western Europe for almost a millennium.

In Islamic cultures, however, water technologies were much better understood and exploited, and in Islamic Spain, Roman water management systems were analysed and emulated, leading to the creation of fountains such as in the Alhambra, Granada, from the beginning of the second millennium CE.[8] In both Christianity and Islam, fountains were regarded as a signifier of paradise, and a means of purification within a holy setting. The Qur'an, like the Bible, is full of references to fountains and waterways as symbols of purity and God's grace. In Islamic paradise gardens, the conventional design features a cross-shaped water course, often with a fountain at the centre to symbolize the source of the rivers of heaven.

Elsewhere in Europe, water supply systems were reinstated from the thirteenth century onwards and public fountains reappeared, as they had in Roman times, as symbols of political generosity. In Rome, the repair and reinstatement of aqueducts feeding the city led to the construction of famous monumental fountains such as Gian Lorenzo Bernini's Fountain of the Four Rivers, or Fiumi Fountain, in 1651 and Nicola Salvi's Trevi Fountain in 1762. For the first time in over a millennium, the waters flowed in abundance.

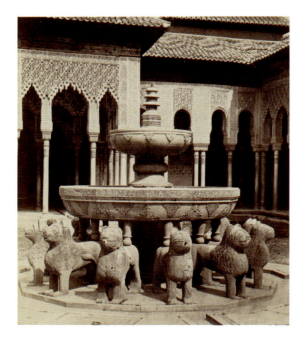

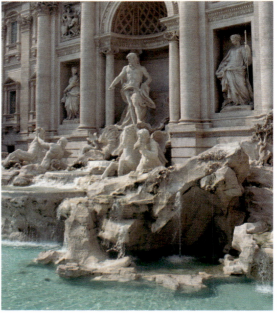

BELOW LEFT Fountain in the Court of the Lions, Alhambra, late 14th century

In Islamic art and design a fountain signifies paradise.

BELOW RIGHT Nicola Salvi, Trevi Fountain, Piazza di Trevi, Rome, 1762

Elaborate city-centre fountains in Europe establish the beneficence of leaders and their power to control life-sustaining water.

THE HIDDEN LANGUAGE OF HOPE

Master of the Getty Lalaing, The Challenge at the Fountain of Tears, from *Livre des faits de Jacques de Lalaing*, Ms. 114, fol. 113, c. 1530. Tempera colours, gold leaf, gold paint and ink, leaf 36.4 × 26.2 cm (14³⁄₈ × 10³⁄₈ in.)

Jacques de Lalaing (1421–1453) was a celebrated Burgundian knight whose purity of heart is symbolized by the fountain, maiden and unicorn.

With the reappearance of functioning fountains in civic spaces came a resurgence of fountains in art, and the development of an iconography relating to them. In Europe, fountains cropped up ever more frequently in images of paradise and became an attribute of the Virgin Mary, because of their association with purity in the Hebrew Bible's Song of Songs.

Many cultures have believed in a fabled 'Fountain of Youth', located in some undiscovered territory, which could restore your natural vigour by drinking or swimming in its waters. Where was it located? In the fifth century BCE, the Greek historian Herodotus claimed that it was in the Land of Macrobians (modern-day Somalia). Later, it was argued to be in the land of the legendary, Christian king Prester John, although no one could agree whether he ruled Mongolia, India or Ethiopia. The Fountain of Youth also appears in the *Alexander Romance*, a collection of fanciful tales about the military expeditions of Alexander the Great composed in the second century CE. The stories, which were translated and adapted through late antiquity and the medieval period, include one description of the Greek general questing for the mystically restorative spring.[9]

Paradise, Power and Eternal Youth: Fountains

ABOVE Master of the Castello della Manta, *Fountain of Youth*, Sala Baronale, Castello della Manta, Saluzzo, 1411–16

The mystical fountain of youth, said to cure ageing.

OPPOSITE Limbourg Brothers, miniature of The Fall and Expulsion from Paradise, from *Les trés riches heures du Duc de Berry*, Ms. 65, c. 1416

An elaborate fountain at the heart of the Garden of Eden symbolizes innocence and virtue.

The design of real fountains became ever more elaborate after the Renaissance, as they came to signify mastery over the natural world, usually dressed up with a cast of classical gods or allegories to ennoble the ensemble into an operatic unity. The bombastic fountains decorating the gardens of the Villa d'Este in Tivoli, Italy, built around 1550 CE, became the inspiration for many subsequent garden fountains in stately homes across Europe. The Villa d'Este was also the site of the first 'rainbow fountain' (see pp. 123–27).[10]

The allure of fountains has not receded in the twenty-first century. In October 2020, the most powerful example in history, called the Palm Fountain, opened in Dubai. This centrepiece of humanity's authority over the elements is capable of shooting plumes of water 105 metres (345 feet) into the air, amid a baroque spectacle of light and music.

Paradise, Power and Eternal Youth: Fountains

The Secret Superpowers of a **Peacock**

A peacock, standing self-confidently in the central portion of Fra Angelico and Fra Filippo Lippi's *Adoration of the Magi* (*c.* 1440/1460), rather steals the limelight from the momentous events unfolding below. Scholars tell us that peacocks are an artistic symbol of immortality, featuring in paintings of religious events to indicate the future resurrection of Jesus.[11] How did they earn such incredibly hopeful associations?

Magical qualities had been ascribed to peafowl for many years before the Renaissance. The most common type seen in art are the Indian variety, though there are also African and Indonesian species. Their earliest representations in art are found in the Palaeolithic rock shelters of Adamgarh Hills and Bhimbetka in the Indian state of Madhya Pradesh, where the artists seem to have been drawn, as all subsequent artists would, to the peacocks' iridescent coloration and extravagant feather display.[12]

In the Indus Valley civilizations, which existed around the Indus River between the fourth and second millennia BCE, peacocks were a popular motif on painted ceramics. Since many of these artefacts were found in funerary sites, archaeologists have concluded that that the bird might have been a symbol of rebirth.[13] The *Mahābhārata*, an epic poem composed and written over a long period between the fifth century BCE and the fourth century CE in India, confirmed the connection between peafowl and the qualities of fertilization and life-creation. This probably derived from people observing the peacocks' extravagant mating dance, which happened to coincide with the rainy season. It must have seemed as though the birds could communicate with the gods to reactivate nature's life-cycle and bring fecundity back

Fra Angelico and Fra Filippo Lippi, *The Adoration of the Magi*, c. 1440–60. Tempera on poplar panel, overall (diameter) 137.3 cm (54⅛ in.)

The prominent peacock in this scene is a symbol of everlasting life.

Wall fragment with peacock, Roman, 1–79 CE. Fresco, 40 × 24.8 cm (15¾ 9⅞ in.)

In ancient Rome, peacocks were among the most exotic species of animal, symbolizing wealth and, in their connection to Juno, queen of the gods, authority.

to the land. Further connections between peacocks and supernatural powers are mentioned in the Vedic religious texts, where peafowl are described as being able to ingest poison and survive unscathed, probably due to their inclination to eat small insects and reptiles, including scorpions and snakes.

Subsequently, the peacock became integrated with Hinduism and Buddhism, with the bird appearing in the decorations of the Great Stupa at Sanchi, constructed in the third century BCE. A peacock was also appointed

THE HIDDEN LANGUAGE OF HOPE

Panel from a rectangular box, probably from Cordova, Spain, 10th–early 11th century. Carved ivory, inlaid with stone with traces of pigment, 10.8 × 20.3 cm (4 3/8 × 8 in.)

The repertory of patterned animals and figures was influenced by the art of late antiquity, but the fine skills needed to make them is testament to the abilities of Islamic artists in the 10th and 11th centuries CE.

as the mount of the Hindu war-god Karttikeya and the attribute of Saraswati, goddess of wisdom and art. Peacocks still have a sacred significance in India, and were awarded the status of national bird of India in 1963 because of their enduring association with divine beauty and goodness.

Around 1200 BCE, the first peacocks were brought to Syria by merchants trading goods along routes between India and Mesopotamia. By the eighth century BCE they had reached Europe, where they became an attribute of the ancient Greek goddess Hera, as an incarnation of the giant Argus, who has one hundred eyes. Like the **parrot** (see pp. 238–42), the peacock was synonymous with exoticism in Western art. This derives from the Bible, in which they are mentioned alongside gold, silver, ivory and apes as examples of treasures brought from abroad to the wealthy and powerful King Solomon (1 Kings 10:22).

A legend developed in the west that peacock flesh does not rot (certainly the colours on the feathers of a peacock are incredibly long-lasting), and this notion, popularized by the writings of St Augustine (354–430 CE), was adopted by Christians who included images of peacocks in their catacomb paintings. Indian peacocks were also exported via trade pathways to China and then Japan, where they became a symbol of magnificence and grandeur.

The Secret Superpowers of a Peacock

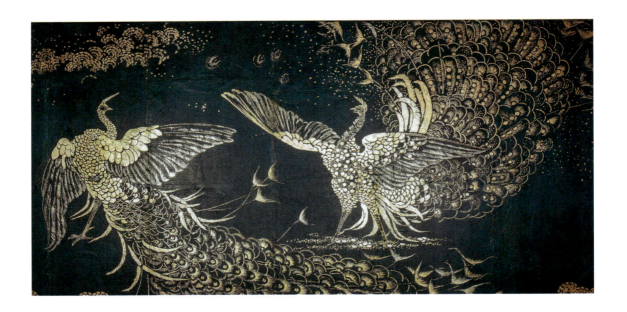

ABOVE James Abbott McNeill Whistler, *Art and Money; or, the Story of the Room*, 1876–77. Detail from the Peacock Room. Oil paint and gold leaf on canvas

In this context, the peacock is an expression of pure beauty.

OPPOSITE Aubrey Beardsley, *The Peacock Skirt*, from a portfolio of drawings illustrating *Salome* by Oscar Wilde, 1906–12. Line block print, 22.8 × 16.3 cm (9 × 6½ in.)

Whistler inspired Beardsley to use a peacock motif in his representation of Salome, giving her a supernatural allure.

In Europe after the Renaissance the link between peacocks and immortality subsided, and they became increasingly portrayed as nature's ultimate expression of beauty. This reached its height during the nineteenth century, particularly for artists of the Aesthetic Movement, whose guiding principle was that aesthetics are the highest concern of life.

In 1877, the American artist James Abbott McNeill Whistler (1834–1903) painted a mural of two peacocks titled *Art and Money; or, the Story of the Room*, the final element of decoration in the dining room of a London house owned by the English shipping tycoon Frederick R. Leyland. Whistler had initially only been consulted on the colour scheme of the 'Peacock Room', but over time he had become obsessed by the project, and took over its complete redecoration. By 1876, Whistler had splurged 2,000 guineas on reconfiguring the entire room, painting it in luxuriant blue-green with gold-leaf patterning. A heated dispute with Leyland ensued about the exorbitant amounts of money Whistler had spent on the scheme. In the aftermath, Whistler painted *Art and Money* on one of the walls, which shows a pair of peacocks sizing each other up for a fight. One of them stands above a floor strewn with coins and blocks the way with his plumage. The other gives him a defiant, foursquare gaze. A peacock, once again stealing the limelight.

210 THE HIDDEN LANGUAGE OF HOPE

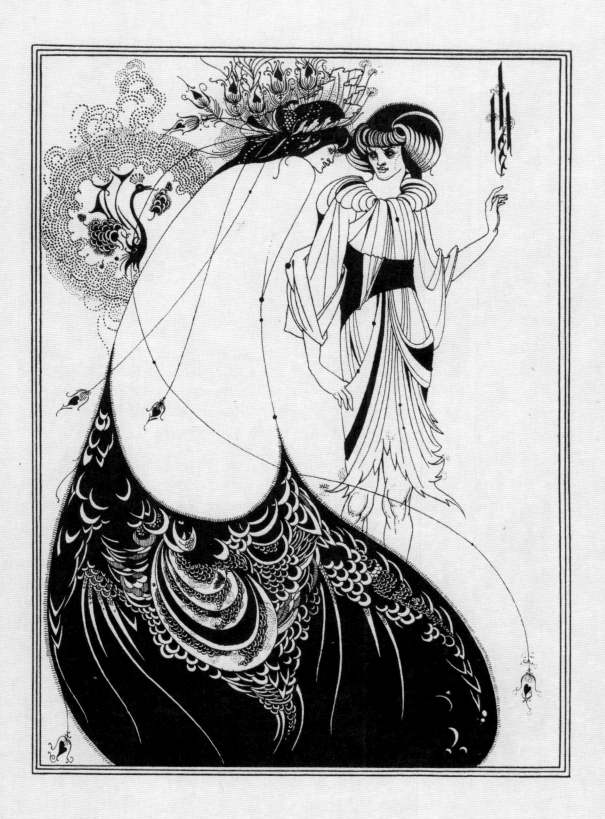

The Greatest Symbol of Hope: a **Fish?**

BELOW Early Christian fish gem, Syria(?) or Asia Minor, 3rd–4th century CE. Rock crystal, 3.5 × 7.5 cm (1½ × 3 in.)

A cryptic token of faith: a fish owned by an early Christian to denote their adherence to Jesus.

OPPOSITE Keisai Eisen, *Carp Ascending a Waterfall*, Japan, Edo period, early or mid-1830s. Colour woodblock print, 72.4 × 24.2 cm (28⅝ × 9⅝ in.)

In Japan and China, carp symbolize perseverance and success.

In Chinese art, a fish sometimes isn't simply a fish. Because the Chinese language is tonal, there are many words that sound alike. As a result, the visual arts sometimes used pictures that when said aloud mean something different. This is an example of a 'rebus' – a visual pun. The Chinese character for the word 'fish' (*yú*) is a homophone for 'abundance'. Fish therefore often appear as symbols for success or wealth, or the desire for them.

Carp are particularly associated with ambition in Chinese art, as they are capable of swimming upstream and can leap high in the air. According to legend, if a carp can leap over a set of falls in the Yellow River called the 'Dragon Gate', it would be transformed into a dragon. From at least as far back as the Han Dynasty (202 BCE–220 CE), the phrase 'to leap the Dragon Gate' was a metaphor for scholars passing their prestigious civil service exams. A street in Beijing was even dubbed 'Carp Lane' because students coming to the city to take the exam would walk through it after arriving by boat.[14] As a result, images of carp would be associated with academic striving in China, but also in Japan, which absorbed Chinese visual symbolism.

In the west, a fish is also commonly seen as an emblem of hope, as it was one of the original symbols of Christianity. But Christianity was not the first religion to exalt the fish as a holy creature. Fish had been accorded divine qualities in ancient Egypt in the form of the Medjed fish, which were reputed to have eaten the penis of the god Osiris and were worshipped at Oxyrhynchus.[15] In ancient Sumerian myth, it was believed that the earliest civilizations were taught wisdom by a race of fish-men who emerged from the Red Sea.

212 THE HIDDEN LANGUAGE OF HOPE

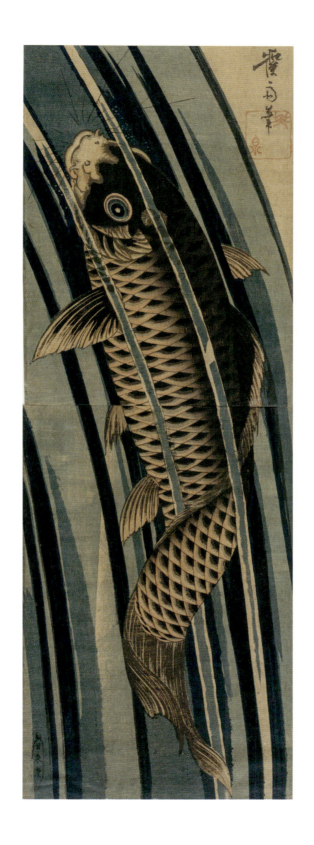

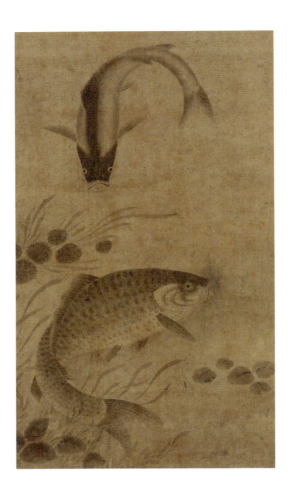

Yōgetsu, *Carp and Waterweeds*, Japan, Muromachi period, late 15th century. Hanging scroll, ink on silk, 85 × 35.2 cm (33½ × 13⅞ in.)

The text that accompanies this skilfully observed representation of a carp pond mentions the Daoist immortal Qingao, whose mount was the auspicious carp.

The Bible abounds with mention of fish.[16] Jesus's disciples are called the 'fishers of men', and one of Jesus's miracles was feeding five thousand people with just five loaves of bread and two fish. The simplified fish symbol comprised of two intersecting arcs (known as an *ichthys* – the Ancient Greek word for fish) enjoyed a curious revival in the late twentieth century to become a widespread pop-cultural emblem of the religion, most commonly seen as a bumper sticker.

The early Christian African theologian Tertullian made a connection between the rite of baptism and fish in the third century CE, claiming that 'we, little fishes, after the example of our *ichthys* Jesus Christ, are born in water, nor have we safety in any other way than by permanently abiding in water.'[17]

The translation of the Greek '*ichthys*' into a symbol is again based on linguistics, as it made up an acrostic – a puzzle decoded by taking the first

THE HIDDEN LANGUAGE OF HOPE

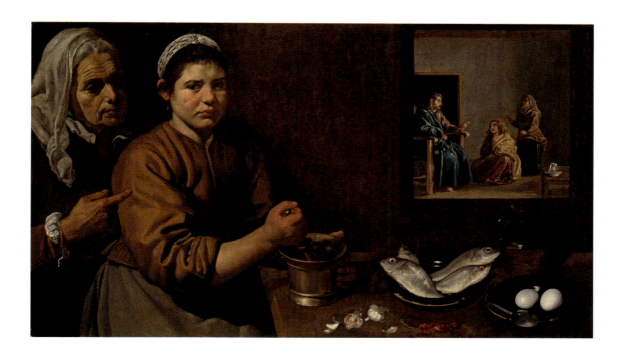

Diego Velázquez, *Kitchen Scene with Christ in the House of Martha and Mary*, c. 1618. Oil on canvas, 60 × 103.5 cm (23⅝ × 40¾ in.)

The fish are part of a Lenten meal prepared by the young woman, but are also suggestive of the fish prominently mentioned in the Bible.

letters of a sentence to create another word – for the phrase (in Greek): 'Jesus [I], Christ [Ch], God [Th], Son [Y] and Saviour [S]'. The 'Jesus Fish' started life as a secret symbol at a time when Christianity was a marginal faith, and was scrawled as graffiti, painted on tombs and inscribed on seals in the first three hundred years of the first millennium CE. As Christianity spread and gathered in strength, its symbolism developed. Symbols like the **halo** (pp. 78–83), **dove** (pp. 96–99) and **palm leaf** (pp. 88–91) survived in popularity, but fish were displaced. Their popularity as a symbol declined, and languished for over a millennium and a half.

The revival of the 'Jesus Fish' as a bumper-sticker icon of Christians in the twentieth century has been traced to a specific student movement in Sydney, Australia, in the 1960s. Looking for a catchy, unexpected and easy-to-replicate emblem, the Evangelical Union of Sydney University decided that the simplified fish icon was perfect. It became popular with Christians in Australia, and then spread to America and Europe from the late 1980s, becoming a recognizable marker of their faith on mugs, t-shirts and stickers. In a final leap of fame, it has even appeared in some of the world's most famous TV comedies, being a target of humour in such shows as *Futurama*, *My Name is Earl* and *Seinfeld*.[18]

The Greatest Symbol of Hope: a Fish?

A Wild **Unicorn** Hunt

Unicorns probably had their heyday in art in the European late Middle Ages and Renaissance. At that time, they were thought to possess bizarre powers, such as being able to purify water with their horns, being the animal version of Christ, or being immune from capture other than by a bare-breasted virgin woman. Most of these connections are lost on us today, but the fascination with unicorns remains strong. Unlike many other fabulous beasts of the past, unicorns are everywhere in popular culture. You see them in music videos, emblazoning a multitude of kids' merchandise, in films and cartoons and on gay pride marches. A 'unicorn' in some sectors of modern parlance is a start-up business valued at over $1 billion. Where did the unicorn myth start, and how did it gain its many strange symbolic associations? The answer lies far from here, in a country of mythical wonders.

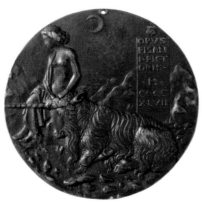

Imagine a sun ten times bigger than our own, above a landscape replete with gold mines guarded by griffins, rivers of honey flowing serenely past and manticores – beasts with human heads, lion's bodies and scorpion tails – prowling menacingly all around. A land that is inhabited by one tribe of dog-headed men, and another of snub-nosed pygmies with long hair and beards that drag along the floor. This is the land of unicorns. It is a country called India.

Although he did not name them as such, the ancient Greek doctor and historian Ctesias made the earliest recorded mention of unicorns, in his book about the mysterious lands

OPPOSITE Pisanello (Antonio Pisano), *Innocence and a Unicorn in a Moonlit Landscape*, 1447. Bronze (copper alloy with warm brown patina under a worn layer of black wax), diameter 8.4 cm (3 3/8 in.)

This medal depicts Cecilia Gonzaga (1426–1451), a brilliant scholar whose purity of heart is symbolized by a unicorn, a beast that was believed to be sedated in the presence of a virgin woman.

ABOVE Seal with unicorn, Mohenjo-daro, Indus civilization, c. 2700–2000 BCE. Steatite, 5.9 × 5.5 × 1.4 cm (2 3/8 × 2 1/4 × 5/8 in.)

4,000-year-old seals from the Indus Valley appear to represent unicorns.

to the east, *Indica*. Written in the early fourth century BCE in the royal courts of Persia, *Indica* is a trove of harebrained fables collected by Persian travellers and gossip-mongers.[19] It led to a degree of scholarly mockery from later historians. Yet its tales of talking birds and men who hunted with raptors rather than hounds makes it the earliest mention in the west of **parrots** (see pp. 238–42) and **falconry** (pp. 21–25).

The garbled and highly mythologized idea of 'India' from Ctesias and his contemporaries had a profound effect on the western imagination in the classical period and beyond. These fables – described by the art historian Rudolf Wittkower (1901–1971) as the 'Marvels of the East' – would have a lasting effect on the intellectual landscape of the west for generations to come, influencing natural science, encyclopaedias, romances, maps and art up to the eighteenth century.[20]

The unicorn was one such marvel, but Ctesias's description of them doesn't fully tally with our modern image. He said that they were like asses, with white hair, blue eyes and a short, dark horn. The myth that the unicorn horn has decontaminating properties originated in this early source. It may be that Ctesias was confused, and had passed on some garbled lore about the rhinoceros, whose horn was likewise considered to be medicinal. The idea that the unicorn horn was a sanitizing instrument migrated east, and became an aspect of Chinese unicorns, which were called *kylin*.

Unicorns may have been an ancient feature of Indian folklore. A large number of seals created by the Indus Valley cultures of Mohenjo-daro and Harappa in the third and second millennia BCE, used to certify trade goods, featured what look like unicorns, with a single horn protruding from their foreheads.[21]

In the west, it was Ctesias's fabulous description of the unicorn that was pivotal in cementing the creature in the popular imagination. It generated a lot of attention from later ancient Greek and Roman writers, such as Aristotle (384–322 BCE) and Pliny the Elder (d. 79 CE). The most influential text was the *Physiologus*, a series of descriptions of animals accompanied by moral reflections, which was written at some point between the second and fifth centuries CE in Alexandria. The basic idea of the *Physiologus* was copied in medieval times in Europe in bestiaries, which led to a fascination

A Wild Unicorn Hunt

RIGHT Tapestry from 'The Lady and the Unicorn' series, late 15th–early 16th centuries. Wool and silk, 3.67 × 3.22 m (12 ft × 10 ft 6 in.)

The virtue of the woman is symbolized by the unicorn beside her.

OPPOSITE *The Unicorn Rests in a Garden* (from a series of seven 'Unicorn' tapestries), France, 1495–1505. Wool warp with wool, silk, silver, and gilt wefts, 3.68 × 2.52 m (12 ft ⅞ in. × 8 ft 3¼ in.)

This captured unicorn is a symbol of wildness tamed, and probably refers to happiness in marriage.

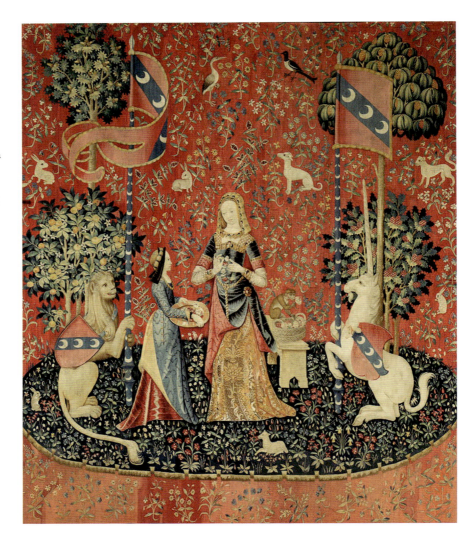

with unicorns (as well as other fabulous beasts, like the **phoenix**, pp. 50–54) throughout the Middle Ages and into the Renaissance.

The *Physiologus* described the unicorn as a goat-like creature. In addition to the magical properties of its horn, another myth was added – that the unicorn was rampant and untameable, except in the presence of a beautiful and virtuous woman.[22] Thus, the creation of the myth that one could only be snared by a virgin female. Within the Christian allegorical imagination the rare, pure and magical unicorn was associated with Christ, and the chaste woman with the Virgin Mary.

218 THE HIDDEN LANGUAGE OF HOPE

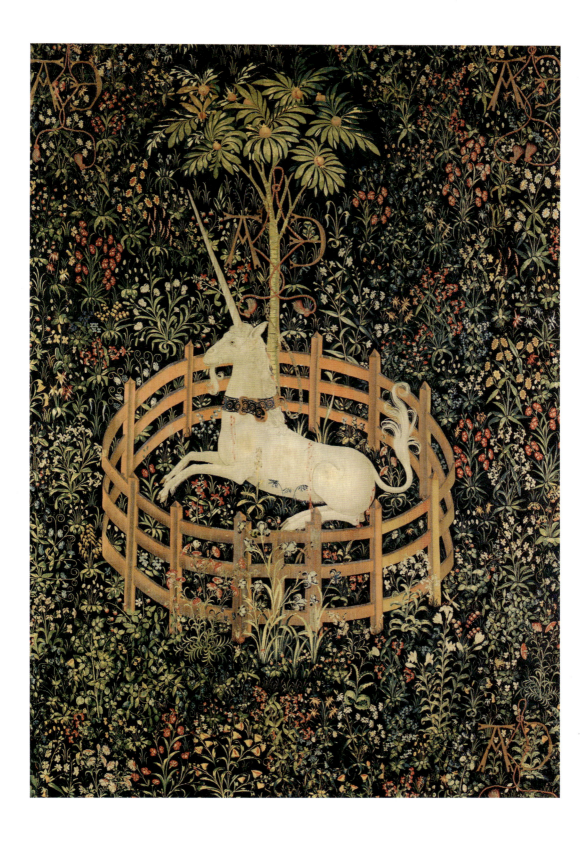

Arthur B. Davies, *Unicorns (Legend–Sea Calm)*, c. 1906. Oil on canvas, 46.4 × 102.2 cm (18 3/8 × 40 1/4 in.)

By the 20th century, unicorns became a symbol of mysticism, uniqueness, immaculacy and romance.

It was generally believed, up until the Renaissance, that unicorns were real. In fact, many Europeans claimed to have actually seen one, including the Italian merchant and explorer Marco Polo (1254–1324) and the German politician Bernhard von Breydenbach (1440–1497), who wrote about his experience in *A Journey to the Holy Land* in 1486.[23]

Another aspect of unicorns, which developed in the late Middle Ages and Renaissance, was their connection with love. Scenes that showed a hunt for a unicorn became an allegory of the pursuit of romance, with the unicorn symbolizing the naturally wild but ultimately biddable groom conquered by the chaste bride.

From the seventeenth century onwards, as the realization dawned that unicorns were not so much rare and real as completely mythical, they became increasingly less prominent in art. However, a resurgence of interest occurred in the Victorian period, with the rediscovery and romanticization of medieval art that was seen by some as a corrective to ills of the industrial revolution. Unicorns began to appear in some art, as well as in children's literature, as a symbol of rarity, the imagination and the ideal.

And so to the present day. The unicorn is now a curious dilution of all the associations it has been burdened with in the past – a creature of innocence and inventiveness, of purity and singularity.

A Wild Unicorn Hunt

A **Rose** by Any Other Name

If you are intending to send flowers to your crush on Valentine's Day, you probably won't be choosing irises, lilies, lotuses or sunflowers: only a rose will do. Farmers from as far afield as China, the Netherlands and Ethiopia co-ordinate with shipping companies, auctioneers and retailers to ensure a healthy supply of red roses on February 14th. This example of floral symbolism is one that the flower industry stakes billions of dollars on every year. Where and when in history did the rose become the flower of love?

In ancient Greece, roses were closely associated with Aphrodite, goddess of sex and beauty. Velvety, voluptuous and headily scented roses were offered to her shrines, just as they would be to Venus, the Roman manifestation of Aphrodite. Various festivals dedicated to Venus involved the display and garlanding of roses, especially to signify the start of spring.[24] Thus, when a well-educated Roman inspected the tight whorls of a rose's petals, their botanical appreciation would have been complemented by cultural associations with Venus's command of erotic desire and animal passions.

Roses (like **pearls**, pp. 252–57) were a major Roman obsession, and they were grown in whichever of the empire's territories could sustain them. The frescoes that survive from the city of Pompeii testify to the grip that roses had on the Roman imagination. An industry in the production of the flower fed an appetite for perfumes, bounteous gardens and decoration in the Roman world.

After the dissolution of the western Roman empire in the fifth century CE, rose propagation declined, and for almost a millennium their symbolic power in the arts receded. Not only was there less infrastructure to support the

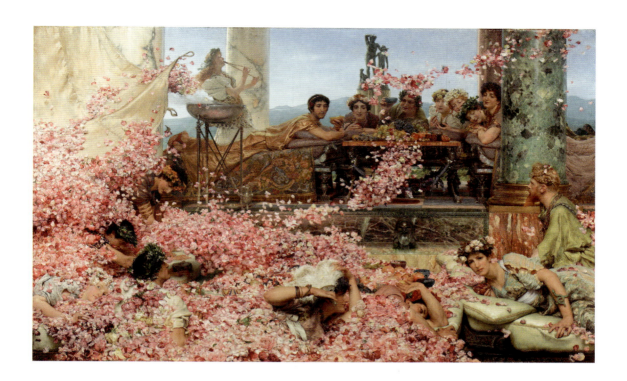

Lawrence Alma-Tadema, *Spring, The Roses of Heliogabalus*, 1888. Oil on canvas, 1.32 × 2.14 m (4 ft 4 in. × 7 ft ¼ in.)

According to ancient sources, the Roman emperor Elagabalus festooned his guests with flower petals during an orgy – so many in fact that some of the guests were suffocated. Alma-Tadema saw roses as the perfect flower to symbolize voluptuousness and danger.

previous levels of flower farming, but roses had also acquired negative associations with the perceived decadence of Rome.[25] Early Christian writers such as Clement of Alexandria (150–215 CE) even singled out the rose specifically as a symbol of the sin of luxury, the kind of thing that could easily lead you away from the straight and narrow path of Christian rectitude.

It was not until the thirteenth century that the propagation and iconographic power of roses in Europe returned to the levels they enjoyed in the Roman world. With an increase in the visibility of the flower at this time, the ancient symbolic link to love resurfaced once again. Secular medieval art increasingly abounded with rose motifs as a symbol of passion, with the Old French poem 'Roman de la Rose' (1275) being the leading literary iteration of a connection between a rose and the pursuit of love. It reflects the period's chivalric attitudes, but also articulated a high degree of sensuality, extending to thinly veiled erotic innuendo in its descriptions of the botany of the flower.[26]

A parallel but divergent association with spiritual love occurred at around the same time, with the rose emerging as the transcendent Christian flower symbol. The Bible itself includes very few references to true roses, but the

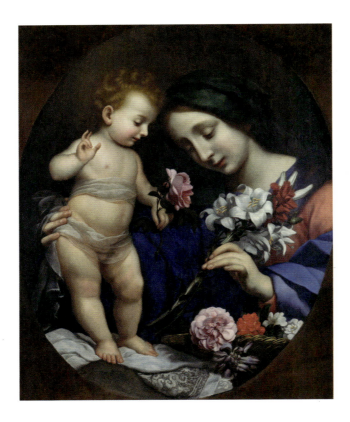

ABOVE After Carlo Dolci, *The Virgin and Child with Flowers*, after 1642. Oil on canvas, 78.1 × 63.2 cm (30¾ × 25 in.)

In this painting the Virgin's tenderness and purity are signified by flowers, of which the rose and lily are the most important.

OPPOSITE Rachel Ruysch, *Roses, Convolvulus, Poppies and Other Flowers in an Urn on a Stone Ledge*, late 1680s. Oil on canvas, 108 × 83.8 cm (42½ × 33 in.)

In still-life paintings, flowers sometimes held hidden meanings. Exotic flowers like roses signified the transience of life and beauty.

flower did receive theological examination in the writing of early Christian thinkers such as St Cyprian (210–258 CE), who, in contrast to the suspicions of Clement of Alexandria, conceived it as the flower of paradise. Other early writers also claimed that roses grew where the blood of certain martyrs touched the earth.

Eventually a recognized system of rose iconography emerged. White roses stood for Mary's virginity, red for her compassion at the suffering of Jesus. Yellow ones, which were believed to resemble the crown of Jesus after his ascension to heaven, signified resurrection.[27]

The high point of the Christian veneration of roses came with the institution of the Pope's annual bestowing of a golden rose on a worthy recipient. The tradition, started in 1096 and continuing to this day, involves the creation of an ornate three-dimensional sculpture of a rose made of pure gold and sometimes also decked with precious gems. Here and throughout Christian art, roses had attained a status and mysticism like that of the **lotus** (see pp. 105–9) in the east. It was a marvel of nature whose perfection signified the mystery

THE HIDDEN LANGUAGE OF HOPE

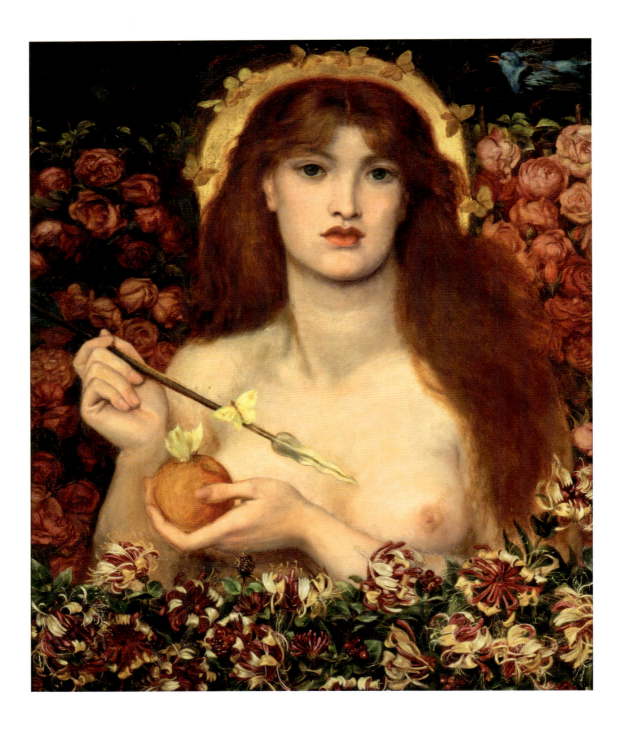

OPPOSITE Dante Gabriel Rossetti, *Venus Verticordia*, 1864–68. Oil on canvas, 81.3 × 68 cm (32⅛ × 26⅞ in.)

The title of this painting translates as 'Venus, changer of hearts', and implies the turn from lust to love, symbolized by multiple motifs including the heady rose.

ABOVE Francisco de Zurbarán, *A Cup of Water and a Rose*, c. 1630. Oil on canvas, 21.2 × 30.1 cm (8⅜ × 11⅞ in.)

Although this looks like a straightforwardly observed still life, the symbolic significance of water and rose would once have been understood as a reference to the Virgin Mary.

and majesty of heaven – the macrocosmic spiritual dimension attainable through the microcosmic.[28]

Roses had more practical emblematic duties too. For example, they were used as family emblems, such as for the houses of Lancaster and York who fought one another during the English Wars of the Roses (1455–1487). Queen Elizabeth I (1533–1603) retained the white rose as an insignia (see pp. 50–51), and it was used prominently in portraits of her and members of her court to express devotion to the Virgin Queen.

In the Baroque period, after the Reformation and bloody wars of religion between the Catholic and Protestant Churches, the symbolism of roses took a darker turn, with the red roses of Christ's ultimate sacrifice for mankind being more prominent in paintings.[29] The period also saw the development of the genre of still-life paintings in the Dutch Republic, in which roses often featured as vanitas symbols, much like **skulls** (pp. 142–47), **bubbles** (pp. 188–91) and guttering candles, to denote the impermanence of worldly pleasure and the brevity of life itself.

The symbolism of plants was marketed to audiences in the Victorian period in several books titled *The Language of Flowers*, including the rose of love. Many painters, most prominently the English Pre-Raphaelite Brotherhood – who followed the fad for flower symbolism, but also believed in the cultural merits of emulating medieval artistic practice – depicted roses to symbolize passion in both the sacred and sexual forms. Artists such as Lawrence Alma-Tadema (1836–1912) and Dante Gabriel Rossetti (1828–1882) drew upon the symbolism of roses as a voluptuous and seductive flower from art history as well as contemporary poetry. The effect was sometimes erotic, sometimes to warn of decadence and sometimes a *memento mori*.[30]

The story behind your Valentine's Day bouquet of roses links classical mythology with Christian teachings, medieval literature and Dutch still lifes. The various associations grafted onto the flower through the generations show us that the rose is much more than a simple flower of love – it has also been associated with eroticism, decadence, sanctity and morbidity. But don't let that put you off on February 14th.

A Rose by Any Other Name

Why an **Orchid** Represents the Perfect Man

Tesshū Tokusai's brush moved like lightning as it licked the blade of an orchid leaf into existence, right to the edge of his paper and beyond. Executed in the tranquillity of a Zen monastery in the heart of Kyoto at some time in the mid-fourteenth century, Tesshū's orchid is a masterpiece of highly trained effortlessness. But while you may think that a delicate orchid would be a symbol of feminine grace to the artist, it was actually a symbol of specifically masculine virtues.

Orchids are a rare flower in nature, and – in European painting at least – equally rare to see as a symbol in art. To trace the origins of symbolic orchids, the place to start is in China. It was there that they have been held in high esteem ever since they were praised in the writings of Confucius (551–479 BCE). In China, orchids only appear in autumn, often in secluded and remote spots, deep in the wilderness – and it was the association with modesty and grace, in tandem with a gentle fragrance, that made the flower particularly appreciated.[31]

Qu Yuan (343–227 BCE), a poet-statesman from the Chu region of China, entrenched the symbolism of the modest orchid in one of his poems for the canonical verse anthology *Songs of the South*. Having been disgraced and exiled from high office to the desolate northern regions, he recast the orchid in verse as a symbol of his own unrecognized honour and loyalty, describing the flower as isolated but self-reliant, cultured yet unpretentious. The orchid was also later to catch on in poetry as a symbol of tragedy: within a few short years of the completion of *Songs of the South*, the distraught Qu Yuan drowned himself in the Miluo river.[32]

ABOVE: LEFT Tesshū Tokusai, *Orchids, Bamboo, Briars and Rocks*, Japan, Nanbokuchō period, mid-14th century. Hanging scroll, ink on paper, 72 × 36.8 cm (28³⁄₈ × 14½ in.); RIGHT Gyokuen Bonpō, *Orchids and Rock*, Japan, Muromachi period, late 14th–early 15th century. Hanging scroll, ink on paper, 100.5 × 33.4 cm (39⁵⁄₈ × 13¼ in.)

These paintings show the enduring popularity of the orchid in Japanese art.

It was not until the Song dynasty (960–1279) that Chinese painters began to represent orchids in ink-and-brush paintings, usually in a rocky setting with maybe one or two other plants, as a symbol of the gentleman in solitude. Its symbolism evolved after China was invaded and ruled by the Mongols during the Yuan dynasty (1279–1368). Artists pointedly started to paint only the leaves and flowers of orchids, but no surrounding rocks or soil. One artist, Zheng Sixiao (1241–1318), was asked why, and merely replied, 'the earth has been taken away by the barbarians'. He became fixated by the symbol, compulsively painting the flower in different formats, including on a monumental 3-metre (10-foot) long piece of paper.

Such artists are referred to as 'literati' painters. The literati were high-ranking Chinese intellectuals who practised art proudly as amateurs. They

Why an Orchid Represents the Perfect Man 229

Zheng Sixiao, *Orchid*, China, Yuan dynasty, *c*. 1306. Ink on paper, 25.7 × 42.4 cm (10⅛ × 16¾ in.)

This orchid is a coded symbol of political protest: the lack of earth was intended to suggest the literati's rootlessness after the Mongol invasion of China.

focused on simple images of nature and painted with a studied simplicity, using ink with the deft touch of a calligrapher. The origins of this very broad school of artists may date from the third and fourth centuries CE, when groups of well-educated dropouts like the self-titled 'Seven Sages of the Bamboo Grove' met in rural retreats to imbue their souls with the simple pleasures of nature, debate artistic and philosophical matters and drink copious amounts of alcohol. The most famous event of this kind occurred in 353, when forty-two literati met up for a rural festival of culture and binge-drinking: it became enshrined in legend as the 'orchid pavilion gathering'.[33]

Literati artists were not all male. The Ming-dynasty courtesan Xue Susu (1564–1650) is one example of a female painter who repeatedly painted orchids, which for her was a symbol of the outsider. But it was much more commonly linked with the cultured gentleman in solitude, and the symbolism eventually spread beyond China to neighbouring regions, including Korea and Japan.

Tesshū Tokusai made a pilgrimage from Japan to the Chinese city of Suzhou at some point in the early fourteenth century, to study under the Zen masters who lived there. He was taught by a monk and artist named Puming, yet another painter so obsessed by orchids that every house in the city was reputed to possess an example of one of his paintings of the flower.[34]

Tesshū in turn caught the orchid addiction, and he painted one every day in a state of ecstatic delirium in his old age. But he never forgot his original Chinese influences. The poem that Tesshū added to the upper section of *Orchids, Bamboo, Briars and Rocks* harks back to Qu Yuan from Chu, and his suicide in the icy rivers of the north:

> Thousands of miles now
> from the River of Chu,
> My thoughts multiply—
> I wonder, could there be anything
> As redolent as the solitary orchid?

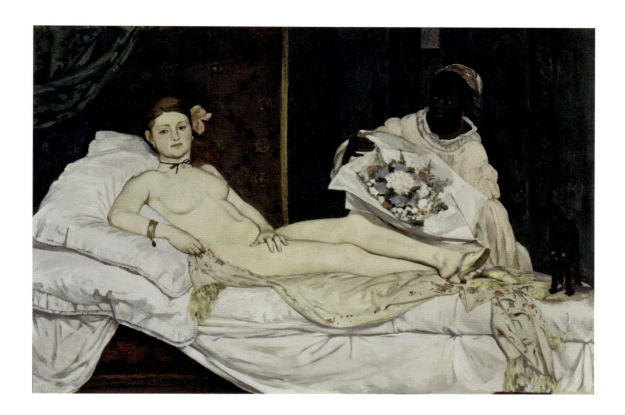

Édouard Manet, *Olympia*, 1863. Oil on canvas, 1.3 × 1.9 m (4 ft 3¼ × 6 ft 2⅞ in.)

Some have suggested that the orchid in the hair of Manet's *Olympia* symbolizes her decadence and indecency (since the flower physically resembles human genitalia) – a far cry from the flower's asceticism as celebrated in Chinese and Japanese art.

It is possible to detect the influence of Zen Buddhism, which was originally introduced to Japan in the Kamakura period (1185–1333), in Tesshū's poem and painting. Zen appealed to the newly influential samurai class because it was unpretentious and put a strong emphasis on mental discipline. Zen taught that spiritual insight was an innate possession of every individual and that it could not be learned through scripture; enlightenment occurs in moments of sudden realization and not through prescribed ceremony. Zen artist-monks like Tesshū made condensed observation and speed of execution a key part of their style, and this artistic discipline and decisiveness would be highly influential on a wide spectrum of Japanese aesthetics over the coming centuries.

If we could see Tesshū painting that final orchid blade in his monastery studio, we might see that this was the perfect match of subject and style: the unpretentious flower of masculine self-reliance painted in a blizzard of Zen realization and artistic efficiency.

Why You Should Always Trust a **Dog**

Petrarch (1304–1374), the early Renaissance Italian poet and scholar, sits in his cosy study, gazing out upon a southern European landscape with nothing to disturb his thoughts except the soft snoring of his pet dog, who lies curled in front of his desk. His portrait in the Hall of the Giants at Padua's Palazzo Liviano captures a vision of the humanist intellectual that would inspire countless other scholars through the Renaissance.

Why does a dog feature so prominently in the painting? The answer is that Petrarch was a great lover of canines. In a poem he penned in 1347 to his friend Cardinal Giovanni Colonna, Petrarch praised the multifaceted virtues of his beloved pet dog, who he described as being impulsive, brave, faithful and intelligent.[35] Anyone who has ever owned a dog will corroborate Petrarch's view: they are certainly not one-dimensional animals. And this is reflected in the way that humans have represented them in art, ever since their first domestication, as far back as 12,000 BCE.[36] Over the course of time, artists across the world have turned them into symbols by drawing upon their vast array of recognized characteristics.

In ancient Egypt, dogs were a common feature of visual imagery, with the focus on their supreme hunting skills and role as the companions of the nobility, two associations that would be perpetuated into the modern world. Dogs were domesticated beasts, belonging to both the human and the animal worlds, and their transitional status was reflected

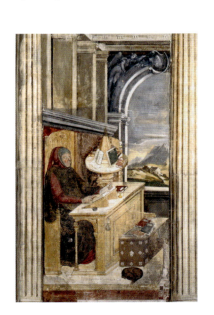

BELOW Attributed to either Altichiero da Zevio or Jacopo Avanzi, fresco with Petrarch in his study, Hall of the Giants, Palazzo Liviano, Padua, after 1374

A turning point in the representation of dogs as loyal companions in art.

THE HIDDEN LANGUAGE OF HOPE

PAGE 233 Anthony van Dyck, *James Stuart, Duke of Richmond and Lennox*, c. 1633–35. Oil on canvas, 2.16 × 1.28 m (7 ft 1 in. × 4 ft 2¼ in.)

Dogs frequently appear as symbols of loyalty and companionship in portraiture.

in Egyptian religious beliefs. The canine-headed god Anubis, for example, existed between life and death and was a 'psychopomp', responsible for escorting souls to the afterlife.[37] This must be a universal association, because dogs are psychopomps in very distinct and disconnected belief systems, including European Celtic mythology, Iranian Zoroastrianism and Aztec religions. In Greek mythology, the ferocious three-headed dog Cerberus sat directly on the border between life and death, guarding the underworld.

Dogs were also represented as beloved pets and faithful companions in ancient Egyptian art, and were sometimes buried with their owners. Likewise, they were routinely represented as domesticated pets in the cultures of ancient Greece and Rome, as well as guards, hunters and the companions of shepherds. Dogs were given human names in these times, as is recorded in Homer's *Odyssey*, and also cherished by humans, according to the writings of Aristotle, Strabo and Pliny the Elder. From this period, we also get the first recognition of hounds as intelligent beasts, in the writings of Plato, among others.[38]

Petrarch's letter to Giovanni Colonna consciously echoed the opinions of these classical authors. His portrait from Padua is an important moment in the iconography of dogs because it would go on to create a link between the ideal humanist scholar and canine companions. Most significant among these are two very famous images from the early sixteenth century, Albrecht Dürer's *Saint Jerome in His Study* and *Melencolia I*, the latter being one of the most famous (and most enigmatic) images to use symbols in art history (see pp. 6–7). It is believed that these two engravings may have been

BELOW Mechanical dog, Egypt, 18th dynasty, c. 1390–1353 BCE. Ivory, 6.1 × 18.2 × 3.6 cm (2½ × 7¼ × 1½ in.)

Dogs were also seen as loyal pets in ancient Egypt. A lever in the underside of this toy makes the mouth open and close.

THE HIDDEN LANGUAGE OF HOPE

ABOVE LEFT Albrecht Dürer, *Saint Jerome in His Study*, 1514. Engraving, 24.6 × 18.9 cm (9¾ × 7½ in.)

Dürer's famous etching inspired the belief that a dog (shown next to the lion) was the ideal companion of a scholar.

ABOVE RIGHT Domenico Fetti, *Melancholia*, c. 1615. Oil on canvas, 149.5 × 113 cm (58⅞ × 44½ in.)

Dürer's *Melencolia I* inspired other artists to treat dogs as a symbol of sadness.

designed as a complementary but opposed pair, reflecting upon the dual nature of the scholarly life.[39] In both of them, Dürer uses a dog to signify intelligence. However, in *Saint Jerome in His Study* the dog, lying contentedly beside Jerome's usual attribute of a lion, is well-fed and content, whereas in *Melencolia I* the dog is skinny and miserable. This second image popularized the notion, recognized before but not hitherto articulated so profoundly in art, of the dog as a symbol of depression.

Yet the most typical symbolism of dogs is in their association with loyalty, particularly to signify fidelity between couples in marriage portraits. This notion was codified in Renaissance books of emblems, known as 'emblemata': Andrea Alciato's famous *Emblemata* of 1531, for example, included a dog to accompany the notion of 'faithfulness in a wife.' This aspect of dogs occurs in various global cultures: in the Chinese and Japanese zodiac, for example, the eleventh sign is a dog, and people who are born in that year are thought to be loyal and honest.

The next twist in the symbolic meaning of dogs came in the seventeenth and eighteenth centuries, as societies in Europe became more affluent. A new middle class of wealthy but non-aristocratic citizens became, among many

Why You Should Always Trust a Dog

BELOW Attributed to Antonio del Massaro da Viterbo, *Santa Francesca Romana Clothed by the Virgin*, c. 1445. Tempera on wood, gold ground, 55.2 × 37.8 cm (21¾ × 15 in.)

The Bible disdained canines: the dogs (and cats) at the bottom of this scene are believed to represent devilish forces, intend on disrupting the heavenly events above them.

OPPOSITE Jean Honoré Fragonard, *The Love Letter*, early 1770s. Oil on canvas, 83.2 × 67 cm (32⅞ × 26½ in.)

In French Rococo paintings by artists such as Fragonard, dogs became playthings, with varying degrees of erotic suggestiveness.

other things, patrons and purchasers of art, as well as proud pet owners. Art made for this new bourgeois class modified its iconography, to make it more relevant to changing values in society. In genre paintings of the Dutch Republic and in the art of William Hogarth (1697–1764) in England, for example, dogs frequently behave in ways that reveal the uncomfortable truths of narrative scenes, reflecting the unconscious attitudes of the humans they accompany, usually their lust or greed.[40]

The greater expressiveness and range of iconographic roles was new, but the idea that dogs symbolize depravity was not. That attitude generally had its roots in the Abrahamic religions, all of which describe dogs as unclean and unwelcome in human society. The Bible is very damning about them, with the Book of Revelation (22:15), for example, explicitly bunching them together with the worst kind of company: 'Outside are the dogs and sorcerers and the sexually immoral and murderers and idolaters, and everyone who loves and practises falsehood.'

The eighteenth and nineteenth centuries saw an increasing sentimentalization of dogs in art. A fashion among upper-class women to be depicted alongside their lapdogs turned canines into symbols of luxury and idleness in Rococo portraits. The close contact of miniature dogs with ladies of leisure led to some artists, such as Jean-Honoré Fragonard (1732–1806), to depict them as erotic symbols in scenes that are little more than a pretext for depicting young women frolicking unguardedly in intimate domestic settings.[41]

The essential nature of dogs has not changed, but human culture has. Over time, different aspects of the canine character have been emphasized in art, but one constant theme has remained. Dogs have generally been regarded as inbetweeners, transitional creatures that inhabit both the human and the animal spheres – they are like us, but they are better connected to the instinctive, primal world of nature. At times this has caused us to revile them, and at other times to regard them as divine. Their usefulness has made them symbols of faithfulness, hunting and guardianship. Their similarity to us has made them symbols of intelligence, melancholy and lust.

Extraordinary **Parrots**

In the twentieth century, specialists identified an Australasian sulphur-crested cockatoo in Andrea Mantegna's *Madonna della Vittoria* (1495–96). It is perched in an opening in the ornamental pergola almost directly above the Madonna's head. How did it get there? The painting was created in the city of Mantua, Italy, long before Europeans had apparently interacted with animals from the other side of the 'Wallace Line'.

The Wallace Line, which runs from the Indian Ocean to the Philippine Sea, is a hypothetical boundary demarcating the ecosystems of Asia and Australasia. It is a useful concept for ecologists to compare the distinctive animal and plant life of the two regions. But it is also helpful for the study of global history, because the regions to the line's east were for a very long period beyond the reach of European trade: the generally held view is that the native Australian ecology was unseen by western eyes until Captain Cook's landfall in 1770.[42]

It is unlikely that Mantegna or his patron Francesco Gonzaga, Marquess of Mantua, were aware just how unique this cockatoo was. At the time, it would have been indistinguishable from other types of parrot hailing from Africa, India and other exotic places of origin. Parrots were certainly an unusual pet for Europeans at the time, and they were treated like a collector's piece in highly crafted ornamental gardens. Paradoxically, this made them a not uncommon subject in art, and particularly in religious imagery: their scarcity in real life made them an automatic symbol of wealth, reflecting favourably on whoever commissioned them and the community they served. Because of their strangeness and the jewel-like radiance of their colouring,

Andrea Mantegna, *Madonna della Vittoria*, 1495–96. Oil on canvas, 2.8 × 1.66 m (9 ft 2¼ in. × 5 ft 5⅜ in.)

The Australasian sulphur-crested cockatoo is in the upper level of the pergola, in the third opening from the left.

they were also assumed to hail from the garden of paradise, giving them an association with holy purity.

Thus, a cockatoo was a very good symbol for a painting like *Madonna della Vittoria*, which was intended to glorify the patron, Gonzaga, who is kneeling in armour at the left forefront of the painting, as well as honour Mary, mother of Jesus. Gonzaga had just claimed a narrow victory in battle against Charles VIII's French army at Fornovo in 1495, and the painting provided some much-needed positive publicity to the city of Mantua. Before being installed in the church of Santa Maria della Vittoria, it was paraded through the streets of Mantua so that the population could admire the Marquess, his divine company and their glamorous, abundant and enchanting setting.

Parrots' exoticism and ability to mimic speech have given rise to both positive and negative associations across cultures. They were highly regarded by the Aztecs and aboriginal peoples of Australia, and a parrot is the attribute of the Hindu god of love, Kama. In the Renaissance, as well as symbolizing purity and wealth, parrots were linked to the Annunciation, when the angel Gabriel tells Mary about her destiny to give birth to Jesus, through their ability to deliver messages. However, in Rome, where parrots were imported as distinctive pets and therefore featured more prominently in art, they were sometimes depicted as ignorant, feckless and inanely repetitive. After the Renaissance, as parrots became more popular and common pets, they once again became associated with decadence and luxury.

Gustave Courbet, *Woman with a Parrot*, 1866. Oil on canvas, 1.3 × 1.96 m (4 ft 3⅛ in. × 6 ft 5⅛ in.)

Parrots became more frequently associated with sex and decadence in art as they became more common pets in post-Renaissance centuries.

THE HIDDEN LANGUAGE OF HOPE

Rosalba Carriera, *A Young Lady with a Parrot*, c. 1730. Pastel on blue laid paper, mounted on laminated paper board, 60 × 50 cm (23⅝ × 19¾ in.)

The exoticism of parrots and their intimate relationship with young women as pets has been used to erotic effect in Carriera's painting.

How did the Antipodean cockatoo manage to get itself into Mantegna's *Madonna della Vittoria*? Historian Heather Dalton has investigated the possible ways that it could have made its epic journey: either as a diplomatic gift, a luxury good to be traded or as a curio picked up by an intrepid Italian merchant. In the latter two cases, it is likely to have been sold in the port city of Venice, which the Gonzagas and Mantegna are known to have visited.[43]

Italian merchants are known to have travelled to Southeast Asia, and may have visited the burgeoning trading station of Malacca in Malaysia. In this frenetic entrepôt, exotic species were bought and sold to merchants from across the world. Among those who brought goods to the city were traders

Caspar Netscher, *A Woman Feeding a Parrot, with a Page*, 1666. Oil on panel, 45.7 × 36.2 cm (18 × 14¼ in.)

Parrots were a prestigious possession in the 17th-century Dutch Republic, evidence of the international trade routes that brought luxury goods to the nation.

from the Indonesian island of Sulawesi. And it is a thrilling possibility that these men may have established a sea route to Arnhem Land in northern Australia, where they collected rare animals for sale.

The cockatoo in the *Madonna della Vittoria* must have had a spectacular life-story, involving youth in the wilds of Australasia, an epic journey through the vibrant late medieval trading stations of Southeast Asia and along the Silk Roads to Mantua. The culmination of this epic voyage was having her portrait painted by one of the Renaissance's greatest painters, enshrining her for immortality.

The Friendly Plant: **Sunflowers**

Sunflowers (*Helianthus annuus*) are a symbol that have blazed like a meteor across art history, seducing countless artists to represent them at the expense of lesser plant species. And although the symbolic meaning of sunflowers has been reshaped to a degree in the hands of different creative individuals through history, they are linked to the same theme: devotion.

That is the reason the Baroque Flemish artist Anthony van Dyck (1599–1641) used them in several of his paintings in the seventeenth century. In his 1635 portrait of the English courtier Sir Kenelm Digby, the sunflower seems to gaze at the sitter, like a pet fawning at its master, yellow petals twitching with excitement. Well might it be fascinated. Digby's life was thoroughly unconventional: at various times he was a writer, astrologer, naval privateer, alchemist and diplomat. His beloved wife Venetia had died in 1633, so the sunflower may be a symbol of his devotion to her, but there are other possibilities. He was a loyal servant of the king, and would fight on the Royalist side in the English Civil War (1642–51), so the flower may allude (as it had in Van Dyke's other portraits) to his loyalty to the sovereign.[44]

Both interpretations indicate the Neoplatonic interests of the artist and sitter. According to Neoplatonism, each human soul is a subdivision of a single, unified and eminent essence with whom humanity yearns to reconnect. The sunflower, which resembles the sun and was believed to be heliotropic (turning its head to face the position of the sun as it moves through the sky), seemed to be an ideal embodiment of this correspondence between earthly matter and the heavens.

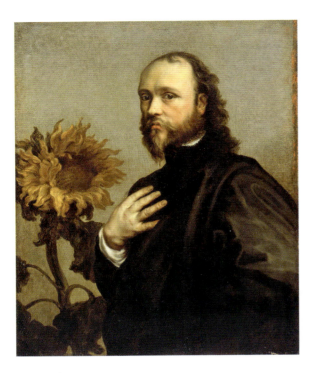

ABOVE LEFT Anthony van Dyck, *Sir Kenelm Digby*, 1635. Oil on canvas, 91.5 × 71 cm (36⅛ × 28 in.)

The sunflower may be a symbol of Digby's devotion either to his recently deceased wife or to the king.

ABOVE RIGHT Maria van Oosterwijck, *Flowers in an Ornamental Vase*, c. 1670–75. Oil on canvas, 62 × 47.5 cm (24½ × 18¾ in.)

A sunflower and carnation stare at one another like lovers above a small statue of Clytie.

The Neoplatonic reading of sunflowers was influenced by a specific source in the previous century. This was a book called *De Materia Medica* (1568), an updated version of a classical text on plants, which included what is probably Europe's first ever image of a sunflower, complete with a description of its properties by the Italian botanist Giacomo Antonio Cortuso (1513–1603).[45]

The symbolism of sunflowers doesn't go back any further in European history because they didn't exist in Eurasia before the sixteenth century. There are no sunflowers in the art of the ancient Greeks or Romans or the civilizations that preceded them, nor in the visual culture of medieval Europe, Africa, Asia or anywhere other than the Americas before the 1560s. Sunflowers are native to South America, and only entered Europe after the Spanish colonization of the New World.

Cortuso initiated the belief that mature sunflowers were heliotropic. In fact, only immature sunflowers face the sun, but the mistake was to have a decisive impact on the sunflower's iconography. In typical Renaissance fashion, Cortuso also felt compelled to understand the plant in the terms of the classical past, so he made a link to the mythological story of Clytie. Clytie was a nymph who fell so deeply in love with the handsome sun-god Apollo

that she metamorphosed into a flower whose face perpetually tracked his solar movements. Originally, it was believed that the diminutive heliotrope was Clytie's flower, but soon it was supplanted by the sunflower in the collective cultural imagination.

When artist's emblem books (known as 'emblemata') began to include sunflowers as a symbolic plant at the beginning of the seventeenth century, they perpetuated the association with Clytie. Sunflowers were now linked with her character: unswervingly devoted to a superior being. So sunflowers became a symbol either for the loyalty of a courtier to a king, or for the besotted lover. Somewhat paradoxically, sunflowers also became an attribute of the Virgin Mary in art. The English writer Henry Hawkins (1577–1646) noted in his book *Partheneica Sacra* that it served well as a symbol of her dedicated motherhood, and thus of Christian commitment in general.[46]

In 1654, the Dutch poet and playwright Joost van den Vondel (1587–1679) pushed the symbolic potential of the sunflower further in his essay 'Inauguration of the Art of Painting on St Luke's Feast':

> 'Just as the sunflower, out of love, turns his eyes towards the heavenly canopy and follows with his face the all-quickening light of the sun who bestows colour upon the universe and kindles trees and plants – thus the art of painting, from innate inclination and kindled by a sacred fire, follows the beauty of nature.'[47]

This likening of a sunflower to the painter's eye transfixed by nature had an influence on Maria van Oosterwijck's *Flowers in an Ornamental Vase* (*c.* 1670–75), in which the flower's seed head has a distinctively ocular aspect as it locks gaze amorously with a red carnation above a statue of Clytie.

Vincent van Gogh (1853–1890) may be the most famous painter of sunflowers in history. What did he think his *Sunflowers* symbolized? In general, he was reticent on such matters, but he made just one telling statement in a self-excoriating letter to one of his sisters, written in the year of his death. 'The desire comes over me to remake myself and try to have myself forgiven for the fact that my paintings are, however, almost a cry of anguish', he wrote, 'while symbolizing gratitude in the rustic sunflower.'[48] This enigmatic statement was perhaps highly personal, directed at his fellow artist Paul Gauguin (1848–1903), on whom he doted for esteem and affection. In Arles, where he had hoped to establish a colony of like-minded artists, he painted a whole series of sunflower still lifes, intending for them to decorate the rooms of the

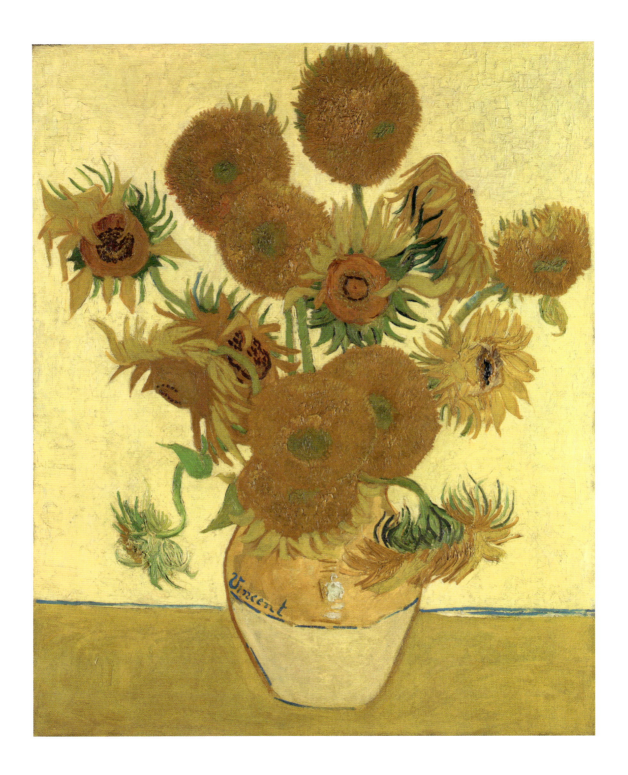

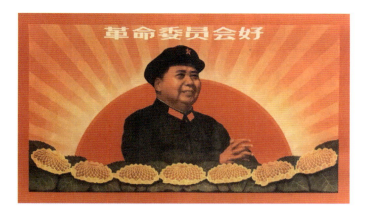

OPPOSITE Vincent van Gogh, *Sunflowers*, 1888. Oil on canvas, 92.1 × 73 cm (36⅜ × 28¾ in.)

Van Gogh wrote 'my paintings are, however, almost a cry of anguish, while symbolizing gratitude in the rustic sunflower' – but gratitude to whom?

ABOVE Poster with Mao Zedong and sunflowers, 1960s

Sunflowers symbolized subservient loyalty in Mao's China.

house he had rented for them to live and work in. Gauguin was the only one to arrive, although he could only bear to live with the irascible Dutchman for a few months. The gratitude, on the other hand, could be of a more numinous order, linking back to the devotion of the Virgin Mary – Vincent, after all, was a deeply religious and artistically literate soul. It could be, as it was for Maria van Oosterwijck, a symbol of 'art' itself. Or it could be gratitude to the south of France, which he had hoped would become his own sun-filled arcadia and for which the sunflower was a perfect motif.

Ai Weiwei's (b. 1957) 2010 *Sunflower Seeds* transformed the Turbine Hall of London's Tate Modern into an indoor pebble beach, where visitors could walk, lie upon and wade around in 100 million porcelain sunflower husks. The idea of representing sunflower seeds came from the artist's memory of propaganda posters during the leadership of Mao Zedong (1893–1976), Chairman of the Communist Party of China from 1949 to 1976. In these images, Mao was often represented above fields of sunflowers that represented the Chinese people, heliotropically loyal to whichever direction he pursued. It was a piece of symbolism that would have been recognizable to a Baroque courtier, proving that the language of symbols can cut across both time and national borders.

But Ai Weiwei's sunflowers also created a new departure. Unlike many sunflowers in art history, Ai Weiwei's seeds are not singular or spectacular, and they embody potential, pointing to future enrichment rather than allegiance to a regime of the present. Each porcelain seed is seemingly interchangeable, an anonymized produce of the communist production line. But they have not yet bloomed into their role as Mao's ideal subjects, and the hope remains that they will be devoted to a different source of light.

The Friendly Plant: Sunflowers

The **Carnation**: Flower of Sorrow or Joy?

Caught in a beam of evening sunlight, the blood-red 'pink' – as carnations were once called – in Rembrandt's (1606–1669) *Woman with a Pink* (early 1660s) seems to glow with life against its dark and dusty setting. What is its significance? Traditionally, carnations are symbols of betrothal, so the painting was assumed to have been made in celebration of a marriage. Another Rembrandt painting of similar dimensions known as *Man with a Magnifying Glass* (early 1660s) could have been a pendant image showing the woman's husband, who is thought to have been Pieter Haringh, an auctioneer who lived in Amsterdam.

The origins of the link between carnations and marriage in the Netherlands is difficult to establish with certainty, although an often-cited explanation is an old Netherlandish marriage tradition in which a bridegroom had to discover a carnation hidden in the clothing of his bride on their wedding night. Rembrandt's painting fits seamlessly into a very popular type of portrait, especially in Northern Renaissance art, of men and women holding carnations to show that they are happily partnered up.[49] But why is this symbol of the hope of a fulfilled marriage set in such a forlorn setting in *Woman with a Pink*?

It may refer to an alternative symbolic meaning of carnations. One was as a symbol of Christ, since the Greek name for the flower is *dianthos*, meaning 'the flower of god'. Red carnations were only developed in the early fifteenth century. Horticulturalists breeding this intense red variant would have an impact on artistic iconography: it would become another emblem of the blood shed during the crucifixion, just like the red **rose** (see pp. 222–27) and **poppy** (pp. 179–83). The link to sacrifice would reoccur in later years too, in

Rembrandt, *Woman with a Pink*, early 1660s. Oil on canvas, 92.1 × 74.6 cm (36³⁄₈ × 29³⁄₈ in.)

The carnation appears to symbolize marriage in this painting.

THE HIDDEN LANGUAGE OF HOPE

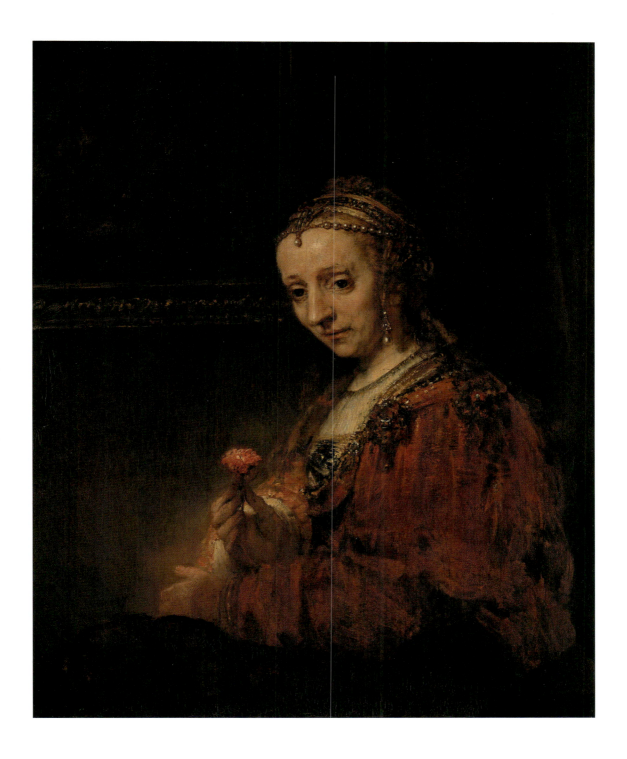

ABOVE LEFT Netherlandish painter, *Portrait of a Man in a Chaperon*, c. 1440s. Oil on wood, 27.9 × 19.7 cm (11 × 7¾ in.)

It is believed that the carnation in this portrait was only painted in after the man (whose identity we do not know) got married.

ABOVE RIGHT Barthel Bruyn the Elder, *Portrait of a Woman*, 1533. Oil on oak, 29.8 × 20.6 cm (11¾ × 8⅛ in.)

This is one of a pair of portraits that show a couple before their wedding day.

sometimes rather unexpected guises. In the twentieth century, carnations took on a political significance after they became the symbols of revolution. During the 1917 Russian Revolution, they became an emblem of the uprising and appeared on badges and posters. In 1974, the Portuguese Revolução dos Cravos ('Carnation Revolution') saw the overthrow of the dictatorial Estado Novo regime celebrated by decorating soldiers' uniforms and rifles with carnations.[50]

Could Rembrandt's carnation be a symbol of sacrifice rather than marriage? The way that the carnation is presented to the viewer in *Woman with a Pink* may be significant. It shows a very specific hand position with upturned and pursed fingertips usually only seen in Indian Mughal miniatures, where the hand pose is known as *mukula*. We know that the artist collected Mughal portraits, and various Indian costumes and poses appear in his work, including *Woman with a Pink*. In fact, it is one of only very few European paintings of the seventeenth century that is likely to have been directly inspired by a non-western source.[51] When Rembrandt painted it, contact between the Dutch Republic and Asian countries was thriving, facilitated by the Dutch East India Company's trading activities. Alongside

ABOVE LEFT Hans Holbein the Younger, *Portrait of Simon George of Cornwall*, c. 1535–40. Mixed technique on oak, diameter 32.4 cm (12⅛ in.)

Simon George probably commissioned this portrait to signify his desire to marry: the carnation and the hat badge showing Leda and the swan (a mythological story about the consummation of love) are both symbolic overtures.

ABOVE RIGHT Otto Dix, *Self-Portrait*, 1912. Oil on paper mounted on poplar panel, 73.7 × 49.5 cm (29⅛ × 19½ in.)

Dix's technique and use of symbolism show his indebtedness to the Northern Renaissance.

the unprecedented influx of exotic spices, fabrics and luxury goods were works of art that were collected by Dutch artists and connoisseurs. The reason that Rembrandt copied non-western accoutrements and gestures was because he was always seeking greater authenticity in his religious commissions, and he believed that people from eastern lands behaved in similar ways to those described in Christian scripture. Even though it is a portrait, Rembrandt clearly aimed to convey in his *Woman with a Pink* a sense of biblical grandeur, which points to a Christian interpretation of the carnation.

When New York's Metropolitan Museum of Art made x-ray and autoradiograph images of *Woman with a Pink*, they discovered something that may answer once and for all the question of what the carnation was meant to symbolize. Underneath the top layer of paint, in the lower left-hand corner of the painting, is a depiction of a child's head that was eventually overpainted. Why was it covered up? One theory is that it was the woman's son, who died before the painting was finished.[52] If so, the carnation may not be a symbol of marriage, but of sacrifice, and the object of a mother's sorrowful meditation.

The Carnation: Flower of Sorrow or Joy? 251

La Peregrina and the History of **Pearls** in Art

When pearls are represented in art, they might be deliberately symbolic, or they may simply record their ownership by an individual. In either case, they are always part of an epic historical story about a human obsession with beauty, purity and perfection. This can be learned from the life-story of one particularly famous pearl.

In the late 1960s, actors Elizabeth Taylor and Richard Burton were Hollywood royalty and indisputably the most famous couple in the world. Taylor was enjoying another carefree day in their apartment in Caesar's Palace, Las Vegas, when a courier arrived with a gift from Burton – a pearl he had recently bought for $37,000 known as La Peregrina, 'The Wanderer'.

Elizabeth Taylor on the set of Charles Jarrott's *Anne of the Thousand Days*, 1969

Elizabeth Taylor wearing La Peregrina.

Taylor was passionate about natural pearls. And she was one of many celebrities of the day who had a similar obsession. In the 1950s and '60s, pearl necklaces and earrings were synonymous with glamour and were worn by the most famous and successful women of the day. La Peregrina was a 25.5-millimetre, perfectly drop-shaped specimen, which for centuries had been renowned as the largest natural pearl in the world. But its unique appearance was only half the story. La Peregrina had once been owned by the Habsburgs, one of Europe's most powerful royal dynasties, as well as the family of Napoleon Bonaparte. It had even been immortalized in portraits by artists including Peter Paul Rubens and Diego Velázquez. However, within minutes of its delivery, the priceless pearl mysteriously vanished into thin air.

THE HIDDEN LANGUAGE OF HOPE

Peter Paul Rubens, *Isabella de Bourbon, Queen of Spain*, 1628–29. Oil on canvas, 112 × 83 cm (44⅛ × 32¾ in.)

King Philip IV of Spain's consort Elisabeth of France, who became known as Isabella, wearing La Peregrina.

This was just the latest misadventure of La Peregrina. It was first discovered in the late sixteenth century in the Gulf of Panama in Central America. The Spanish had begun their conquest of the New World around a century earlier, with Christopher Columbus (1451–1506) famously making landfall in the Caribbean in 1492. In a way, the pearl served as a symbolic justification of the whole project of colonization: among the original motivations for the Spanish to explore and exploit new lands was the lure of ever bigger and more beautiful pearls. La Peregrina was sent back to the King of Spain, Philip II, and became a centrepiece of the Spanish crown jewels. Thus, later portraits of members of the Spanish royal family wearing La Peregrina don't just signify personal wealth. They also connoted the nation's colonial expansions in the New World and the authority it granted Spain via trade and the exploitation of natural resources.

Have pearls always connoted such qualities? Historical data suggests that they have been a high-status commodity and a key trading asset for a very long time. Archaeological evidence of pearl hunting shows that it has been thriving since 5000 BCE, and led to the establishment of ancient trade routes between pearling sites around the coast of the Indian Ocean and Red Sea, connecting the world's first cities.[53]

Pearls were also connected with ideal beauty. In Greek mythology Aphrodite, the goddess of love, is frequently linked with pearls. She was believed to have been born from the sea, and was frequently depicted in Roman art reclining within a shell or adorned with pearl jewelry, as can be seen in first-century CE frescoes from Pompeii.

For the Romans, 'the topmost rank of all things of price is held by pearls', according to Pliny the Elder, who was writing in the first century BCE.[54] This is corroborated by funerary portraits that survive from the Faiyum basin in Roman Egypt. Many of the women wear ostentatious pearl necklaces and earrings, even if they are likely not to be real ones. Even in Roman times, fake pearls had to suffice for those who could not afford them, leading to a thriving market of counterfeits made from silver and glass.

Like the Spanish many centuries later, the Romans were also motivated to conquer foreign lands due to the lure of pearls.[55] In 121 CE the historian Suetonius, for example, described how Rome's invasion of Britain was inspired by the promise of pearling sites in the territory's rivers.[56]

Added to wealth, ideal beauty and imperialism, pearls were also used as a religious symbol. In the 'Parable of the Pearl' in St Matthew's Gospel, Jesus is reported to have compared a pearl to heaven, and the believer to a pearl merchant: 'when he found one of great value, he went away and sold everything he had and bought it.' Pearls were later used as a symbol of Jesus himself: rare, perfect and pure. By the Renaissance, pearls were adhered to decorative religious items like crucifixes to indicate the high virtues of Christ and the Virgin Mary. This came in spite of early Christian writers like Clement of Alexandria who condemned the pearl if it was used decoratively as a distracting luxury that would misdirect believers from their proper Christian meaning (much as he criticized the **rose**, see pp. 222–27).[57]

Diego Velázquez, *Queen Elisabeth of France on Horseback*, c. 1635. Oil on canvas, 3.01 × 3.14 m (9 ft 10½ in. × 10 ft 3⅝ in.)

Another painting of King Philip IV's consort with La Peregrina on a necklace.

THE HIDDEN LANGUAGE OF HOPE

Juan Pantoja de La Cruz, *Margaret of Austria, Queen Consort of Philip III of Spain*, c. 1605. Oil on canvas, 2.05 × 1.21 m (6 ft 8¾ in. × 3 ft 11⅝ in.)

Elisabeth of France's predecessor as Queen of Spain with La Peregrina on her chest.

La Peregrina appeared in such paintings as a portrait of Margaret of Austria, Queen of Spain (King Philip III's wife), by Juan Pantoja de la Cruz (1553–1608). The pearl hangs at her chest, centre stage in the image, much as it is in later portraits of Queen Elisabeth of France (King Philip IV's wife) by Velázquez and Rubens. Velázquez's equestrian portrait of the queen was intended to be displayed beside a similar scene of the king on his horse. Elisabeth's is serene to the point of indifference, exemplifying casual authority and instinctive elegance. The pearl is discreet in all these Spanish royal portraits, but that was the point – they are meant to tell you about the sitter in lieu of facial expression, and indicate immense power held in the hands of suave but unassuming individuals.

La Peregrina and the History of Pearls in Art 255

In the same period, but on the other side of Europe, the Dutch painter Johannes Vermeer (1632–1675) was fascinated by pearls and represented them in many of his works, including *Woman Holding a Balance* (1664) and *Allegory of the Catholic Faith* (*c.* 1670). The string of pearls around the woman's neck in *Allegory of the Catholic Faith* is a symbol of purity. It, alongside many other symbolic objects in the painting, spell out the spirit of Catholicism: powerful, untainted and enraptured by faith.[58]

Undoubtedly Vermeer's most famous pearl is in *Girl with a Pearl Earring* (*c.* 1665). It is about the same size and shape as La Peregrina, and glints as vivaciously as the young woman's eyes and lips, even though it must have been a fake one, just like those depicted on the Faiyum portraits.

The genuine La Peregrina was a possession of the Spanish royal family until the early nineteenth century. It fell into foreign hands after 1808, when Napoleon's forces invaded Spain and Joseph Bonaparte, Napoleon's brother, was installed as king. Joseph later bequeathed it to his sister-in-law Hortense de Beauharnais. Charles Louis Napoleon Bonaparte, the future Napoleon III, President and Emperor of France, was her son, and he became the next to own the famous pearl.

James Hamilton, Duke of Abercorn, was its next owner after Napoleon III had to sell it for financial reasons. Hamilton's wife Louisa reportedly misplaced La Peregrina more than once, including in Buckingham Palace, where it was discovered between the cushions on a sofa. In 1969, it was bought at auction by Richard Burton.

Which brings us to Elizabeth Taylor's panic at the missing pearl. After she had digested the heart-stopping realization that La Peregrina had gone, Taylor got on her hands and knees, and scoured the suite's shag carpet. Just when she was giving up hope, she noticed one of her Pekinese dogs distractedly chewing on something. Opening its mouth, she found the legendary La Peregrina.[59]

The pearl later became one of Elizabeth Taylor's most prized possessions. After her death in March 2011, it was sold at auction to an anonymous buyer for £11,842,500.

All pearls are marvels of nature, with on average only one oyster in ten thousand producing a natural pearl of even moderate worth. A pearl like La Peregrina is a phenomenon, and has been pulled into the orbit of some of the most phenomenally wealthy people in history. But pearls aren't simply trinkets of the rich: they are also symbols of hope, holiness, power and ultimate beauty.

Johannes Vermeer, *Girl with a Pearl Earring*, 1665. Oil on canvas, 39 × 44.5 cm (15 3/8 × 17 5/8 in.)

The pearl in Vermeer's painting, which appears to be the same dimensions as La Peregrina, was most likely a false one.

Notes

Introduction

1. Panofsky, Erwin. *Albrecht Dürer*. Princeton: Princeton University Press (1955), p. 161.
2. Read, John. 'Dürer's Melencolia: An Alchemical Interpretation.' *The Burlington Magazine for Connoisseurs* 87, no. 512 (1945): p. 283.
3. Manning, Robert J. 'Dürer's "Melencolia I": A Copernican Interpretation.' *Soundings: An Interdisciplinary Journal* 66, no. 1 (1983): p. 28.
4. Sohm, Philip L. 'Dürer's "Melencolia I": The Limits of Knowledge.' *Studies in the History of Art* 9 (1980): p. 31.
5. Jung, Carl. 'Approaching the Unconscious', from *Man and His Symbols*. London: Aldus Books (1964).

The Hidden Language of Power

1. Tolnay, Charles de. 'L'Atelier de Vermeer.' *Gazette des Beaux-Arts*, 41 (1953): pp. 265–72.
2. Creel, H. G. 'The Role of the Horse in Chinese History.' *The American Historical Review* 70, no. 3 (1965): p. 648.
3. Lobell, Jarrett A., and Eric A. Powell. 'The Story of the Horse.' *Archaeology* 68, no. 4 (2015): p. 30.
4. Bendrey, Robin. 'Population Genetics, Biogeography, and Domestic Horse Origins and Diffusions.' *Journal of Biogeography* 41, no. 8 (2014): pp. 1,441–42.
5. Bell, Julian. *Mirror of the World: A New History of Art*. London: Thames & Hudson (2007), p. 77.
6. Frankopan, Peter. *The Silk Roads*. London: Bloomsbury (2015), p. 9.
7. Hearn, Maxwell K. Lecture given at the Metropolitan Museum of Art for the exhibition 'The World of Khubilai Khan: A Revolution in Painting', 15 October 2010: https://www.youtube.com/watch?v=QKQ2Ya5dDQg [last accessed 4 March 2022].
8. Lobell, Jarrett A., and Eric A. Powell. 'The Story of the Horse.' *Archaeology* 68, no. 4 (2015): p. 33.
9. Brighton, Caroline H., Adrian L. R. Thomas, Graham K. Taylor. 'Guidance of peregrine attack trajectories.' *Proceedings of the National Academy of Sciences* 114, no. 51 (2017): pp. 13495–13500; DOI: 10.1073/pnas.1714532114.
10. Mills, R., H. Hildenbrandt, G. K. Taylor, and C. K. Hemelrijk. 'Physics-based simulations of aerial attacks by peregrine falcons reveal that stooping at high speed maximizes catch success against agile prey.' *PLoS Computational Biology* 14(4) (2018): e1006044. https://doi.org/10.1371/journal.pcbi.1006044.
11. Canby, Jeanny Vorys. 'Falconry (Hawking) in Hittite Lands.' *Journal of Near Eastern Studies* 61, no. 3 (2002): pp. 161–201.
12. Anderson, Eugene N. 'Birds of the Mongol Empire.' *Ethnobiology Letters* 7, no. 1 (2016): p. 69.
13. Averett, Matthew Knox. 'Becoming Giorgio Cornaro: Titian's "Portrait of a Man with a Falcon".' *Zeitschrift Für Kunstgeschichte* 74, no. 4 (2011): pp. 559–68.
14. Grassby, Richard. 'The Decline of Falconry in Early Modern England.' *Past & Present*, 157, no. 1 (1997): p. 47.
15. Boccassini, Daniela. 'Falconry as a Transmutative Art: Dante, Frederick II, and Islam.' *Dante Studies, with the Annual Report of the Dante Society*, no. 125 (2007): pp. 157–82.
16. Grassby, Richard. 'The Decline of Falconry in Early Modern England.' *Past & Present*, 157, no. 1 (1997): pp. 37–62.
17. Resnik, Judith, and Dennis E. Curtis. 'The Jayne Lecture: Representing Justice: From Renaissance Iconography to Twenty-First-Century Courthouses.' *Proceedings of the American Philosophical Society* 151, no. 2 (2007): p. 144.
18. Perry, Mary Phillips. 'On the Psychostasis in Christian Art.' *The Burlington Magazine for Connoisseurs* 22, no. 116 (1912): p. 101.
19. De Ville, Jacques. 'Mythology and the Images of Justice.' *Law and Literature* 23, no. 3 (2011): p. 349.
20. Hall, James. *Hall's History of Ideas and Images in Italian Art*. London: John Murray (1995), p. 7.

21 Eusebius, translated and edited by Cameron Averil and Stuart Hall. *Life of Constantine.* Oxford: Clarendon Press (1999).

22 Blust, Robert. 'The Origin of Dragons.' *Anthropos* 95, no. 2 (2000): pp. 519–36.

23 Wilson, J. Keith. 'Powerful Form and Potent Symbol: The Dragon in Asia.' *The Bulletin of the Cleveland Museum of Art* 77, no. 8 (1990): p. 286.

24 Wittkower, Rudolf. 'Eagle and Serpent. A Study in the Migration of Symbols.' *Journal of the Warburg Institute* 2, no. 4 (1939): pp. 293–325.

25 Pliny the Elder. *The Natural History.* 10.5.16. Trans. H Rackham, Loeb edition.

26 Wilkins, Ernest H. 'Petrarch's Coronation Oration.' *PMLA* 68, no. 5 (1953): pp. 1241–50.

27 Flory, Marleen B. 'The Symbolism of Laurel in Cameo Portraits of Livia.' *Memoirs of the American Academy in Rome* 40 (1995): p. 43.

28 *Ibid.*

29 Hollis, Adrian S. 'Ovid, Metamorphoses 1,445ff.: Apollo, Daphne, and the Pythian Crown.' *Zeitschrift für Papyrologie und Epigraphik* 112 (1996): pp. 69–73.

30 Frankopan, Peter. *The Silk Roads.* London: Bloomsbury (2015), p. 216.

31 Rosenthal, Earl E. 'The Invention of the Columnar Device of Emperor Charles V at the Court of Burgundy in Flanders in 1516.' *Journal of the Warburg and Courtauld Institutes* 36 (1973): p. 199.

32 Neville, Kristoffer. 'The Early Reception of Fischer Von Erlach's Entwurff Einer Historischen Architectur.' *Journal of the Society of Architectural Historians* 66, no. 2 (2007): pp. 160–75.

33 Bailey, Meryl. '"Salvatrix Mundi": Representing Queen Elizabeth I as a Christ Type.' *Studies in Iconography* 29 (2008): p. 187.

34 Walker, Alicia. 'Patterns of Flight: Middle Byzantine Adoptions of the Chinese Feng Huang Bird.' *Ars Orientalis* 38 (2010): p. 194.

35 *Ibid.*

36 Rawson, Jessica. *Chinese Ornament: The Lotus and the Dragon.* London: British Museum Publications (1984), p. 100.

37 Schrader, J. L. 'A Medieval Bestiary.' *The Metropolitan Museum of Art Bulletin* 44, no. 1 (1986): pp. 1–55.

38 Heckscher, William S. 'Bernini's Elephant and Obelisk.' *The Art Bulletin* 29, no. 3 (1947): pp. 155–82.

39 Epstein, Marc Michael. 'The Elephant and the Law: The Medieval Jewish Minority Adapts a Christian Motif.' *The Art Bulletin* 76, no. 3 (1994): pp. 465–78.

40 Pettigrew, William A., *Freedom's Debt: The Royal African Company and the Politics of the Atlantic Slave Trade, 1672–1752.* Chapel Hill, NC: Omohundro Institute of Early American and the University of North Carolina Press (2016).

41 From the exhibition catalogue, quoted from *Art Journal*, 1885, p. 322.

42 Wendelin, Greta. 'A Rhetoric of Pornography: Private Style and Public Policy in "The Maiden Tribute of Modern Babylon".' *Rhetoric Society Quarterly* 42, no. 4 (2012): p. 385.

43 Wischnitzer, Rachel. 'Picasso's "Guernica". A Matter of Metaphor.' *Artibus Et Historiae* 6, no. 12 (1985): pp. 153–72.

44 Petrey, Sandy. 'Pears in History.' *Representations*, no. 35 (1991): p. 54.

45 *Ibid.*

46 Childs, Elizabeth C. 'Big Trouble: Daumier, Gargantua, and the Censorship of Political Caricature.' *Art Journal* 51, no. 1 (1992): p. 35.

47 Kemp, Martin, *Christ to Coke: How Image Becomes Icon.* Oxford: Oxford University Press (2012), p. 116.

48 Aruz, Joan (ed.). *The Art of the First Cities.* New York: Metropolitan Museum of Art; Yale University Press: New Haven and London (2003), p. 23.

The Hidden Language of Faith

1 Milne, Marjorie J. 'Perseus and Medusa on an Attic Vase.' *The Metropolitan Museum of Art Bulletin* 4, no. 5 (1946): p. 128.

2 Ramsden, E. H. 'The Halo: A Further Enquiry into Its Origin.' *The Burlington Magazine for Connoisseurs* 78, no. 457 (1941): p. 124.

3 *Ibid.*

4 *Ibid.*, p. 126.

5 Honour, Hugh and Fleming, John. *A World History of Art*. London: Laurence King Publishing (2009), p. 230.

6 Whitfield, Susan (ed.). *Silk Roads: Peoples, Cultures, Landscapes*. London: Thames & Hudson (2019).

7 Watson, Burton (trans.). *The Complete Works of Zhuangzi*. New York: Columbia University Press (2013), p. 77.

8 Leone, Massimo. 'Signs of the Soul: Toward a Semiotics of Religious Subjectivity.' *Signs and Society* 1, no. 1 (2013): pp. 115–59.

9 Marren, Peter. *Rainbow Dust: Three Centuries of Delight in British Butterflies*. London: Vintage (2016).

10 Cashford, Jules (trans.). *The Homeric Hymns*. London: Penguin (2003), pp. 117–18.

11 Collins, Paul. 'The Symbolic Landscape of Ashurbanipal.' *Notes in the History of Art* 23, no. 3 (2004): pp. 1–6.

12 Panzini, Franco. 'Pines, Palms, and Holm Oaks: Historicist Modes in Modern Italian Cityscapes.' *Studies in the History of Art* 78 (2015): pp. 117–36.

13 Bondár, Mária. 'Prehistoric innovations: Wheels and wheeled vehicles.' *Acta Archaeologica Academiae Scientiarum Hungaricae* 69, no. 2 (2019): pp. 271–97. https://doi.org/10.1556/072.2018.69.2.3

14 Seckel, Dietrich, and Andreas Leisinger. 'Before and beyond the Image: Aniconic Symbolism in Buddhist Art.' *Artibus Asiae. Supplementum* 45 (2004): p. 11.

15 Hall, James. *Hall's History of Ideas and Images in Italian Art*. London: John Murray (1995), p. 64.

16 Aruz, Joan (ed.). *The Art of the First Cities*. New York: Metropolitan Museum of Art; Yale University Press: New Haven and London (2003), p. 490.

17 Marcovich, Miroslav. 'From Ishtar to Aphrodite.' *Journal of Aesthetic Education* 30, no. 2 (1996): pp. 43–59.

18 Morris, Lynda and Grunenberg, Christoph (ed.). *Picasso, Peace and Freedom*. London: Tate Publishing (2010).

19 Caldwell, Mary Channen. '"Flower of The Lily": Late-Medieval Religious and Heraldic Symbolism in Paris, Bibliothèque Nationale de France, Ms Français 146.' *Early Music History* 33 (2014): p. 6.

20 Chapin, Anne P. 'Power, Privilege, and Landscape in Minoan Art.' *Hesperia Supplements* 33 (2004): pp. 47–64.

21 Potter, Jennifer. *Seven Flowers And How They Shaped Our World*. London: Atlantic Books (2013), p. 38.

22 *Ibid.*, p. 50.

23 *Ibid.*, p. 4.

24 Kandeler, Riklef and Wolfram R. Ullrich. 'Symbolism of Plants: Examples from European-Mediterranean Culture Presented with Biology and History of Art.' *Journal of Experimental Botany* 60, no. 9 (2009): p. 2,464.

25 Lerner, Martin and Steven Kossak. *The Lotus Transcendent: Indian and Southeast Asian Art from the Samuel Eilenberg Collection*. New York: The Metropolitan Museum of Art (1991), p. 120.

26 Stone, Richard. 'Divining Angkor.' *National Geographic Magazine*, July 2009.

27 Texier, Pierre-Jean *et al.* 'A Howiesons Poort tradition of engraving ostrich eggshell containers dated to 60,000 years ago at Diepkloof Rock Shelter, South Africa.' *Proceedings of the National Academy of Sciences*, April 2010, 107 (14): pp. 6180–85.

28 Hodos, T. *et al.* 'The origins of decorated ostrich eggs in the ancient Mediterranean and Middle East.' *Antiquity* 94, no. 374 (2020): pp. 381–400.

29 Kemp, M. 'Science in culture: Eggs and exegesis.' *Nature* 440 (2006): p. 872.

30 Meiss, Millard, and Theodore G. Jones. 'Once Again Piero Della Francesca's Montefeltro Altarpiece.' *The Art Bulletin* 48, no. 2 (1966): pp. 203–6.

31 Wood, Jeryldene (ed.). *The Cambridge Companion to Piero della Francesca*. Cambridge: Cambridge University Press (2002).

32 Cantelupe, Eugene B. 'Titian's Sacred and Profane Love Re-examined.' *The Art Bulletin* 46, no. 2 (1964): pp. 218–27.

33 Whitfield, Susan (ed.). *Silk Roads: Peoples, Cultures, Landscapes*. London: Thames & Hudson (2019).

34　Goffen, Rona. 'Titian's Sacred and Profane Love: Individuality and Sexuality in a Renaissance Marriage Picture.' *Studies in the History of Art* 45 (1993): p. 142.

35　Friedmann, H. *The Symbolic Goldfinch: Its History and Significance in European Devotional Art*. Washington, D.C.: Pantheon Books for Bollingen Foundation (1946), pp. 4–5.

36　*Ibid*.

37　Wilson, E. Faye. 'Reviewed Work: The Symbolic Goldfinch, Its History and Significance in European Devotional Art by Herbert Friedmann', *Speculum* 23, no. 1 (1948): pp. 121–25.

38　Kern, Ulrike. 'Samuel Van Hoogstraeten and the Cartesian Rainbow Debate: Color and Optics in a Seventeenth-century Treatise of Art Theory.' *Simiolus: Netherlands Quarterly for the History of Art* 36, no. 1/2 (2012): p. 103.

39　Steadman, Philip. 'Water in the Air.' In *Renaissance Fun: The Machines behind the Scenes*. London: UCL Press (2021).

40　Werrett, Simon. 'Wonders Never Cease: Descartes's "Météores" and the Rainbow Fountain.' *The British Journal for the History of Science* 34, no. 2 (2001): pp. 129–47.

41　Quoted in Mindock, Clark. 'Gilbert Baker: All you need to know about the man who designed the iconic LGBT flag.' *The Independent*, 1 June 2017.

42　Savo, V., A. Kumbaric and G. Caneva. 'Grapevine (Vitis vinifera L.) Symbolism in the Ancient Euro-Mediterranean Cultures.' *Economic Botany* 70, no. 2 (2016): p. 190.

43　Toynbee, J. M. C., and J. B. Ward Perkins. 'Peopled Scrolls: A Hellenistic Motif in Imperial Art.' *Papers of the British School at Rome* 18 (1950): pp. 1–43.

44　*Ibid*.

The Hidden Language of Uncertainty

1　Helland, Janice. 'Aztec Imagery in Frida Kahlo's Paintings: Indigenity and Political Commitment.' *Woman's Art Journal* 11, no. 2 (1990): pp. 8–13.

2　Alexander, Robert L. 'The Mirror, Tool of the Artist.' *Source: Notes in the History of Art* 4, no. 2/3 (1985): pp. 55–58.

3　Kozloff, Arielle P. 'Mirror, Mirror.' *The Bulletin of the Cleveland Museum of Art* 71, no. 8 (1984): p. 274.

4　Healy, Paul F., and Marc G. Blainey. 'Ancient Maya Mosaic Mirrors: Function, Symbolism, and Meaning.' *Ancient Mesoamerica* 22, no. 2 (2011): pp. 229–44.

5　Janson, Anthony F. 'The Convex Mirror as Vanitas Symbol.' *Source: Notes in the History of Art* 4, no. 2/3 (1985): p. 51.

6　MacGregor, Neil. *A History of the World in 100 Objects*. London: Allen Lane (2010), p. 320.

7　Perkinson, Stephen. 'Lessons for Living: The Macabre in Renaissance Art.' Lecture at Bowdoin College, 24 June 2017.

8　Wasserman, Anastasia Keshman. 'The Cross and the Tomb: The Crusader Contribution to Crucifixion Iconography.' In 'Between Jerusalem and Europe: Essays in Honour of Bianca Kühnel (Visualising the Middle Ages, 11).' Renana Bartal, Hanna Vorholt (eds). Leiden: Brill (2015), pp. 13–33.

9　Perkinson, Stephen. 'Lessons for Living: The Macabre in Renaissance Art.' Lecture at Bowdoin College, 24 June 2017.

10　*Ibid*.

11　Jacobsen, Thorkild. *The Treasures of Darkness: A History of Mesopotamian Religion*. Cambridge, Mass.: Harvard University Press (1976).

12　Hirsch, Brett D. 'From Jew to Puritan: The Emblematic Owl in Early English Culture.' In *"This Earthly Stage": World and Stage in Late Medieval and Early Modern England*. Brett Hirsch and Christopher Wortham (eds). Turnhout, Belgium: Brepols (2010).

13　Aperghis, G. 'Athenian Mines, Coins and Triremes.' *Historia: Zeitschrift Für Alte Geschichte* 62, no. 1 (2013): pp. 1–24.

14　Watson, Michael. 'The owls of Athena: some comments on owl-skyphoi and their iconography.' *Art Bulletin of Victoria* 39 (2014).

15　Kipling, Rudyard. 'The cat that walked by himself.' In *Just So Stories*. London: Macmillan (1902).

16　Driscoll, Carlos A., *et al*. 'The Near Eastern Origin of Cat Domestication.' *Science* 317, no. 5837 (2007): pp. 519–23.

17 Friesen, Ilse E. 'Leonardo Da Vinci's Unorthodox Iconography: The "Madonna with the Cat"'. *RACAR: Revue D'art Canadienne / Canadian Art Review* 16, no. 1 (1989): p. 21.

18 Gombrich, Ernst. 'Icones Symbolicae.' In *Gombrich on the Renaissance Volume 2: Symbolic Images*. London: Phaidon (1972), p. 184.

19 Colonna, Francesco. *The Dream of Poliphilo*. Venice: Aldus Manutius (1499).

20 Ripa, Cesare, *Iconologia* (1758–60 Hertel Edition, ed. Edward A. Maser – Toronto: Dover Publications, Inc., 1971).

21 Driskel, Michael Paul. 'By the Light of Providence: The Glory Altarpiece at St. Paul's Chapel, New York City.' *The Art Bulletin* 89, no. 4 (2007): pp. 715–37.

22 Ammann, Rudolf. *'A great gogle eye': Some panopticon iconography*, UCL website (17 March 2015) https://blogs.ucl.ac.uk/panopticam/2015/03/17/eye-panopticon-iconography/

23 *The Great Seal of the United States* (booklet), Washington: U.S. Department of State Bureau of Public Affairs (2003). https://2009-2017.state.gov/documents/organization/27807.pdf

24 Schrader, J. L. 'A Medieval Bestiary.' *The Metropolitan Museum of Art Bulletin* 44, no. 1 (1986): pp. 1–55.

25 Uther, Hans-Jörg. 'The Fox in World Literature: Reflections on a "Fictional Animal".' *Asian Folklore Studies* 65, no. 2 (2006): p. 140.

26 Miyamoto, Yuki. 'Fire and Femininity: Fox Imagery and Ethical Responsibility.' In *Imagination without Borders: Feminist Artist Tomiyama Taeko and Social Responsibility*, Laura Hein and Rebecca Jennison (eds). Michigan: Center for Japanese Studies, University of Michigan (2010), p. 77.

27 Panofsky, Erwin. *Studies in Iconology – Humanistic Themes in the Art of the Renaissance*. Oxford: Oxford University Press (1939).

28 Vardi, Liana. 'Imagining the Harvest in Early Modern Europe.' *The American Historical Review* 101, no. 5 (1996): p. 1,383.

29 Higgins, Charlotte. *Red Thread. On Mazes & Labyrinths*. London: Jonathan Cape (2018).

30 Molholt, Rebecca. 'Roman Labyrinth Mosaics and the Experience of Motion.' *The Art Bulletin* 93, no. 3 (2011): pp. 287–303.

31 Doob, Penelope Reed. *The Idea of the Labyrinth from Classical Antiquity through the Middle Ages*. Ithaca and London: Cornell University Press (1990).

32 *Ibid*.

33 Bassani, Ezio. *African Art*. Milan: Skira (2012), p. 104.

34 Blier, Suzanne Preston. 'Imaging Otherness in Ivory: African Portrayals of the Portuguese Ca. 1492.' *The Art Bulletin* 75, no. 3 (1993): p. 379.

35 Van Buren, E. Douglas. 'Entwined Serpents.' *Archiv Für Orientforschung* 10 (1935): pp. 53–65.

36 Smith, Duane E. 'The Divining Snake: Reading Genesis 3 in the Context of Mesopotamian Ophiomancy.' *Journal of Biblical Literature* 134, no. 1 (2015): pp. 31–49.

37 McCrae, John. *In Flanders Fields and Other Poems (WWI Centenary Series)*. Last Post Press (2014).

38 Fox, James. 'Poppy Politics: Remembrance of Things Present.' In *Cultural Heritage Ethics: Between Theory and Practice*, ed. Sandis Constantine. Cambridge: Open Book Publishers (2014), pp. 21–30.

39 Keller, Mara Lynn. 'The Eleusinian Mysteries of Demeter and Persephone: Fertility, Sexuality, and Rebirth.' *Journal of Feminist Studies in Religion* 4, no. 1 (1988): pp. 27–54.

40 Potter, Jennifer. *Seven Flowers And How They Shaped Our World*. London: Atlantic Books (2013), p. 102.

41 Merlin, M. D. 'Archaeological Evidence for the Tradition of Psychoactive Plant Use in the Old World.' *Economic Botany* 57, no. 3 (2003): pp. 295–323.

42 Loewenstein, John Prince. 'The Swastika; Its History and Meaning.' *Man* 41, May–June (1941): pp. 49–55.

43 Heller, Steven. *The Swastika: Symbol Beyond Redemption?* New York: Allworth Press (2008).

44 Fredericksen, Burton B. *et al. Masterpieces of the J. Paul Getty Museum: Paintings*. Los Angeles: J. Paul Getty Museum (1997).

45 Prosperetti, Andrea. 'Bubbles.' *Physics of Fluids* 16, no. 6 (2004): p. 1,852.

46 *Ibid.*, p. 1,856.

47 Screech, Timon. 'Bubbles, East and West: An Iconic Encounter in 18th-Century Ukiyo-e.' *Impressions*, no. 22 (2000): pp. 86–107.

The Hidden Language of Hope

1 Assmann, Jan. 'Ouroboros. The Ancient Egyptian Myth of the Journey of the Sun.' *Aegyptiaca. Journal of the History of Reception of Ancient Egypt*, no. 4 (2019): p. 25.

2 Ekiert, Leszek. 'Alchemical Symbols at the Museum of Pharmacy of the Jagiellonian University.' *Pharmacy in History* 41, no. 3 (1999): p. 111.

3 Assmann, Jan. 'Ouroboros. The Ancient Egyptian Myth of the Journey of the Sun.' *Aegyptiaca. Journal of the History of Reception of Ancient Egypt*, no. 4 (2019): p. 29.

4 *Ibid.*, p. 27.

5 Wilson, Ben. *Metropolis: A History of Humankind's Greatest Invention*. London: Jonathan Cape (2020), p. 21.

6 Juuti, Petri *et al.* 'Short Global History of Fountains.' *Water* 7, no. 5 (2015): p. 2,318.

7 Dragoni, Walter. 'Rome's fountains: beauty and public service from geology, power and technology.' In *Water Fountains in the Worldscape*, Ari Hynynen, Petri S. Juuti, Tapio Katko (eds). Tampere: International Water History Association and Kehrämedia Inc. (2012), pp. 18–33.

8 Juuti, Petri *et al.* 'Short Global History of Fountains.' *Water* 7, no. 5 (2015): p. 2,338.

9 Klapisch-Zuber, Christiane and Siân Reynolds. 'The Fountain of Youth: Bathing and Youthfulness (fourteenth–sixteenth century).' *Clio. Women, Gender, History*, no. 42 (2015): pp. 178–88.

10 Steadman, Philip. 'Water in the Air.' In *Renaissance Fun: The Machines behind the Scenes*. London: UCL Press (2021), p. 197.

11 Sale, J. Russell. 'Birds of a Feather: The Medici "Adoration" Tondo in Washington.' *The Burlington Magazine* 149, no. 1246 (2007): pp. 4–13.

12 Kadgaonkar, Shivendra B. 'The Peacock in Ancient Indian Art and Literature.' *Bulletin of the Deccan College Research Institute* 53 (1993): p. 96.

13 *Ibid.*

14 Laing, Ellen Johnston. 'Carp and Goldfish as Auspicious Symbols and Their Representation in Chinese Popular Prints.' *Arts Asiatiques* 72 (2017): p. 99.

15 Hooke, S. H. 'Fish Symbolism.' *Folklore* 72, no. 3 (1961): p. 535.

16 *Ibid.*

17 Edmondson, Todd. 'The Jesus Fish: Evolution of a Cultural Icon.' *Studies in Popular Culture* 32, no. 2 (2010): p. 57.

18 *Ibid.*, pp. 57–66.

19 Nichols, Andrew. *Ctesias: On India*. London: Bloomsbury (2013).

20 Wittkower, Rudolf. 'Marvels of the East. A Study in the History of Monsters.' *Journal of the Warburg and Courtauld Institutes* 5, no. 1 (1942): p. 159.

21 Aruz, Joan (ed.). *The Art of the First Cities*. New York: Metropolitan Museum of Art; Yale University Press: New Haven and London (2003), p. 246.

22 Schrader, J. L. 'A Medieval Bestiary.' *The Metropolitan Museum of Art Bulletin* 44, no. 1 (1986): p. 17.

23 Châtelet-Lange, Liliane and Renate Franciscond. 'The Grotto of the Unicorn and the Garden of the Villa Di Castello.' *The Art Bulletin* 50, no. 1 (1968): p. 53.

24 Kandeler, Riklef and Wolfram R. Ullrich. 'Symbolism of Plants: Examples from European-Mediterranean Culture Presented with Biology and History of Art.' *Journal of Experimental Botany* 60, no. 13 (2009): p. 3,612.

25 Potter, Jennifer. *Seven Flowers And How They Shaped Our World*. London: Atlantic Books (2013), p. 136.

26 *Ibid.*, p. 149.

27 Wittkower, R. 'Domenichino's Madonna Della Rosa.' *The Burlington Magazine* 90, no. 545 (1948): p. 221.

28 Potter, Jennifer. *Seven Flowers And How They Shaped Our World*. London: Atlantic Books (2013), p. 153.

29. Wittkower, R. 'Domenichino's Madonna Della Rosa.' *The Burlington Magazine* 90, no. 545 (1948): p. 221.

30. Barrow, Rosemary. 'The Scent of Roses: Alma-Tadema and the Other Side of Rome.' *Bulletin of the Institute of Classical Studies* 42, no. 1 (1997): pp. 183–202.

31. Barnhart, Richard M. *Peach blossom spring: gardens and flowers in Chinese paintings*. New York: Metropolitan Museum of Art (1983), p. 35.

32. Li, Chu-tsing. 'The Oberlin Orchid and the Problem of P'u-ming.' *Archives of the Chinese Art Society of America* 16 (1962): p. 52.

33. Cahill, Suzanne E. 'The Moon Stopping in the Void: Daoism and the Literati Ideal in Mirrors of the Tang Dynasty.' *Cleveland Studies in the History of Art* 9 (2005): p. 27.

34. Li, Chu-tsing. 'The Oberlin Orchid and the Problem of P'u-ming.' *Archives of the Chinese Art Society of America* 16 (1962): p. 54.

35. Schiesari, Juliana. 'Portrait of the Poet as a Dog: Petrarch's Epistola Metrica III, 5.' *Italica* 84, no. 2/3 (2007): pp. 162–72.

36. Hole, Frank and Cherra Wyllie. 'The Oldest Depictions of Canines and a Possible Early Breed of Dog in Iran.' *Paléorient* 33, no. 1 (2007): pp. 175–85.

37. Arnold, Dorothea. 'An Egyptian Bestiary.' *The Metropolitan Museum of Art Bulletin* 52, no. 4 (1995): p. 57.

38. Lonsdale, Steven H. 'Attitudes towards Animals in Ancient Greece.' *Greece & Rome* 26, no. 2 (1979): pp. 146–59.

39. Reuterswärd, Patrik. 'The dog in the humanist's study.' *Konsthistorisk tidskrift/Journal of Art History* 50, no. 2 (1981): p. 53.

40. Farrell, Kaitlyn. 'A Dog's World: The Significance of Canine Companions in Hogarth's "Marriage A-la-Mode".' *The British Art Journal* 14, no. 2 (2013): pp. 35–38.

41. Milam, Jennifer. 'Rococo Representations of Interspecies Sensuality and the Pursuit of "Volupté".' *The Art Bulletin* 97, no. 2 (2015): pp. 192–209.

42. Dalton, Heather. 'A Sulphur-crested Cockatoo in Fifteenth-century Mantua: Rethinking Symbols of Sanctity and Patterns of Trade.' *Renaissance Studies* 28, no. 5 (2014): p. 678.

43. *Ibid*., pp. 676–94.

44. Peacock, John. *The Look of van Dyck: The Self-Portrait with a Sunflower and the Vision of the Painter*. Aldershot: Ashgate (2006), p. 219.

45. *Ibid*., p. 110.

46. Potter, Jennifer. *Seven Flowers And How They Shaped Our World*. London: Atlantic Books (2013), p. 80.

47. Bruyn, J. and J. A. Emmens. 'The Sunflower Again.' *The Burlington Magazine* 99, no. 648 (1957): pp. 96–97.

48. Roskill, Mark W. *The Letters of Vincent van Gogh*. London: Fontana (1983).

49. Milman, Miriam. 'The Mysterious "Nejlikan" Revisited.' *Konsthistorisk tidskrift/Journal of Art History* 65, no. 2 (1996): pp. 115–34.

50. Boddy, Kasia. *Blooming Flowers: A Seasonal History of Plants and People*. New Haven: Yale University Press (2020).

51. Filipczak, Zirka Z. 'Rembrandt and the Body Language of Mughal Miniatures.' *Nederlands Kunsthistorisch Jaarboek (NKJ) / Netherlands Yearbook for History of Art* 58 (2007): pp. 162–87.

52. Ainsworth, Maryan W. *et al*. *Art and Autoradiography: Insights into the Genesis of Paintings by Rembrandt Van Dyck and Vermeer*. New York: Metropolitan Museum of Art (1980).

53. Lawler, Andrew. 'The Pearl Trade.' *Archaeology* 65, no. 2 (2012): pp. 46–51.

54. Pliny the Elder. *The Natural History*. Book IX, Chapter 54. Trans. H Rackham, Loeb edition.

55. Fitzpatrick, Matthew P. 'Provincializing Rome: The Indian Ocean Trade Network and Roman Imperialism.' *Journal of World History* 22, no. 1 (2011): p. 34.

56. Suetonius. *De vita Caesarum: The Life of Julius Caesar*. Chapter 47. Trans. Alexander Thomson, Philadelphia. Gebbie & Co. (1889).

57. De Jongh, E. 'Pearls of Virtue and Pearls of Vice.' *Simiolus: Netherlands Quarterly for the History of Art* 8, no. 2 (1975): p. 76.

58. *Ibid*., pp. 69–97.

59. Taylor, Elizabeth. *My Love Affair with Jewelry*. London: Simon & Schuster (2002).

Sources of Illustrations

Details on p. 1 taken from works illustrated within the book; see individual page credits.
l = left, r = right, a = above, b = below

Accademia Carrara, Bergamo. Collezione Giovanni Morelli, 1891 **64**. Photo akg-images/Gerard Degeorge **194l**. Photo akg-images/André Held **98l**. Photo akg-images/Marcus Hilbich **202r**. American Numismatic Society, New York **55**. Art Institute of Chicago: Gift of Mrs Richard E. Danielson and Mrs Chauncey McCormick **15**; Gift of Mary P. Hines in memory of her mother, Frances W. Pick. Photo The Art Institute of Chicago/Art Resource, NY/Scala, Florence. © Man Ray 2015 Trust/DACS, London 2022 **134b**; Charles L. Hutchinson Collection **180**; Kate S. Buckingham Fund **178bl**; The Regenstein Collection **241**; Through prior bequest of Joseph Winterbotham **235r**. Courtesy the artist and Galerie Peter Kilchmann, Zurich **141**. Bayeux Museum. Photo Granger Historical Picture Archive/Alamy Stock Photo **22**. Bayerische Staatsgemäldesammlungen –Sammlung Moderne Kunst in der Pinakothek der Moderne, Munich. © Georg Baselitz 2022 **38**. Beinecke Rare Book and Manuscript Library, Yale University, New Haven **53**. Bibliothèque nationale de France, Paris **66, 67**. Bodleian Libraries, University of Oxford. Photo Bodleian Libraries, University of Oxford **154a**. Photo Bridgeman Images **130b**. British Library, London. Photo British Library Board. All Rights Reserved/Bridgeman Images **161, 165**. The British Museum, London. Photo The Trustees of the British Museum **27, 72, 74, 79, 90, 112, 136, 138, 151, 164l, 174, 178a, 187**. Collection Juan Antonio Pérez Simón, Mexico **223**. Châteaux de Versailles et de Trianon. Photo RMN-Grand Palais (Château de Versailles)/ Franck Raux **39**. Photo Chronicle/Alamy Stock Photo **69**. The Cleveland Museum of Art: Gift of Drs Thomas and Martha Carter in Honour of Sherman E. Lee 1995.301 **137**; Leonard C. Hanna, Jr Fund 1963.502 **183**; Mr and Mrs William H. Marlatt Fund 1960.79 **97**; Bequest of James Parmelee 1940.1049 **213**; Bequest of John L. Severance 1942.776 **152**; John L. Severance Fund 1962.150 **73**; John L. Severance Fund 1964.369 **146r**; John L. Severance Fund 1971.102 **28r**; Purchase from the J. H. Wade Fund 1944.492 **52b**; Purchase from the J. H. Wade Fund 1954.592 **212**; Purchase from the J.H. Wade Fund 1965.473 **71**; Purchase from the J. H. Wade Fund 1977.37.2 **150a**; John L. The Worcester R. Warner Collection 1918.550 **192–93**. Commission for the 150th Anniversary of London Underground, 2013. © Mark Wallinger. All rights reserved, DACS/Artimage 2022. Photo Thierry Bal **171**. The Courtauld, London (Samuel Courtauld Trust), London **177**. The David Collection, Copenhagen **33**. Photo DeAgostini/A. De Gregorio /Getty Images **204**. Dell Publishing, 1975. © Carlos Victor Ochagavia **160**. Detroit Institute of Arts: Gift of Robert H. Tannahill. Photo Detroit Institute of Arts/ Bridgeman Images. © DACS 2022 **251r**; Gift of Mrs James E. Scripps **135**. Photo English Heritage/Heritage Images/Getty Images **186**. Egyptian Museum, Cairo **197**: Photo Granger Historical Picture Archive/Alamy Stock Photo **62l**; Photo Robertharding/Alamy Stock Photo **70**. Photo Patrick Escudero/Gamma-Rapho/ Getty Images **106**. Photo Fine Art Images/Heritage Images/Getty Images **232**. Freer Gallery of Art, National Museum of Asian Art, Smithsonian, Washington, D.C. Gift of Charles Lang Freer **25, 210**. Germanisches Nationalmuseum, Nuremberg **198**. Getty Research Institute, Los Angeles **159l**. Harry Ransom Center, Austin. Nickolas Muray Collection of Mexican Art. © Banco de México Diego Rivera Frida Kahlo Museums Trust, Mexico, D.F./DACS 2022 **132**. Hettenburg Museum, Baden-Württemberg. Photo Nathan Benn/GEO Image Collection/Art Resource, NY **117**. Installation view, Hyundai Commission: Kara Walker – Fons Americanus, Tate Modern, London, UK, 2019. Photo Tate (Matt Greenwood). Artwork Kara Walker, courtesy of Sikkema Photo Interfoto/Alamy Stock Photo **57**. Jenkins & Co., New York, Sprüth Magers, Berlin **9**. Isabella Stewart Gardner Museum, Boston **14**. The J. Paul Getty Museum, Los Angeles **54, 95, 163, 167, 189, 195, 208**: Acquired in honour of Thomas Kren **203**; Photo Juan Laurent **202l**. Photo Carolyn Jenkins/Alamy Stock Photo **48l**. Photo Keystone-France/Gamma-Keystone via Getty Images **47l**. Photo

Laurenz Kleinheider **46**. Kunsthistorisches Museum, Vienna **12, 65, 86, 172b**. Photo © Vladimir Korostyshevskiy/Dreamstime.com **16**. Leeds Art Gallery. Photo Leeds Museums and Galleries/Bridgeman Images **139**. Los Angeles County Museum of Art: Mary D. Keeler Bequest **42**; Gift of Mr and Mrs Harry Lenart **107, 176**; William Randolph Hearst Collection **178br**. Mauritshuis, The Hague **23, 122, 244r, 257**. The Metropolitan Museum of Art, New York: Purchase, 2015 Benefit Fund and Lila Acheson Wallace Gift, 2016 **134a**; Bequest of Benjamin Altman, 1913 **89, 131, 249**; The Jules Bache Collection, 1949 **121r, 237, 250l**; From the Collection of A.W. Bahr, Purchase, Fletcher Fund, 1947 **84**; Louis V. Bell Fund, 1966 **108**; Bequest of Lillie P. Bliss, 1931. Photo The Metropolitan Museum of Art/Art Resource/Scala, Florence **220–21**; Gift of Mrs Joseph Brummer and Ernest Brummer, in memory of Joseph Brummer, 1948 **130a**; The Cloisters Collection, 1950 **128**; The Cloisters Collection, 1957 **56l**; Gift of Emily Crane Chadbourne **43**; Gift of Nathan Cummings, 1963 **162l**; Gift of Mr and Mrs Nathan Cummings, 1964 **149b**; Charles B. Curtis, Marquand, Victor Wilbour Memorial, and The Alfred N. Punnett Endowment Funds, 1974 **190**; Gift of Lewis Einstein, 1954 **32b**; Gift of Ernest Erickson Foundation, 1985 **32a**; Fletcher Fund, 1919 **235l**; Fletcher Fund, 1927 **99**; Mary Griggs Burke Collection, Gift of the Mary and Jackson Burke Foundation, 2015 **214, 229l**; Gift of Edward S. Harkness, 1917 **109**; Purchase, Edward S. Harkness Gift, 1926 **21**; Purchase, Enid A. Haupt Gift and Gwynne Andrews Fund, 1981 **41**; H.O. Havemeyer Collection, Bequest of Mrs H.O. Havemeyer, 1929 **185, 240**; Bequest of Harriet H. Jonas, 1974 **24**; John Stewart Kennedy Fund, 1913 **209**; Gift of M. Knoedler & Co., 1918 **11**; Robert Lehman Collection, 1975 **29, 118, 181, 216, 236**; Gift of Jacqueline Loewe Fowler, 2020 **153**; Marquand Collection, Gift of Henry G. Marquand, 1889 **233**; The Pierre and Maria-Gaetana Matisse Collection, 2002. Photo The Metropolitan Museum of Art/Art Resource/Scala, Florence. © Estate of Leonora Carrington/ARS, NY and DACS, London 2022 **20**; Gift of Miss Helen Miller Gould, 1910 **196**; Bequest of Miss Adelaide Milton de Groot (1876–1967), 1967 **168**; Bequest of Herbert Mitchell, 2008 **142**; Gift of James A. Moffett 2nd, 1962 **250r**; Courtesy of the Museum of South Dakota State Historical Society, Pierre **19**; Gift of Muneichi Nitta, 2003 **82**; The Harry G.C. Packard Collection of Asian Art, Gift of Harry G.C. Packard, and Purchase, Fletcher, Rogers, Harris Brisbane Dick, and Louis V. Bell Funds, Joseph Pulitzer Bequest, and The Annenberg Fund Inc. Gift, 1975 **229r**; Gift of J. Pierpont Morgan, 1917 **121l**; Gift of Mr and Mrs Leon Pomerance, 1953 **88**; Bequest of George D. Pratt, 1935 **56r**; Gift of John D. Rockefeller Jr, 1937 **219**; Rogers Fund, 1907 **149a**; Rogers Fund, 1909 **150b**; Rogers Fund, 1911 **158a**; Rogers Fund, 1930 **52a**; Rogers Fund, 1940 **234**; Rogers Fund, 1947 **182**; Gift of Mrs Russell Sage, 1910 **162r**; Purchase, Denise and Andrew Saul Gift, in honour of Maxwell K. Hearn, 2014 **81**; Gift of Daniel Slott, 1980 **93r**; Harry G. Sperling Fund, 2014 **78**; The Elisha Whittelsey Collection, The Elisha Whittelsey Fund, 1951 **191l**. The Minneapolis Institute of Art: Gift of Ruth and Bruce Dayton **18**; The Ethel Morrison Van Derlip Fund, proceeds from the 2011 Minneapolis Print and Drawing Fair, the Richard Lewis Hillstrom Fund, gift of funds from Nivin MacMillan, the Winton Jones Endowment Fund for Prints and Drawings, and gift of Herschel V. Jones, gift of Mrs Ridgely Hunt, and gift of Miss Eileen Bigelow and Mrs. O.H. Ingram, in memory of their mother, Mrs Alice F. Bigelow, by exchange **7**. Musée de Cluny – Musée national du Moyen Âge, Paris **218**. Musée Condé, Chantilly **205**. Musée Granet, Aix-en-Provence **36**. Musée du Louvre, Paris **115, 147**: Photo akg-images/Erich Lessing **239**; Photo RMN-Grand Palais (musée du Louvre)/Jean-Gilles. Musée d'Orsay, Paris **231**. Berizzi **143**; Photo RMN-Grand Palais (musée du Louvre)/Gérard Blot **85**. Museo Nacional Centro de Arte Reina Sofía, Madrid. © Succession Picasso/DACS, London 2022 **60–61**. Museo del Prado, Madrid **17**: Photo Museo Nacional del Prado/Scala, Florence **31, 254**. Museu Calouste Gulbenkian, Lisbon. Photo akg-images **191r**. Muzeum Narodowe, Gdansk **126–27**. National Archaeological Museum, Athens. Photo funkyfood London/Paul Williams/Alamy Stock Photo **102b**. National Archaeological Museum, Naples. Photo akg-images/Mondadori Portfolio/Luciano Pedicini **145**. The National Gallery, London **49, 215, 227, 246**: Photo The National Gallery, London/Scala, Florence **2, 28l, 91, 94**; Bequeathed by Revd Holwell Carr, 1831. Photo The National Gallery, London/Scala, Florence **155**; Wynn Ellis Bequest, 1876. Photo The National Gallery, London/Scala, Florence **224**. National Gallery of Art, Washington, D.C.: The Lee and Juliet Folger Fund **242**; Gift of the Stephen Hahn Family Collection. © ADAGP, Paris and DACS, London 2022 **87**; Samuel H. Kress Collection **76, 102a, 158b, 207**; Andrew W. Mellon Collection **44, 129**; Ailsa Mellon Bruce Fund **77**; Patrons' Permanent Fund **154b**. National Maritime Museum, London. Caird Fund **244l**. National Museum, Warsaw

169. National Museum of Anthropology, Mexico City 146l. National Museum of India, New Delhi. Photo akg-images/Nimatallah 217. National Museum of Women in the Arts, Washington, D.C. Gift of Wallace and Wilhelmina Holladay 225. National Portrait Gallery, London 50, 51l. Osaka City Museum of Fine Arts, Abe Collection 230. Palatine Gallery, Pitti Palace, Florence 35. Palazzo Schifanoia, Ferrara 116. Philadelphia Museum of Art. Purchased with funds contributed by the E. Rhodes and Leona B. Carpenter Foundation, 1989 164r. Photo Album/Superstock 101. Pinacoteca di Brera, Milan. Photo Scala, Florence/courtesy of the Ministero Beni e Att. Culturali e del Turismo 111. Princeton University Art Museum 211. Rijksmuseum, Amsterdam 45, 47r, 172a. © ROA 199. Royal Academy of Arts, London. Commissioned from Angelica Kauffman RA in 1778–1780. Royal Collection Trust, London 255. Photo Royal Academy of Arts, London 123. Russell-Cotes Art Gallery and Museum, Bournemouth. Photo Russell-Cotes Art Gallery/Supported by the National Art Collections Fund/Bridgeman Images 226. Sichuan Museum 51r. Solomon R. Guggenheim Museum, New York. Purchased with funds contributed by the Photography Committee, 2009. Photo The Solomon R. Guggenheim Foundation/Art Resource, NY/Scala, Florence. © ARS, NY and DACS, London 2022 140. St Bavo's Cathedral, Ghent 201. St Nicholas Church, Art Museum of Estonia, Tallinn. Photo Art Museum of Estonia/Bridgeman Images 144. Städel Museum, Frankfurt 251l. The State Hermitage Museum, St Petersburg 62r, 125, 253. Tate: © Salvador Dali, Fundació Gala-Salvador Dalí, DACS 2022 113; Photo Ramon Manent/Album/Superstock. © Succession Picasso/DACS, London 2022 98r. Tate Britain, London 59, 103l, 104. Thorvaldsens Museum, Copenhagen 37b. Tokyo National Museum 103r. The Uffizi, Florence 120, 157. Photo Universal Images Group North America LLC/DeAgostini/Alamy Stock Photo 83. Photo Universal Pictures/Album/Alamy Stock Photo 252. Photo Nandan Upadhyay 93l. Vatican Pinacoteca, Vatican City. Photo Prisma/Universal Images Group/Getty Images 37a. Photo Ivan Vdovin/Alamy Stock Photo 80. Whitworth University Library, Spokane 247. World Museum, National Museums Liverpool. Gift of Joseph Mayer. Photo National Museums Liverpool/Bridgeman Images 175. Yale Center for British Art, New Haven. The Lewis Walpole Library Collection. © Joe Tilson. All rights reserved, DACS 2022 173.

Acknowledgments

My thanks to Roger Thorp, Mohara Gill and Jen Moore at Thames & Hudson for their assistance and advice, to Sarah Wilson, Mark Mortimer and the Art History students at Bryanston School for their support, and to Noah Charney and Susie Hodge for their early encouragement. On the home front I am grateful for the support of Joanna, Jenny and Michael Rayner, and Orla and George Wilson. For their wise words and insights, I am indebted to Sophie Pearce, Ben Wilson and Matt Stockwell, as well as my inspirational parents Marney and Chris, to whom this book is dedicated with love.

Index

Page references in *italics* refer to illustrations

A Cup of Water and a Rose (Zurbarán) *227*
A Goldsmith in his Shop (Christus) *29*
A Guardian of Shiva (unknown) *146*
Adam and Eve (Cranach) *177*
Adam and Eve (Dürer) *135*
The Adoration of the Magi (Angelico and Lippi) 206, *207*
Alexander the Great 14, *56*, 56, 86, 131, 203
Allegory of Fortune (Dossi) 188, *189*
Apep slain, from the Book of the Dead of Hunefer (unknown) *178*
Angkor Wat 105–9, *106*
The Annunciation (Lippi) *102*
The Antioch Chalice (unknown) 128, *128*, 131
Anubis 26, *27*, 234
Aphrodite/Venus *44*, 98, 114–15, *116*, 138, 222, 253, 227
Apis 60, *62*
Apollo 40, 43, 44, 88, 178, 244
Apse mosaic, Santa Pudenziana (unknown) *80*
Apse mosaic, Church of St Apollinaris (unknown) *101*
Apotheosis of Antoninus Pius and his wife Faustina (unknown) *37*
Aristotle 86, 87, 114, 161, 217, 234
Art and Money; or, the Story of the Room (Whistler) 210, *210*

The Art of Painting (Vermeer) *12*
Asclepius-Hygieia Diptych (unknown) *175*
Ashoka 47, 72, 92–95
Ashurbanipal 72, *72*, 90
Ashurbanipal killing a lion (unknown) *72*
Assyria 72, 90
Austria 45, 254, 255
Aztecs 133, 138, 146, 234

Babylon 34, 58, 148
Bacchus *see* Dionysus
Bastet 152, *152*, 154, 178
Bayeux Tapestry (unknown) 22, *22*
Beijing 33, 212
bestiaries 54, 56, 112, 121, 148–49, 154, 161–62, 217
Bimaran reliquary (unknown) 79, *79*
Birds on a Dead Fox (unknown) *163*
The Black Cat (Beardsley) *153*
Black-figured lekythos with Hermes Psychopompos weighing the souls (unknown) *27*
Bonaparte, Napoleon 21, 52, *53*, 252
Bottle in the shape of a fox (unknown) *162*
Boy Blowing Bubbles (Manet) *191*
Brahma 106, 109, 146
Branch of Gooseberries with a Dragonfly (Dietzsch) *77*
Brera Altarpiece (Piero) *111*
Bride's robe (unknown) *192*
British empire 14, 55–57, 68–73

British Empire Exhibition guide cover (Sheringham) *69*
The Broom Tree (Kuniyoshi) *164*
Bronze cat statue (unknown) *152*
Bronze mirror with face of Hathor (unknown) *136*
bubbles 134, 188–91, 227
Buddha/Buddhism 78–83, 79, *81*, *82*, 92–95, *93*, 106, 108, *108*, 175, 176, 184, *185*, 208, 228–31
Buddha (unknown) *81*
bulls 14, 58–62, 170
The Burney Relief (unknown) 138, *151*
butterflies 75, 76, *77*, 84–87, 104, 119, 193

Cambodia 105–9
carnations 193, 195, 245, 248, 251
Carnation, Lily, Lily, Rose (Sargent) *103*, 103
Carp Ascending a Waterfall (Eisen) *213*
Carp and Waterweeds (Yōgetsu) *214*
cats 134, 152–55, 161, 162, 174, 236
Ce qui manque à nous tous (Ray) *134*
Celts 18, 92, 136, 186, 234
The Challenge at the Fountain of Tears (Master of the Getty Lalaing) 203
Charlemagne 56, *56*, 103
China 8, 13, 14, 19, 22, 30, 33, 51, 52, 54, 71, 78, 82, 83, 84, 86, 104, 106, 116, 137, 164, 194, 200, 209, 212, 222, 228–30, 247
Christianity 19, 28, 30–33, 34–36, 50, 55, 62, 75, 80–83, 87, 91, 94, 96–99, 100–4, 110–13, 114–18, 119–22, 124, 127–31, 134, 144–46, 148, 156, 158, 161, 172, 176, 181, 195, 200, 202–3, 206, 209, 212–15, 216, 218, 223–27, 236, 240, 245–47, 248, 251, 254–56
Chronos (Romanelli) *169*
Clement of Alexandria 96, 223, 224, 254
Clytie 244, *244*, 245
Coatlicue statue (unknown) *146*
Coffin of Ameny (unknown) *158*
Colour (Kauffman) *123*
columns 45–48, 72, 92, 95
Confucius 106, 228
Constantine 30, 32, 80
Crete 58, 62, 103, 171, 182
The Cry of the Fox (Yoshitoshi) *164*
Ctesias 216–17
Cupid and Psyche (Gérard) *85*

da Montefeltro, Federico 110–13
Dance of Death (Wolgemut) *142*
Danse Macabre (Notke) *144*
Daoism 84–86, 106, 164
The Declaration of the Rights of Man and of the Citizen (Le Barbier) *159*
Delphic Oracle (Tilson) *173*
Demeter 182–83
Depiction of the four-lions capital surmounted by a Wheel of Law (unknown) *93*
Dionysus/Bacchus 130, 131
Diptyque Carondelet (Gossaert) *143*

268 INDEX

The Distribution of the Eagle Standards (David) 39
dogs 8, 152, 162, 193, 195, 216, 232–37
Donatello 16, *16*
Dove (Picasso) *98*
doves 52, 75, 96–99, *100*, 181, 205, 215
dragons 13, 14, *15*, 18, 19, 30–33, 52, 54, 60, 80, 174, 212
Dragon in foliage with lion and phoenix heads (Sahkulu, attr.) *52*
Dürer, Albrecht 6, 63, *65*, 134, *135*, 144, 234–35, *235*

eagles 13, 21, 24, 25, 34–39, 50, 60, 128
Early Christian fish gem (unknown) *212*
eggs 76, 110–13, 119
Egypt 13, 21, 26, 27, *27*, 28, *43*, 47, 48, 50, 57, 60, 62, *62*, *70*, 71, 75, 79, 90, 105, 106, 109, *109*, 110, 116, 129, 130, 133, *136*, *137*, 149, *149*, 152, *152*, 154, 158, *158*, 171, 175, 178, *178*, 194, 196, 197, *197*, 200, 212, 232, 234, *234*, 253
Elizabeth I 50–51, *51*, 227
Elephant and Castle 14, 55–57
Elephant and Obelisk (Bernini) 57, *57*
Emperor's 12-symbol festival robe *32*
Equestrian Statue of Gattamelata (Donatello) 16, *16*
Equestrian Statue of Khosrow II (artist unknown) *83*
Ethiopia 47, 203, 222
Etruscans 94, 112, 130
Europa *14*, 61–62
Eye of Providence 9, 156–60, 197
Ezekiel's Vision (Raphael) *35*

falcons 13, 21–25, 123, 152, 158, 217
Falconer with Two Ladies, a Page and a Foot Soldier (unknown) *24*
The Fall and Expulsion from Paradise (Limbourg Brothers) *205*
The Fall of Man (Goltzius) 154
fenghuang 51–54, *52*
Figure of an owl (unknown) *149*
Fingermalerei – Adler (Baselitz) *38*
fishes 96, 193, 212–15
Flowers and Butterflies (Quan, attr.) *84*
Flowers in an Ornamental Vase (Van Oosterwijck) *244*
Fons Americanus (Walker) *9*
fountains 9, 126, 194, 200–5
Fountain in the Court of the Lions (unknown) *202*
Fountain of Youth (Master of the Castello della Manta) *204*
foxes 161–65, 174, 193
France 8, 28, 39, 63, 67, 71, 103, 119, 122, 144, 159, 168, 172, 247, 256
Freemasons 48, 156, 159, 160
Fresco with elephant (unknown) *56*
Fritware tile with dragon (unknown) *33*

Gandhara 80–82, 93, 131
Ganymede 34, 36, *37*
Ganymede with Jupiter's Eagle (Thorvaldsen) *37*
The Ghent Altarpiece (Van Eyck) *201*
Girl with a Pearl Earring (Vermeer) *257*

The Girlhood of Mary Virgin (Rossetti) *104*
Gold five guinea of James II of England (unknown) *55*
Goldfinch (Fabritius) *122*
goldfinches 76, 119–22, 155
Gonzaga, Federico 114–18
grapes 76, 128–31
Greece 22, 50, 99, *99*, 101, 133, 150, *150*, 170, 175, 194, 200, 201, 222, 234
Gregory IX, Pope 154–55
Guardian lion, China (unknown) *71*

Habsburgs 8, 13, 45
haloes 75, 78–83, 123, 215
Han Dynasty 19, 30, 33, 51, 137, 212
Hera/Juno 103, 208, 209
Hermes/Mercury 27, *27*, 28, 103
Herodotus 50, 114, 162, 171, 203
The High Priestess (Coleman Smith) *48*
The High Priestess (Wirth) *48*
Hinduism 80, 104–9, 110, 178, 186, 187, 194, 209, 240
Hinton St Mary mosaic (unknown) *74*
Hippopotamus ('William') (unknown) *109*
Holy Roman Empire 23, 34, 39, 45, 47
Homer 44, 234
Horse Effigy (He Nupa Wanica/No Two Horns) *19*
horses 16–20, 123, 254, 25
Horus 21, 105, 158

Illuminati 9, 156, 160
Illuminatus Part II: The Golden Apple (Ochagavia) *160*

Illustration from Poncher Hours (unknown) *167*
India 22, 24, 25, *25*, 56, 72, 78, 79, 80, 82, 92–95, *93*, 106, *107*, 116, 146, *146*, 172, *176*, *178*, 194, *194*, 200, 203, 206–9, 216–17, *217*, 238, 250
Indus Valley 78, 184, 200, 206, 217, *217*
Infinitas (ROA) *199*
Inlay depicting 'Horus of Gold' (unknown) *21*
Innocence and a Unicorn in a Moonlit Landscape (Pisanello) *216*
Iran 30, 33, 73, 78, 79, 83, 217, 234
Isabella de Bourbon, Queen of Spain (Rubens) *253*
Ishtar 90, 98, 148
Islam 23, 79, 91, 116, 200, 202, 209

Jainism 80, 95, 184
James Stuart, Duke of Richmond and Lennox (Van Dyck) *233*
Japan 24, 33, 82, 83, 104, 136, 141, 164–65, 184, 191, 209, 212, 228–31, 235
Jardin de Bibi Trompette (Dubuffet) *87*
Jasper intaglio with ouroboros enclosing Serapis (unknown) *196*
Jesus 6, 28, 50, 63, 72, 75, 80, 87, 91, 96, 110, 113, 114, 119, 121, 122, 124, 127, 128–130, 133, 156, 176, 181, 206, 212, 214, 215, 216, 218, 224, 240, 248, 254
John Dee's magical mirror (unknown) *138*
Judaism 55, 57, 91, 96, 124, 149, 200
Jung, Carl 10, 11
Juno *see* Hera
Jupiter and Thetis (Ingres) *36*

INDEX 269

Kama with a parrot (unknown) 194
Karlskirche (Von Erlach) 46, 47
Karttikeya seated on a peacock (unknown) 194
Kauffman, Angelica 123–24, *123*, 126
Kipling, Rudyard 152
The Kiss of Peace and Justice (De La Hyre) 28
Kitchen Scene with Christ in the House of Martha and Mary (Velázquez) 215
Knotted dragon pendant (unknown) 33
Korea 33, 83, 193, 230
Krishna dancing on the head of the snake demon Kaliya (unknown) 178

La Caricature 63–67
La Mort Saint Innocent (unknown) 147
La Peregrina 252–57
labyrinths 58, 101, 134, 170–73, 193, 201
Labyrinth # 98/270 Mansion House (Wallinger) *171*
The Lady of Shalott (Waterhouse) *139*
The Lansdowne Throne of Apollo (unknown) *178*
Lascaux caves 18, 71
The Last Judgment (Memling) *127*
laurels 14, 40–44, 88, 90, 150
Lekythos (Brygos Painter, attr.) *150*
Lekythos (Nikon Painter, attr.) *88*
lilies 100–4
lions 14, 60, 68–73
Lion head from the tomb of Tutankhamun (unknown) *70*
lotuses 75, 105–9, 112, 193, 224

Louis Philippe, King of France 63–67
The Love Letter (Fragonard) *237*
Madonna del Cardellino (Raphael) *120*
The Madonna of the Cat (Barocci) 155, *155*
Madonna and Child (Bellini) *64*
Madonna and Child (Crivelli) *121*
Madonna of the Pear (Dürer) *64*
Madonna della Vittoria (Mantegna) *238*
Maidservant Idol of Jiangdu Temple (unknown) *51*
Man Wearing Laurels (Sargent) *42*
Marble grave stela of a little girl (unknown) *99*
Marcantonio Pasqualini Crowned by Apollo (Sacchi) *41*
Margaret of Austria, Queen Consort of Philip III of Spain (De La Cruz) *255*
Mauryan empire 47, 92–93
Mechanical dog (unknown) *234*
Medal in honour of Charles V (unknown) *45*
Melancholia (Fetti) *235*
Melencolia I (Dürer) 6, 7, 8, 11
Memento mori 145, 190, 193, 227
Memento mori floor mosaic (unknown) *145*
Metamorphoses (Ovid) 43, 183
Metamorphosis of Narcissus (Dalí) *113*
Mexico 137, 146, 200
Miniature with cats (unknown) *154*
Miniature of Pope Celestine V kneeling in prayer (unknown) *165*

Miniature with Reynard the Fox (unknown) *161*
Minoans 101–3, *102*, 183, 200–1
Minos 58, 62, 170–71
The Minotaur (Watts) *59*, 62
Mirror Piece I (Jonas) *140*
Mirror with four spirits and companions (unknown) *137*
mirrors 134, 136–41, 193
Mithraism 62, *62*, 79–83
Moche people 149, 162, 164
Mongolia 19, 22, 33, 203, 230
Morpheus and Iris (Guérin) *125*
Mosaic floor at the Lullingstone Roman villa (unknown) *186*
A mounted man hunting birds with a falcon (unknown) *25*
Mughals 24, 25, *25*, 79, 250
Mummy portrait of a Roman man wearing a laurel wreath (unknown) *43*
Mural with Noah leaving the ark (unknown) *98*

Napoleon Bonaparte (Gillray) *53*
Nazis 184–87
Nelson's Column (Railton and Baily) *47*, 48
Netherlands 13, 87, 145, 190–91, 227, 236, 245, 250
Netsuke of fox (unknown) *162*
Nile 105, 152, 198
Noah 96, 98, *98*, 124
Nuinaku (Noh costume with lilies) (unknown) *103*
Nuihaku (Noh costume with symbols) (unknown) *184*
Nyx 182, 183

Obelisk of Axum (unknown) *47*
Olmecs 137
Olympia (Manet) *231*
Oosterwijck, Maria van 86, *244*, 245, 247
orchids 193, 228–31
Orchid (Sixiao) *230*
Orchids, Bamboo, Briars and Rocks (Tokusai) 228, *229*
Orchids and Rock (Bonpō) *229*
Osiris 105, 130, 212
ouroboros 193, 194, 196–99
Ovid 43, 148, 171, 183
owls 9, *11*, 26, 133, 134, 148–51, 162, 174, 193

Padua 16, 232–34
Pakistan 56, 79, 82, 116, 131
palm branches 75, 76, 88–91, 94, 104, 215
Panel from a rectangular box (unknown) *209*
Panofsky, Erwin 6, 7, 8, 10, 11, 166, 169
Panopticon design (Reveley) *159*
Paris 48, 63–67, 98–99, 141
parrots 193, *194*, 209, 217, 238–42
The Peacock Skirt (Beardsley) *211*
peacocks 193, *194*, 206–11
pears 14, 63–67
pearls 8, 98, 138, 194, 222, 252–57
Peirce, Charles Sanders 10, 11
Per Speculum (Paci) *141*
Petrarch 40, 44, 232, 234
Petrarch in his study (da Zevio or Avanzi, attr.) *232*
Philip IV on Horseback (Velázquez) *217*
Philipon, Charles 63–67

phoenixes 50–54, 193, 218
Phoenix, from a medieval bestiary (unknown) 54
The Phoenix Portrait (Hilliard) 51
Philosophy Consoling Boethius and Fortune Turning the Wheel (Coëtivy Master) 95
Physiologus 112, 162, 217, 218
Picasso, Pablo 60, *60–61*, 62, 98–99, *98*
Pliny the Elder 148, 171, 217, 234, 253
Pompeii *145*, 201, 222, 253
poppies 9, 134, 179–83, 248
Portrait of the Chancellor Gregor Brück (Cranach) *198*
Portrait of a Gentleman with his Helmet on a Column Shaft (Moroni) *49*
Portrait of a Man in a Chaperon (unknown) *250*
Portrait of Robert Cheseman (Holbein) *23*
Portrait of Simon George of Cornwall (Holbein) *251*
Portrait of a Woman (Bruyn the Elder) *250*
Portugal 55, 174–76, 250
Poster with Mao Zedong and sunflowers (unknown) *247*
Pottery pyxis (with swastikas) (unknown) *186*
Prancing horse (unknown) *18*
Pre-Raphaelite Brotherhood 181, 227
Providentia Divina (after Eichler the Younger) *159*

Qu Yuan 228, 230
Queen Elisabeth of France on Horseback (Velázquez) *254*
Quis Evadet? (Goltzius) *191*

Ra 79, 105, 154
rabbits 76, 114–18, 128
rainbows 8, 76, 123–27, 204
The Rape of Europa (Titian) *14*
Raphael 35, 119, *120*
Relief plaque with face of an owl hieroglyph (unknown) *149*
Rembrandt 248, 250, 251
Renaissance 13, 14, 24, 40, 43, 45, 50, 63, 100, 110, 116, 119, 124, 133, 144, 150, 158, 169, 189, 191, 194, 197, 204, 206, 210, 216, 218, 220, 232, 235, 240, 242, 244, 248, 251, 254
Ripa, Cesare 19, 57, 124, 158, *159*
Romans 16, 19, 23, 28, 30, 34, 36, 39, 43, 47, 62, 75, 79, 80, 83, 91, 122, 130, 131, 144, 148, 166, 171, 181, 196, 201, 202, 217, 222, 223, 253
roses 50–51, *51*, 98, 174, 179, 193, *195*, 222–27, 248, 254
Roses, Convolvulus, Poppies and Other Flowers in an Urn on a Stone Ledge (Ruysch) *225*
Rossetti, Dante Gabriel 104, *104*, *180*, 181, *226*, 227
Rubens, Peter Paul 16, 30, *31*, 32, 252, 253, *255*

Saint Augustine 98, 209
Saint Catherine of Alexandria (Bulgarini) *76*
Saint Catherine of Alexandria (Crivelli) *94*
Saint George and the Dragon (Martorell) *15*
Saint George and the Dragon (Rubens) 30, *31*
Saint Jerome in His Study (Dürer) *2*, 146, 234–35, *235*
Saint John 36, 96, 128
Saint Justina of Padua (Montagna) *89*

Saint Mark 36, 72, 144
Saint Matthew 36, 100, 128, 254
Saint Michael (Crivelli) *28*
Salt cellar (unknown) *174*
Santa Francesca Romana Clothed by the Virgin (da Viterbo, attr.) *236*
Sapi peoples 174–76
Sarcophagus of Tutankhamun (unknown) *197*
Sargent, John Singer 42, *103*, 104
Sarnath 92–94
Sasanians 30, 72, 73, 83
Scenes of Witchcraft: Day (Rosa) *150*
scythes 134, 166–69, 196
Scythians 79, 136
Seal with unicorn (unknown) *217*
Seated Buddha (unknown) *82*
Self-Portrait (Alberti) *158*
Self-Portrait (Carrington) *20*
Self-Portrait (Dix) *251*
Self-Portrait as Saint Catherine of Alexandria (Gentileschi) *91*
Serpent labret (unknown) *134*
Shakespeare, William 51, 142
Shiva *107*, 109, 146
Shiva as the Lord of the Dance (unknown) *107*
Sir Kenelm Digby (Van Dyck) *244*
skulls 134, 142–47, 190, 227
The Sleep of Reason Produces Monsters (Goya) *11*
snakes 26, 134, 146, 154, 174–78, 196, 208
Solomon, King 48, 209
Spain 45–48, 56, 75, 202, 209, 253–56

Spring, The Roses of Heliogabalus (Alma-Tadema) *223*
'Springtime Fresco' from Akrotiri (unknown) *102*
The Statue of Liberty Illuminating the World (Bartholdi) *78*
Statue with Virgin and Child (unknown) *121*
sunflowers 8, 138, 193, 195, 222, 243–47
Sunflowers (Van Gogh) *246*
Supper at Emmaus (Pontormo) 156, *157*
swastikas 26, 133, 134, 184–87

Tapestry from 'The Lady and the Unicorn' series (unknown) *218*
Tara, the Buddhist Saviour (unknown) *108*
Taylor, Elizabeth 252, *252*, 256
Theatrical robe with phoenix and floral patterns (unknown) *52*
Theseus and Ariadne (Van de Passe the Younger) *172*
Theseus mosaic from a Roman villa (unknown) *172*
Tomb relief with Christ giving the Law (unknown) *130*
Tomb of Sennefer (unknown) *130*
Transformation caricaturale du roi Louis Philippe (Daumier) *66*
Trevi Fountain (Salvi) *202*
The Trinity (Girardin) *97*
The Triumph of Fame over Death (unknown) *56*
Tutankhamun 71, 196

Ukraine 17, 184
The Unicorn Rests in a Garden (unknown) *219*

INDEX

unicorns 54, 56, 193, *203*, 216–21
Unicorns (Legend–Sea Calm) (Davies) 220–21
Untitled, La Caricature, 19 July 1832 (Daumier) 66
Untitled (Self-Portrait with Thorn Necklace and Hummingbird) (Kahlo) 132
United States of America 34, 156, 159, 160

Vajrapani attends the Buddha at his first sermon (unknown) 93
van Dyck, Anthony 8, *233*, 234, *244*
van Gogh, Vincent 8, 245, *246*
Vanitas Still Life (de Gheyn II) 190, *190*
Vanitas Still Life (Van Oosterwijck) 86

Vedas 93, 106, 208
Velázquez, Diego 16, *17*, *215*, 252, *254*, 255
Venus *see* Aphrodite
Venus with a Mirror (Titian) 44
Venus Verticordia (Rossetti) 226
Vermeer, Johannes 12, 13, *256*, *257*
Vessel (decorated egg) (unknown) 112
The Veteran in a New Field (Homer) 168
Vignette from the Book of the Dead of Hunefer (unknown) 27
Villa d'Este 124, 204
The Virgin and Child with Flowers (after Dolci) 224
Virgin and Child with Saints Catherine of Alexandria and Barbara

(Memling) *131*
The Virgin and Child in a White Rose (unknown) 195
Virgin Mary 50, 63, *64*, *65*, 75, 100, 101, *102*, 104, *104*, 110, *111*, 112, 114, 115, *115*, 119, *120*, *121*, 129, *131*, 155, *181*, 195, 203, *207*, 218, 224, *224*, 227, *239*, 240, 245, 247, 254
Vishnu 93, 109, 176
Vishnu in his cosmic sleep (unknown) *176*
von Erlach, Johann Bernhard Fischer 47
Voulez-vous aller faire vos ordures plus loin, polissons! (Bouquet) 67

Wall panel with banquet scene (unknown) 90
Wall fragment with peacock (unknown) 208

Wallinger, Mark 170, *171*, 173
weighing scales 14, 26–29
Weiwei, Ai 247
wheels 72, 75, 79, 92–95
Wittkower, Rudolf 34, 217
A Woman Feeding a Parrot with a Page (Netscher) 242
Woman with a Parrot (Courbet) 240
Woman with a Pink (Rembrandt) 249

Yin and Yang 33, 54, 164
A Young Lady with a Parrot (Carriera) 241

Zedong, Mao 247
Zen Buddhism 228–31
Zeus 34, *36*, 61, 88
Zhuang Zhou 84–86
Zoroastrianism 78, 83, 234

To my parents, Marney and Chris

First published in the United Kingdom in 2022 by Thames & Hudson Ltd, 181A High Holborn, London WC1V 7QX

First published in the United States of America in 2022 by Thames & Hudson Inc., 500 Fifth Avenue, New York, New York 10110

The Hidden Language of Symbols © 2022 Thames & Hudson Ltd, London

Text © 2022 Matthew Wilson

Layout design by Samuel Clark
www.bytheskydesign.com

All Rights Reserved. No part of this publication may be reproduced or transmitted in any form or by any means, electronic or mechanical, including photocopy, recording or any other information storage and retrieval system, without prior permission in writing from the publisher.

British Library Cataloguing-in-Publication Data

A catalogue record for this book is available from the British Library

Library of Congress Control Number 2022931878

ISBN 978-0-500-02529-1

Printed and bound in Slovenia by DZS-Grafik d.o.o.

Be the first to know about our new releases, exclusive content and author events by visiting
thamesandhudson.com
thamesandhudsonusa.com
thamesandhudson.com.au